Museums and Well-being

Museums and Well-being outlines the historical development of well-being within museums and offers a critical engagement with this field from a museum studies perspective. The essential thesis of the book is that well-being is a collective action.

The book utilises the Five Ways to Well-being as a model: Connect, Be Active, Keep Learning, Give and Take Notice. Each of these Ways are explored through a specific museum object illustrating the important role collections can play in museum well-being. The book considers how museum well-being, and the austerity project became entwined, and how the COVID-19 pandemic supercharged growth in this field. The book explores such diverse topics as walking, slow art, social capital, Virginia Woolf, body positivity, collective joy, identity, art therapy, yoga, Squid Game, Effective Altruism, mindfulness, gift exchange, the Preston model, the limits of data, sketching, photography, inclusive spaces, and workplace well-being. The book signposts a vast array of existing information, and offers a critical engagement with current practices.

Museums and Well-being is aimed initially to students of museum studies programmes, it is also an ideal book for museum staff who need to add a well-being component to their existing programming; or to reconsider existing programming from the perspective of well-being.

Rose Cull is Adjunct Faculty at Johns Hopkins University Advanced Academic Programs. She holds an MS in Conservation from the Winterthur/University of Delaware Program in Art Conservation, and a BA in Art History from The University of Texas at Austin. Rose has worked at institutions in Europe and the USA. Rose is a lifelong yoga practitioner as well as a YMCA qualified yoga instructor with a certificate in teaching yoga.

Daniel Cull ACR is Adjunct Faculty at Johns Hopkins University Advanced Academic Programs. He holds an MA and an MSc in Conservation, and a BSc in Archaeology from the University College London, he is an Accredited Conservator-Restorer. Daniel has worked at institutions in the UK and USA. Daniel is authorised to teach Mindfulness Meditation, and is a practitioner in the Karma Kagyu lineage of Vajrayana Buddhism.

Routledge Guides to Practice in Museums, Galleries and Heritage

This series provides essential practical guides for those working in museums, galleries, and a variety of other heritage professions around the globe.

Including authored and edited volumes, the series will help to enhance practitioners' and students' professional knowledge and will also encourage sharing of best practices between different countries, as well as between different types and sizes of organisations.

Titles published in the series include:

Managing Change in Museums and Galleries
A Practical Guide
Piotr Bienkowski and Hilary McGowan

Applying for Jobs and Internships in Museums
A Practical Guide
Martha Schloetzer

Welcoming Young Children into the Museum
A Practical Guide
Sarah Erdman and Nhi Nguyen with Margaret Middleton

Museums and Interactive Virtual Learning
Allyson Mitchell, Tami Moehring and Janet Zanetis

The Sustainable Museum
How Museums Contribute to the Great Transformation
Christopher J. Garthe

Museums and Well-being
Rose Cull and Daniel Cull

For more information about this series, please visit: https://www.routledge.com/Routledge-Guides-to-Practice-in-Museums-Galleries-and-Heritage/book-series/RGPMGH

Museums and Well-being

Rose Cull and Daniel Cull

Routledge
Taylor & Francis Group
LONDON AND NEW YORK

Cover image: Reliquary Casket of Saints Adrian and Natalia. Spain. 1100–1200. Kate S. Buckingham Endowment. The Art Institute of Chicago. Made available under Creative Commons Zero (CC0).

First published 2023
by Routledge
4 Park Square, Milton Park, Abingdon, Oxon OX14 4RN

and by Routledge
605 Third Avenue, New York, NY 10158

Routledge is an imprint of the Taylor & Francis Group, an informa business

© 2023 Rose Cull and Daniel Cull

The right of Rose Cull and Daniel Cull to be identified as authors of this work has been asserted in accordance with sections 77 and 78 of the Copyright, Designs and Patents Act 1988.

All rights reserved. No part of this book may be reprinted or reproduced or utilised in any form or by any electronic, mechanical, or other means, now known or hereafter invented, including photocopying and recording, or in any information storage or retrieval system, without permission in writing from the publishers.

Trademark notice: Product or corporate names may be trademarks or registered trademarks, and are used only for identification and explanation without intent to infringe.

British Library Cataloguing-in-Publication Data
A catalogue record for this book is available from the British Library

Library of Congress Cataloging-in-Publication Data
A catalog record has been requested for this book

ISBN: 978-0-367-75674-1 (hbk)
ISBN: 978-0-367-75671-0 (pbk)
ISBN: 978-1-003-16348-0 (ebk)

DOI: 10.4324/9781003163480

Typeset in Times New Roman
by Taylor & Francis Books

For Eve

Contents

List of figures viii
Acknowledgements ix

1 Introduction 1
2 Why well-being now? 8
3 Museums as spaces of well-being 19
4 Work and the limitations of well-being 30
5 Introduction to the Five Ways to Well-being toolkit 41
6 Connect 48
7 Be Active 61
8 Keep Learning 72
9 Give 83
10 Take Notice 94
11 Conclusion: So where to start? 108

Index 119

Figures

2.1 "Seeing Buddha": How we show our museums to the blind. Boys examining a Buddha at Sunderland Museum, 1913. Tyne & Wear Archives & Museums. No known copyright restrictions 9
6.1 Palmyran Sculpture Fragment, A.D. 150–160, Limestone. Object Number: 81.AA.170. Dimensions: 16.5 cm (6.5 in.). Digital image courtesy of the Getty's Open Content Program 48
7.1 The Dancing Lesson, 1878, Thomas Eakins (American, Philadelphia, Pennsylvania, 1844–1916). Watercolour on off-white wove paper. Dimensions: 18 1/16 x 22 9/16 in. (45.9 x 57.3 cm). Metropolitan Museum of Art. Open access/public domain 61
8.1 The Bodhisattva Mañjuśrī, c. 800 – c. 900, Candi Plaosan. Object number AK-MAK-240. Measurements height 138 cm × width 90 cm × depth 60 cm × weight 663 kg. Rijksmuseum. Copyright public domain 72
9.1 The Death of Sir Philip Sidney at the Battle of Zutphen: He Passes a Water-flask to a Fellow Soldier. Mezzotint by J. Jones after G. Carter, 1782. Wellcome Collection. Public Domain Mark 1.0 83
10.1 Five Girls, 7 January 1903, New Zealand, by Department of Tourist and Health Resorts, James McDonald. Te Papa (B.079478). No known copyright restrictions 94

Acknowledgements

First and foremost, we'd like to thank our son Teddy for his understanding and support during the writing of this book.

We'd like to thank Phyllis Hecht, the founding director of the Johns Hopkins University Master of Arts in Museum Studies program, for her support in developing a seminar on Well-being for the Museum Studies program, and for her encouragement with the idea of writing a book.

We would like to thank Nancy P. Daly and Marion G. Keller for reading through some initial drafts. At Routledge we'd like to thank our Editor Heidi Lowther, Commissioning Editor Emmie Shand, as well as our Editorial Assistants Kangan Gupta and Manas Roy, and the team commissioning works for Museum & Heritage Studies; Library, Archival & Information Science; Conservation; Digital Humanities.

For being a continuing inspiration as to the ways well-being can be actualised, we'd like to thank our village, Paulton, and the surrounding community farms and alternative spaces in this region, including the Exchange, Rockaway Park, Bath City Farm, and Hauser & Wirth Somerset.

We'd also like to thank the many museums that are mentioned in this book, as well as the many that aren't, for the work they've been doing to bring well-being into the museum and the many ways this has enriched so many lives.

1 Introduction

The question of well-being is a growing area of concern with museums. We invite you to join us as we offer this intervention into the burgeoning development in museology and museum practice. Our essential thesis is that well-being must be a collective action in which "we must dare to create lives of sustained optimal well-being and joy"[1] within and beyond the walls of the museum. This book is principally aimed towards practitioners; the people in museums and galleries who are leading, in whatever capacity, on programming well-being activities within the museum sector. We wrote this book as an intervention in these spaces, as a moment of reflection, and as a process of grounding, and we hope, too, as a source of inspiration for new ideas and approaches, as this nascent field takes life. Through the book we seek to amplify the whispers of this future that exist in the present, to give voice to some of those exploring this emerging field of museology and to explore the possibilities and also the limitations.

The ideas in this book were formulated over countless hours of late night conversations, reading and reflection, initially formulated for a seminar for Postgraduate Museum Studies students at Johns Hopkins University Advanced Academic Programs, where we are adjunct faculty. These ideas began to take further shape and morph into this text within the changing landscape of the impact of SARS-CoV-2, known as the COVID-19 pandemic. We write with a growing sense of concern or uneasiness as to the approach that the coupling of these ideas of museology and well-being have been taking. It is this concern that is the source of our critical engagement with this material, and ultimately for our desire to see these ideas reach their full potential within the museum, and in so doing in wider society. The purpose of this book is to be found in its application, in taking the ideas out from between the book covers and discussing them with colleagues, taking the practises and reshaping and employing them in your museums, or indeed your wider lives, to fit your own context and needs. For some these ideas will be new and exciting, for others they may offer critical engagement with, or give shape, depth or context to, activities they are already exploring. To others they may be too radical. The intention is to give the reader cause to pause. At the same time the book seeks to offer you the support to feel free to experiment, to try things out and to see what happens. In short, to play.

DOI: 10.4324/9781003163480-1

2 Introduction

The phrases "well-being" and "wellness" are often used interchangeably. We would, however, use the latter as a shorthand to describe the wellness industry, a multi-billion pound industry surrounding personal well-being. This industry has grown from a variety of sources, such as the secularisation of religious practises, self-help books, spas and gyms. We will consider the ideological framing of this industry in the age of austerity and offer a critical approach to the commodification of well-being, one that will be familiar to museum professionals who have long discussed the Disneyfication of museums. Conversely we would offer that well-being refers to the condition of an individual or group, which the Centers for Disease Control and Prevention (CDC) define as "what people think and feel about their lives, such as the quality of their relationships, their positive emotions and resilience, the realization of their potential, or their overall satisfaction with life."[2] These are aspects of physical, mental and social being that extend beyond the traditional definition of health. Well-being is therefore about personal subjective individual satisfaction: one may be dying but report a high level of well-being, equally one may be physically healthy but lacking in friendship, altruism or creativity, and report a low level of well-being. It will likely be self-evident, therefore, that we see well-being as a spectrum and would avoid the binary identification of "well" or "unwell." Moreover we will throughout argue the importance of the collective community as a key element of well-being, in that our individual well-being is collectively formulated as much as it is individually subjectively created.

We approach museums, and therefore well-being within museums, through the lens of collections, art and artefacts. We believe the primary functions of museums are to collect, preserve, exhibit and research material culture. When we consider museums and well-being, we do so with the idea that their intersection might form both an institution that practises well-being programming and the possibility of a new type of museum space in which the collections are utilised to fulfil the institutional mission of well-being. We will utilise these understandings throughout, drawing upon collections, art and artefacts to illustrate how material culture can support our understanding of well-being, and how this is the unique opportunity open to museums within the wider world of well-being programming.

The last decade has seen a steady growth of well-being related events, programming and projects within the museum sector, and a growing interest in partnership working between the museum and health sectors.[3] These interventions have also sought to increase accessible education, vocational skills, support for Specialist Educational Needs (SEN) and facilitation of museums working with marginalised communities, as well as to position museum spaces, and particularly objects, as having a role in healing from trauma. All this is to say that this has led to increasing funding and greater networking for museum well-being professionals; indeed, the birth of a field of work within the museum that in most

respects didn't previously exist. This explosion of well-being has reached a point at which it is now an expected part of museum practice, for example the National Heritage Lottery Fund granting applications asking applicants to describe how "people will have greater well-being"[4] as a result of their project funding.

This growth of interest in well-being practises in museums is mirrored in wider society, both as the government seeks to utilise well-being as a political tool, and as people are increasingly feeling drawn to focus on their own well-being as a response to a sense of loss of control over the society in which they live. In writing this book, we are seeking to offer something different, to step back from the noise and to consider this emerging field with a critically engaged eye. There are numerous existing books, pamphlets and websites that have collected case studies from a variety of institutions, and there are also books that look at well-being through a theoretical lens, typically focussing on one aspect within the museum sector. These are usually developed from a medical background, meaning that the critical eye of the museum studies professional is notably absent. It is this we wish to offer herein, we do so also from the position of collections specialists, and offer a reminder that ultimately what makes the museum special, and the opportunities for well-being therein unique, is their collections, in whatever form they may take. This may seem obvious, but it is an often-overlooked factor in considering programming within the museum as a place of well-being. We hope by exploring the *Five Ways to Well-being*[5] toolkit utilising the lens and language of the museum collections professional, we can offer insights that are useful to those seeking to add well-being content.

Outline of the book

The book is split into two sections: in the first half we seek to consider questions of why now?, why here?, and for whom?, and in the second half we offer our take on the Five Ways to Well-being: Connect, Be Active, Keep Learning, Give and Take Notice. These will function as the categories through which well-being practises can be considered. Woven throughout the chapters of the book, themes, or threads of thought float amongst the body of text. We discuss ideas of memory and documentation, care and community, emergence and collision, and the pandemic as a portal to a new world. Whether they appear explicitly or as subtle shadows, they serve as the ground upon which our ideas of well-being as a collective enterprise rest. We see the opening of well-being into the museum as an act of emergence, based on the formulation that "there is a conversation in the room that only these people at this moment can have. Find it."[6] We see this idea fundamentally as being about prioritising process over end-result and about welcoming experimentation, risk and openness. Holding space for collective well-being, our ideas of collision, community and the street draw upon a reading of Jane Jacobs[7] and her observation that community is formed organically from the bottom up,

and is not created top down by planners. An overarching major theme is that the COVID-19 pandemic holds not only the negative connotations of being a deadly and traumatic event, but also the potential of a positive outcome through opening of a crack in our reality in which new possibilities might emerge, an idea that was most eloquently described by Arundhati Roy as a "portal."[8]

The first half of the book begins by asking "Why now?" We seek to explore how and why well-being has become a factor of museology today. What is it about this particular conjuncture that gives well-being such a buzz? Why has the cultural sector begun to consider well-being a part of what it does? We consider the history of how well-being became interlinked with the austerity project and the rise of *positive psychology* as a political and socio-cultural tool. We explore a little of how museum well-being developed from the university sector and professional academic organisations. We will see how the COVID-19 pandemic supercharged the existing growth in this field, ultimately mainstreaming the idea of museum well-being.

In the next chapter we continue by asking "Why here?" We consider the connections between space, place and well-being, and the museum. We offer the street as a place of intercultural connection and a model for considering the possibilities that a museum space might hold for much needed community well-being. We consider the role space, whether the street or the museums, plays in developing an inclusive environment or shared space.

In the next section we ask "What about us?" This chapter is very much concerned with the position from which we write within the museum. We explore in what amounts to a form of workers inquiry into what it means to offer well-being practises in a workplace, and the economic management systems and ideas of biomorality that have shaped these offers into often negative experiences for workers. The comparison between well-being for visitors and staff allows us to illustrate how these institutions are not always places in which staff well-being has been a central concern; we are concerned then with the promise and limitations of well-being in the workplace.

The second half of the book begins by introducing the Five Ways to Well-being, the model for well-being that we have chosen to utilise. We explain within this chapter why it is we have chosen this model, and also why we would suggest you do too. It is worth mentioning that when we first began discussing the idea of writing this book, we chose the Five Ways to Well-being as what seemed like the most common framework within the museum sector, yet few people would claim that it was part of a common lexicon within the museum. The pandemic has changed that; today there must be few people working in museums who have not at least heard of it. The book continues with a chapter concerning each of the Five Ways to Well-being: Connect, Be Active, Keep Learning, Give and Take Notice. We offer our own take on those ideas.

To *Connect*, a *Palmyran Sculpture Fragment*, demonstrates that fragments, collections and documentation are culturally influenced. Barriers to connection

are addressed with representation, diverse programming and audience segmentation. Connection is related to identity, duality, diversity and access; and collective joy, community healing and building social capital in museums.

Be Active is illustrated in the watercolour, *The Dancing Lesson*, considering performance art, joy and collective liberation, active viewing of artworks, walking and yoga. Expectations and measurements of activity could be a barrier to participation, questioning what activity means in light of body differences, cultural assumptions and long-COVID fatigue.

To *Keep Learning*, references the sculpture of wisdom deity *Mañjuśrī*. Then we examine Bloom's Taxonomy, the history and examples of art therapy, learning to look, self-care, unlearning, the decolonial lens and ultimately how the act of keep learning is a political act that requires political support.

To *Give* through a mezzotint, *The Death of Sir Philip Sidney* illustrates the myth of gallantry. We discuss forgiveness and suicide as acts of giving, gift exchange and trans-action to critique effective altruism, a Tolstoyian story of forgiveness, altruism in Squid Game, the role of budgets in gift economies, the Preston Model and global commons.

We *Take Notice* of a photograph of Victorian Māori, indigenous identity, the opening and closing of possibilities through approaches to collaboration, deep noticing from the perspective of an art historian, slow art, collection checking by museum conservators, mindfulness and how reality can be noticed differently through sketching and photography.

We conclude the book with the question of "Where to start?" We consider training, partnerships, and assessment options that you might want to consider in order to start working on well-being programming, all the while remaining vigilant that creating spaces of joyous well-being and data sets of customer satisfaction may not be mutually compatible. Sometimes you might just need to read the room to know if something is working. We also include a final section with some key resources for further consideration.

A few words about context

The context in which we wrote this book is living through the on-going COVID-19 pandemic. The pandemic fundamentally changed the focus of what we set out to write—how could it not? This period of sickness, stress and on-going uncertainty was a difficult time to focus on our project, to consider what it would mean to spend more time at the museum creating lives of joyous well-being. This was a period of seemingly never-ending rolling lockdowns, constant signs of death, which made way for food and petrol shortages, and rising costs of living. The spectre of austerity dragged back out to haunt us once more. Our own lives have involved juggling home, school, work and writing, catching and slowly recovering from COVID, learning to live with the chronic illness of long-COVID and wondering what the future may bring. We are in a strange position in which we are looking tentatively and anxiously to the future, a future in which you, as the reader, have the

advantage of knowing. You likely know the answer to what comes next, the world after the pandemic. We can but wonder how our future has shaped your past. What has occurred between the now in which we are writing, and the now in which you are reading these words? From where we sit now, the COVID-19 event that we are in the middle of has shaped our thoughts over these past months and years, a pandemic that has forced us to learn a new lexicon; R number, transmission, incubation, asymptomatic, ventilator, sceptics, Zoom bombing, contact tracing, vaccine uptake, essential businesses, flattening the curve and of course social distancing, quarantine, mask mandates and partygate. We wonder, for example, whether agreement was reached on whether a scotch egg constitutes a substantial meal?

We write towards this unknown future, an offering into the void of the unknowable, this book contains ideas and practises for future museum practitioners that draws upon current trends within museology that we believe will likely be particularly relevant in a post-COVID world; whatever the future holds. We believe the pandemic has caused many to re/consider their own well-being, as well as more widely to re/consider the world before the pandemic. We see how every call to return to normal, even the phrase new-normal, is met with a question as to whether normal was actually a place anyone wanted to be. A question as to whether we should really have referred to that as *normal* by any rational metric. A feeling so wonderfully described by Arundhati Roy: "Our minds are still racing back and forth, longing for a return to 'normality', trying to stitch our future to our past and refusing to acknowledge the rupture. But the rupture exists."[9]

This book serves in some respects as a physical manifestation of our rupture with the past, our questioning of the pre-pandemic museology and a proposition that focusing upon well-being would be a timely turn for the museum in a post-pandemic world. We offer the question, and herein some pointers, to all museums: does your museum work for the well-being of all? And, if not, what might that look like for your institution? These words flowing from the chaos of this rupture are our attempt, with hope and purpose, to grapple with these issues. We seek to consider how we step out of the collective trauma of the pandemic and into a post-pandemic museum. How we might collectively step out of our museums and into the street.

Notes

1 hooks, b. (2016). Beyoncé's Lemonade Is Capitalist Money-Making at Its Best. *The Guardian*. London. 11 May 2016. https://www.theguardian.com/music/2016/may/11/capitalism-of-beyonce-lemonade-album
2 Centers for Disease Control and Prevention. n.d. Well-being Concepts. [website] https://www.cdc.gov/hrqol/wellbeing.htm
3 Lackoi, K., Patsou, M., and Chatterjee, H.J. et al. (2016). Museums for Health and Wellbeing: A Preliminary Report, National Alliance for Museums, Health and Wellbeing. https://museumsandwellbeingalliance.files.wordpress.com/2015/07/museums-for-health-and-wellbeing.pdf

4 NHLF Grant Application Section 4.f.
5 New Economics Foundation (NEF) on behalf of Foresight and Government Office for Science (2008). Guidance: Five Ways to Mental Well-being. 22 October 2008. https://www.gov.uk/government/publications/five-ways-to-mental-wellbeing
6 Brown, A. M. (2017). *Emergent Strategy: Shaping Change, Changing Worlds.* AK Press. Chico, CA and Edinburgh, Scotland, p. 41.
7 Jacobs, J. (1962). *The Death and Life of Great American Cities.* Jonathan Cape. London.
8 Roy, A. (2020). The Pandemic Is a Portal. *The Financial Times.* 3 April 2020. https://www.ft.com/content/10d8f5e8-74eb-11ea-95fe-fcd274e920ca
9 Ibid.

2 Why well-being now?

A big society

Museums don't operate in a vacuum, and nor could they. The story of why well-being has become an element of museology is really the story of why it has become an element of all our lives. In the UK it was the 2010–2015 coalition government that helped place well-being at the heart of the cultural landscape as an essential component of their programme of economic austerity. The pitch was that it was necessary to end what were described as years of excessive government spending, and usher in a new society known as the Big Society[1]: "The age of irresponsibility is giving way to the age of austerity."[2] The language deliberately borrowing from the Second World War heralded the "austerity nostalgia"[3] of the now ubiquitous *Keep Calm and Carry On* paraphernalia.

In essence the Big Society meant the welfare state, a publicly funded social safety net, was to be removed and replaced with a complete network of charities and/or corporate entities. This reorganisation was tangible and symbolic, aiming to unmake the idea of social solidarity and replace it with the logic of the market. Austerity policies, however, were never popular and successive governments have sought to claim their end. From the start, the Big Society idea was entwined with well-being, the government announced that "we'll start measuring our progress as a country, not just by how our economy is growing, but by how our lives are improving; not just by our standard of living, but by our quality of life."[4]

For austerity to work it was recognised that it was imperative that people feel better about having less. Looking around for a way to achieve this, the government fixed upon the work of a movement in psychology known as *positive psychology.*[5] Martin Seligman, the founder of these ideas, was to meet with the government in 2011, the same year he appeared on Newsnight to present these same ideas of well-being to a public audience.[6] The government wanted to know if positive psychology could be applied to an entire country, with the goal of making it flourish without spending on public services. Positive psychology suggested, with some evidence, that this would be possible, although it had never been tried on such a large scale. In effect the UK was to

be offered as a country on which to test such a theory, the country's population was signing up to be part of an experiment. But it was an experiment we could have predicted the results of for "in history and decades of research, the price of austerity has been recorded in death statistics and body counts."[7] The poor health outcomes of austerity it is worth noting extends equally to mental as well as physical health,[8] especially in marginalised communities such as LGBTQ+ youth.[9] It remains a tragedy that positive psychology and austerity were seen as effective measures to replace a functioning welfare state.

The idea of austerity has had a wide spectrum of negative impacts. The UK was reported to be "the capital of loneliness in Europe according to our government's own happiness index."[10] The UK after austerity is not a country built upon well-being, far from it, the new shape of the country is one in which charities now feed vast swathes of our population, it is said there are more food banks than McDonalds, and in which footballers must advocate for the right for the poorest children in society to receive food. This is the reality for many in our society, now supercharged through the pandemic. Therefore, this is the reality in which museums operate, and it's the reality that makes a critically engaged well-being approach so vital to museums if they are to have a positive role in society.

Well-being is not all new

The shift towards a well-being focus in museums and cultural institutions was recognised in a 2016 government white paper produced by the Department

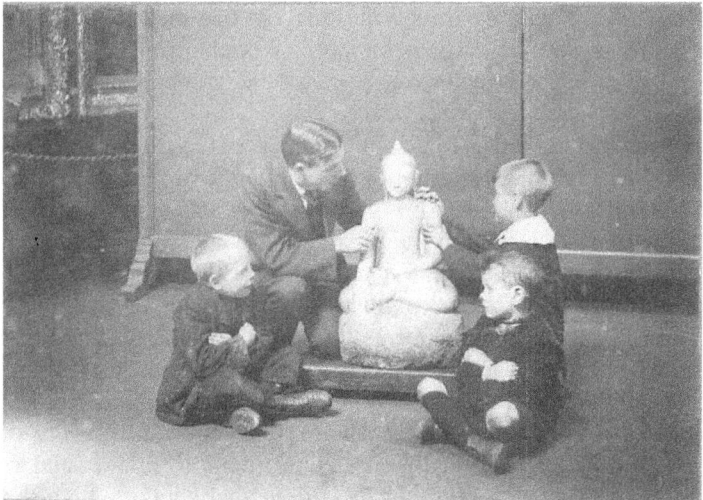

Figure 2.1 "Seeing Buddha": How we show our museums to the blind. Boys examining a Buddha at Sunderland Museum, 1913. Tyne & Wear Archives & Museums. No known copyright restrictions.

for Culture, Media and Sport (DCMS) which reported "evidence suggests that culture has an intrinsic value through the positive impact on personal wellbeing."[11] Although it is clear that the Big Society was a key driver in the expansion of well-being into museums and cultural institutions, and shaped the landscape and data motivated approach over the last decade, it is important to recognise that well-being ideas and practises have a longer history within museums. Points of connection can be found in the 1970s counterculture where museums hosted be-ins, such as the Be Here Now with Ram Dass, at the Museum of Natural History, Cleveland, Ohio, or earlier still in the pioneering work of John Alfred Charlton Deas, a former curator at Sunderland Museum, who in 1913 organised several handling sessions for the blind, recorded for posterity in a set of photographs, including this example entitled *Seeing Buddha* (see Figure 2.1) of a group of blind boys from Sunderland Council Blind School examining a statue of Buddha.

At first offering an invitation to the children from the Sunderland Council Blind School to handle a few of the collections, Deas went on to develop and arrange a course of regular handling sessions, extending the invitations to blind adults. Today touch in museums has taken on a broad spectrum of possibilities, and emerging technologies, as well as a wide range of locations both within and beyond museums such as hospitals, prisons and the wider community.[12] Discussion around blind and partially sighted access has also moved on from the experimental approach of John Alfred Charlton Deas, and today scholars are questioning the supremacy of sight over touch as greater understanding of ways of learning have been understood. "Unlike art museums where emotion is often privileged, feeling has not been considered an appropriate response within the scholarly environments that prize objectivity. Actively encouraging personal and intimate engagement with the objects thus suggests that the Museum's definitions of learning and of who is allowed to know might be changing."[13] Unsurprisingly, it turns out what is good for the well-being of one group, is likely good for the understanding of all.

An innovative and intriguing early example of considering well-being in museums comes from the American Museum of Natural History, where in 1909 the Department of Public Health was founded. It was a small department in which, amongst other activities, a collection of live microbial cultures known as "the Living Museum"[14] were created. The goal of the department was to link human health outcomes to the natural world of plants, animals and the physical (natural and manmade) environments we inhabit. The department was eventually closed and its collections sent elsewhere or incorporated into other departments within the museum. It is interesting that a critique of the department, from its inception, was that its stance was ideologically driven to blame disease on public ignorance and not unequal distribution of power and wealth. It was both then, and now, conceived as a critique that comforted not those who most needed its message but the museum trustees on whose support the department depended for its existence; and when those trustees focus turned to rebuilding Europe after the First World War (WWI), the department closed.

Working with military veterans within the cultural sector, especially those with post-traumatic stress disorder (PTSD) has a long history, dating to at least WWI. In the age of the War on Terror, a successful programme has been running to assist in the recovery of wounded and sick military personnel and veterans through involvement with archaeological projects, known as Operation Nightingale[15] This programme mirrors rehabilitation work undertaken after WWI[16] when it was recognized that historic sites and the countryside were of benefit to recovery from shell shock. An approach pioneered at Seale Hayne Hospital, near Newton Abbott, Devon, by Arthur Hurst, who was experimenting with using therapeutic landscapes as a cure for shell shock.[17] English Heritage Curator Martin Alfrey describes how these techniques were expanded from Seale Hayne Hospital, though farming, arts and crafts, and then into working to stabilise the ruins of historic sites that had come into state guardianship in and around 1917, such as Rievaulx Abbey in Yorkshire. Often veterans were employed to use their war trench digging skills, sometimes men with disabilities were deliberately recruited through "the King's National Roll Scheme, set up to encourage employers to take on disabled ex-servicemen."[18] Alfrey draws comparison between these WWI-era projects and more recent projects such as Human Henge, which was a major recent well-being project at Stonehenge that aimed to improve mental health through creative explorations of historic landscapes, and to incorporate "a systematic empirical evaluation of the health impact of the programme."[19] The project was funded by the Heritage Lottery Fund, the Restoration Trust, in partnership with Bournemouth University, the Richmond Fellowship, English Heritage, National Trust, and the Avon and Wiltshire Mental Health Partnership NHS Trust.

However, it was in the age of austerity that museum well-being began to become organised in a structured way. In the UK two early organisations, with names so similar they could come from a Monty Python sketch, were the National Alliance for Museums, Health & Wellbeing, and the National Alliance for Arts, Health and Wellbeing. It was through the auspices of the National Alliance for Museums, Health, and Wellbeing that some of the most significant contemporary forays into well-being in museology were first made. Most triumphantly they heralded their preliminary report on current trends declaring a "new era"[20] regarding the important role of culture in helping to improve the public's health. Two years later they followed this up to explore developing themes and best practises.[21] This National Alliance was a consortium funded by Arts Council England which ran from 2015–2018 and was led by UCL Public and Cultural Engagement. The consortium also included: National Museums Liverpool, the British Museum, the UK Medical Collections Group represented by the Thackray Medical Museum, Tyne & Wear Archives & Museums, Manchester Museums and Galleries Partnership, the Research Centre for Museums and Galleries (RCMG) at the University of Leicester's School of Museum Studies, the Museums Association and the National Alliance for Arts, Health & Wellbeing. After its initial year, new partners joined

the Alliance including: Public Health England, Happy Museum Project; Age Friendly Museums Network; Age of Creativity; Group for Education in Museums; Sport in Museums Network; Cultural Commissioning Project and The Wellcome Trust. In 2019 the Alliance eventually merged with the National Alliance for Arts, Health and Wellbeing to become the Culture, Health and Wellbeing Alliance,[22] a national membership organisation with links to the All-Party Parliamentary Group on Arts, Health and Wellbeing, a cross party group of parliamentarians, formed in 2014, who led a two-year inquiry (2015–2017) resulting in the report *Creative Health: The Arts for Health and Wellbeing*.[23] These organisations then are the main contributors to the world of well-being in museums in the UK.

This new era has been documented by a wide array of studies, which collectively demonstrate many positive benefits, including positive social experiences and opportunities for learning, increased hope, optimism, enjoyment, calm, self-esteem, sense of self, meaning-making, communication, and interestingly, and we might say importantly, positive distraction from clinical environments. According to the Art Fund, museums are "a significant untapped resource"[24] that can help us achieve a greater sense of well-being, and others have also supported the idea to "advocate for museums and galleries making health and wellbeing part of their core activity."[25] Yet underlying these studies it is recognised that the current conjuncture is perhaps the biggest driving force behind the spread of these practises. An idea best echoed by Stephen Deuchar, Director of the Art Fund, who said: "in our present time of great uncertainty—economic, political and technological—we feel more than ever that people need places where they can relax, learn, contemplate and wander, whether together or alone."[26]

Austerity Gospel

It is clear that well-being is not a new practice for museology, but a longstanding if understated tradition, seemingly growing in popularity mirroring wider societal trends. While it is clear museums have been influenced by the Big Society idea, there is another perhaps even more significant influence, that of the Wellness Industry. If we look beyond government statistics and policy papers, and simply spend a few minutes on social media, we'll realise that well-being and wellness are major, and lucrative, components of the lifestyle-branded consumerism that "influencers" market to their followers. Of course this isn't really new; in many ways it mirrors earlier celebrity endorsement and interest in self-help books, magazines, and videos. We believe we are actually seeing a coming together of Wellness and Austerity in popular culture; a platform we have come to refer to as the *Austerity Gospel*, in which contemporary wellness experts host television programmes, podcasts and lucrative seminars, that preach the merits of small homes, minimalism, completing domestic tasks, mindfulness, positive affirmations, decluttering and tidying. We take this term from the idea of the prosperity gospel, a theological idea amongst some Christian Protestants that

financial and physical well-being are the will of God, and that faith, positive speech and donations to the church will increase your chance with God.

We believe that the proponents of the Austerity Gospel feed on the trend in society for people to focus upon themselves, through hashtag self-care and personal growth, when they feel they have lost control of the society in which they live. The Austerity Gospel tells us you will be better, healthier, mentally fitter, if you have less. That in fact austerity isn't bad for you, despite what you may believe, and ultimately if you just change the way you feel you would realise you are better off. The Austerity Gospel acts as a sacred text of bio-morality "the moral demand to be happy and healthy"[27] that is shaping our contemporary world.

In searching for a foundational text of the Wellness Industry, we wondered what might be the first self-help book ever published, despite the many books on manners, self-discipline, love and sex, that had been written throughout history. It might be fairest to say that the specific genre of self-help, as we know it today as a tool within capitalist realism,[28] really took shape after 1859 when a doctor, with the appropriate name of Samuel Smiles, published a book entitled *Self-Help*. Launching him almost overnight into celebrity status, giving both a form and name to this new genre of literature; and later cultural artefacts. It was this coupling of celebrity and literature that gave shape to the genre; a genre in which the author, as brand, is as important as the content of their work.

Today the book *Self-Help* is not only the progenitor of a movement but is also considered a classic of literature surrounding business management, which explains its popularity amongst business leaders such as Sakichi Toyoda, the founder of Toyota, who considered the book such a huge personal influence that a copy of *Self-Help* is on display in the museum at Sakichi's birth site.[29] The source of this influence can be clearly seen from chapter titles such as "Leaders of Industry: Inventors and Producers," "Energy and Courage" and "Character: The True Gentleman." Moreover, the idea of a self-made Victorian middle-class entrepreneurial gentleman leaps from its pages, as does the expected class prejudice, exemplified by lines such as "any class of man that lives from hand to mouth will ever be an inferior class."[30] Perhaps it is no great surprise that the line from the origin of the self-help movement to the denigration of the working class in Austerity Britain is a straight and direct one.

We do not know if David Cameron, Nick Clegg or Martin Seligman are avid readers of the works of Samuel Smiles, but the idea of positive psychology that they championed are clearly elucidated within *Self-Help*. Smiles writes, "Even happiness itself may become habitual. There is a habit of looking at the bright side of things, and also of looking at the dark side."[31] There's little doubt that Smiles would have been an avid supporter of the Big Society. The opening line of the book, in many respects its whole thesis, reads: "'Heaven helps those who help themselves' is a well-tried maxim."[32] However, not everyone appreciated the book. It appeared within a Robert Tressel novel as a book that was "suitable for perusal by persons suffering from almost

complete obliteration of the mental faculties,"[33] while elsewhere it was called "a brutal book; it ought to be burnt by the common hangman."[34]

Over the century that followed, as the idea of self-help grew, many would re-hash these same arguments around the role of the individual, the community and questions of whether this type of self-help was, inherently, selfish. Interestingly in the preface to the 1886 edition, the author himself notes that selfishness is "the very opposite of what it really is—or at least of what the author intended it to be" noting that "in one respect the title of the book, which it is now too late to alter, has proved unfortunate."[35] In his book, Smiles is however keen to promote personal agency stating that "men must necessarily be the active agents of their own well-being and well-doing."[36] The phrase well-doing, that is, the practice of good conduct, is much less frequently used today. Perhaps its modern equivalent in the self-help movement revolves around discussions of social solidarity and collective action; broadly helping one another. This mutuality was a key element of the boom in self-help in the wake of the 1970s counterculture, however, once again we see that "in less than thirty years, 'self-help'—once synonymous with mutual aid—has come to be understood…as a largely individual undertaking."[37] It seems the ebb and flow between these ideas is also not a new thing.

Social carelessness

In 2008 a pamphlet reviewing the state of cultural heritage conservation and volunteering offered the field as "a paradigm…for a wider social ethos of care."[38] This focus on the idea of care, within museology, is one we found and continue to find intriguing. Within the many words associated with well-being, we consider care to be of particular utility in tracking and tracing discussions of the politics associated with well-being, and as such a useful reference point for understanding why well-being is a key element of contemporary society. The world of austerity has been described as "one in which carelessness reigns."[39] The phrase care crisis has joined alongside the opioid crisis, the environmental crisis, the refugee crisis, the cost-of-living crisis, and a growing list of other crises in which the world is living through. Cuts to the welfare state and the impact upon social reproduction[40] have meant of course that it is women who have been most negatively impacted by austerity measures.[41] In the wake of cuts to social welfare, and the side-lining of concepts of community solidarity, the wellness industry promotes individualised notions of self-care sold at a price, biomorality writ large in which we are told those who truly cared about themselves, and their health and happiness, would buy these products and services.

There is no escaping that care has become a key battleground of contemporary politics; although it probably always was, only it appeared under different terminology. The economy and citizenship well-being have unfortunately been pitted against each other, however, many organisations, such as the Wellbeing Economy Alliance, propose a new envisioning of the economy that "doesn't focus on growth in economic terms—but instead, growth in human

wellbeing, flourishing, environmental quality."[42] There is growing parliamentary support for economic practises that put "care at the very centre of life."[43] These themes are also observable within extra-parliamentary politics, where the importance of care has been recognised by groups, such as Sisters Uncut, who in 2017 occupied the recently closed visitors centre at Holloway Women's Prison under the banner "care not cages."[44] It highlights the failures of care in society that often leads people into crime and prison; and also offers an abolitionist view in which cages would be replaced by systems of care. Museum collections and heritage sites provide a wonderful paradigm for this social ethos of care, and a route out of social-carelessness, moreover, the well-being agenda of museums provides a model that others are increasingly seeking to emulate.

The shadow of COVID

There is a recognisable, if potentially unexpected, pattern of human behaviour in the event of disasters and crisis. Generally people come together to help one another out, and in so doing experience hope, joy and an unravelling of the problems of alienation in society.[45] Similar experiences have been reported during the pandemic. During this crisis governments stepped up to care for people they previously cared little for, such as the homeless, and communities stepped up to care for each other through mutual aid, locking down, clapping for carers, rainbow images, paying people not to work and a network of local purchasing. The idea of the Big Society found a positive home in the masses of people who volunteered support for government initiatives and health care providers. People who contributed their time reported feeling useful in helping "the well-being of others."[46] Others marvelled at how previous obstacles were put aside to address societal issues "homelessness was essentially ended overnight in the UK."[47] The sense of joy and wonder was also widely experienced in the changes to the environment that we all inhabited: "who could not be thrilled by the swell of birdsong in cities, peacocks dancing at traffic crossings and the silence in the skies?"[48] For us, too, these visions of hope played out in our small actions and in our hearts as we saw the greatest act of social solidarity and collective action to improve well-being that the world has probably ever seen. Arundhati Roy describes this as a portal to another world: "Historically, pandemics have forced humans to break with the past and imagine their world anew. This one is no different. It is a portal, a gateway between one world and the next."[49]

Mutual aid has been described as "a feeling infinitely wider than love or personal sympathy,"[50] and in the Catholic Workers Movement these activities are described as "works of Mercy."[51] These activities are the glue that holds many communities together through difficult times, and in some places have done so for generations. Their stories are usually told only by themselves, and in "collective note-taking"[52] efforts to record and analyse these histories. We wonder whether their stories collectively would make for a fascinating history of social change and crisis. Their stories should be told so these memories are

not lost. We believe mutual aid networks and similar organisations are amongst the best examples of collective well-being in practice. We know that it was us and millions like us, all doing just a little bit, that saved lives, supported one another and worked to bring about care during this crisis.

In this context it is interesting that museums are beginning to be seen as an important source of well-being to assist recovery. In Belgium you might find yourself "under doctors' orders to visit museums"[53] in a pilot programme based on a Canadian programme developed at the Montreal Museum of Fine Arts, that describes itself as a research laboratory for measuring the impact of art on health, where even digital access has been described as having benefits. The pandemic not only offered every individual the opportunity to re/consider what was normal in their lives, but, for museums, too, should they choose to take it, a portal to a new museology is opening. We don't know how the final stages of the pandemic will play out. The pandemic though has highlighted further crisis looming on the horizon, another hyperobject,[54] at once bigger and more terrifyingly massively distributed, the climate crisis, and how we in museums address well-being within the context of the Anthropocene should be a growing concern for us all.

Notes

1 Cameron, D. (2010). *Big Society Speech*. Published under the Conservative and Liberal Democrat Coalition Government. 19 July 2010. https://www.gov.uk/government/speeches/big-society-speech
2 Cameron, D. (2009). *The Age of Austerity*, 26 April 2009. Via: Say It Modern Transcripts. https://conservative-speeches.sayit.mysociety.org/speech/601367
3 Hatherley, O. (2017). *The Ministry of Nostalgia: Consuming Austerity*. Verso Books. London.
4 Cameron, D. (2010). *Speech on Well-being*. Published under the Conservative and Liberal Democrat Coalition Government. 25 November 2010. https://www.gov.uk/government/speeches/pm-speech-on-wellbeing
5 Seligman, M. (2003). *Authentic Happiness: Using the New Positive Psychology to Realise Your Potential for Lasting Fulfilment*. Nicholas Brealey Publishing.
6 Paxman, J. & BBC. (2011). Martin Seligman on Newsnight. 8 July 2011. [YouTube] https://www.youtube.com/watch?v=Q-Vhjmdp4nI
7 Stuckler, D. & Basu, S. (2013). *The Body Economic: Why Austerity Kills*. Allen Lane. London. p. xv.
8 Knapp, M. (2012). Mental Health in an Age of Austerity. *Evidence-Based Mental Health*, 15(3): 54–55. doi:10.1136/ebmental-2012-100758. PMID 22888109.
9 Sinclair, S. (2016). Austerity Measures Are Harming the LGBT Community's Mental Health. *Pink News*, 25 September 2016. https://www.pinknews.co.uk/2016/11/25/austerity-measures-are-harming-the-lgbt-communitys-mental-health/
10 Bingham, J. (2014). Britain the Loneliest Capital in Europe. *The Telegraph*. 18 June 2014. https://www.telegraph.co.uk/lifestyle/wellbeing/10909524/Britain-the-loneliness-capital-of-Europe.html
11 DCMS. (2016). The Culture White Paper [Online document]. London: HM Government. p. 15. https://www.gov.uk/government/uploads/system/uploads/attachment_data/file/510798/DCMS_The_Culture_White_Paper__3_.pdf
12 Chatterjee, H. J. (ed). (2008). *Touch in Museums: Policy and Practice in Art Handling*. Routledge. London.

13 Candlin, F. (2006). The Dubious Inheritance of Touch: Art History and Museum Access, *Journal of Visual Culture* 5: 137–54. p. 149.
14 Brown J. K. (2014). Connecting Health and Natural History: A Failed Initiative at the American Museum of Natural History, 1909–1922. *American Journal of Public Health, 104*(10), 1877–1888. https://doi.org/10.2105/AJPH.2013.301384
15 Ministry of Defense. (2019). Operation Nightingale. https://www.gov.uk/guidance/operation-nightingale
16 Cohen, D. (2001). *The War Come Home. Disabled Veterans in Britain and Germany 1914–1939*. University of California Press. Oakland, CA.
17 Jones, E. (2012). War Neuroses and Arthur Hurst: A Pioneering Medical Film about the Treatment of Psychiatric Battle Casualties. *Journal of the History of Medicine and Allied Sciences, 67*(3): 345–373.
18 Allfrey, M. (2019). A place to heal: Past perceptions and new opportunities for using historic sites to change lives. In: Darvill, T., Barrass, K., Drysdale, L., Heaslip, V., & Staelens, Y. (eds). *Historic Landscapes and Mental Well-being*. Archaeopress. Oxford. p. 139.
19 Heaslip, V. (2019). Human Henge: The impact of Neolithic healing landscapes on mental health and well-being. In: Darvill, T., Barrass, K., Drysdale, L., Heaslip, V., & Staelens, Y. (eds). *Historic Landscapes and Mental Well-being*. Archaeopress. Oxford. p. 124.
20 Lackoi, K., Patsou, M., & Chatterjee, H.J. et al. (2016). *Museums for Health and Wellbeing. A Preliminary Report, National Alliance for Museums, Health and Wellbeing*. https://museumsandwellbeingalliance.files.wordpress.com/2015/07/museums-for-health-and-wellbeing.pdf
21 Desmarais, S., Bedford, L., & Chatterjee, H.J. (2018). *Museums as Spaces for Wellbeing: A Second Report from the National Alliance for Museums, Health and Wellbeing*. https://museumsandwellbeingalliance.files.wordpress.com/2018/04/museums-as-spaces-for-wellbeing-a-second-report.pdf
22 https://www.culturehealthandwellbeing.org.uk/ [website]
23 All-Party Parliamentary Group on Arts. (2017). *Health and Wellbeing Inquiry Report: Creative Health: The Arts for Health and Wellbeing* (2nd ed.), https://ncch.org.uk/uploads/Creative_Health_Inquiry_Report_2017_-_Second_Edition.pdf
24 Art Fund. (2018). Calm and Collected,. Museums and Galleries: the UK's untapped wellbeing Resource? https://bigbangartfund-assets.s3.eu-west-2.amazonaws.com/national-art-pass/artfund_calm-and-collected-wellbeing-report.pdf
25 Dodd, J. & Jones, C. (2014). Mind, body, spirit: How museums impact health and wellbeing. Research Centre for Museums and Galleries and School of Museum Studies, University of Leicester. https://southeastmuseums.org/wp-content/uploads/PDF/mind_body_spirit_report.pdf
26 Art Fund. (2018). Calm and Collected,. Museums and Galleries: the UK's untapped wellbeing Resource? https://bigbangartfund-assets.s3.eu-west-2.amazonaws.com/national-art-pass/artfund_calm-and-collected-wellbeing-report.pdf
27 Cederström, C. & Spicer, A. (2015). *The Wellness Syndrome*. Polity Press. Cambridge. p. 5.
28 Fisher, M. (2009). *Capitalist Realism: Is There No Alternative?* O Books. Hants.
29 Liker, J. K. (2004). *The Toyota Way*, p. 17. McGraw Hill.
30 Smiles, S. (1986). *Self-Help* (Library of Management Classics, Abridged Version), p. 181. Sidgwick and Jackson, London. (first published in 1859).
31 Ibid., p. 236.
32 Ibid., p. 19.
33 Tressell, R. (2004). *The Ragged Trousered Philanthropists*. Penguin. p. 572.
34 quoted in Jonathan Rose, J. (2002). *The Intellectual Life of the British Working Classes*. Yale Nota Bene. pp. 68–9. p. 68.

35 Smiles, S. (1986). *Self-Help* (Library of Management Classics, Abridged Version). Sidgwick and Jackson, London. (first published in 1859). p. 17.
36 Ibid., p. 38.
37 McGee, M. (2005). *Self-Help, Inc.: Makeover Culture in American Life*. Oxford p. 19.
38 Jones, S. & Holden, J. (2008). *It's a Material World: Caring for the Public Realm*. Demos. London. p. 16.
39 The Care Collective (Chatzidakis, A., Hakim, J., Littler, J., Rottenberg, C., & Segal, L). (2020). *The Care Manifesto: The Politics of Interdependence*. Verso. London and New York. p. 1.
40 Fraser, N. (2017). Crisis of care? On the social-reproduction contradictions of contemporary capitalism. In: Bhattacharya, T. (Ed) (2017). *Social Reproduction Theory: Remapping Class, Recentering Oppression.* Pluto Press. p. 21.
41 Segal, L. (2018). *Radical Happiness: Moments of Collective Joy*. Verso. London & New York. p. 228.
42 Wellbeing Economy Alliance [website]. https://weall.org/
43 The Care Collective (Chatzidakis, A., Hakim, J., Littler, J., Rottenberg, C., & Segal, L). (2020). *The Care Manifesto: The Politics of Interdependence*. Verso. London and New York. p. 5.
44 Olufemi, L. (2020). *Feminism Interrupted: Disrupting Power*. Pluto Press, London. p. 117.
45 Solnit, R. (2009). *A Paradise Built In Hell: The Extraordinary Communities That Arise in Disaster*. Penguin Books. London. p. 26.
46 Sitrin, M. & Colectiva Sembrar (eds). (2020). *Pandemic Solidarity: Mutual Aid during the COVID-19 Crisis*. Pluto Press. London. p. 171.
47 Ibid., p. 172.
48 Roy, A. (2020). The Pandemic Is a Portal. *The Financial Times.* 3April 2020. https://www.ft.com/content/10d8f5e8-74eb-11ea-95fe-fcd274e920ca
49 Ibid.
50 Kropotkin, P. (1902). Mutual Aid: A Factor in Evolution. McClure Phillips and Co. New York. p. xii. https://libcom.org/files/Mutual_Aid.pdf
51 Day, D. (1939). House of Hospitality Dorothy. *The Catholic Worker*, May 1939, 1, 3, 4. (DDLW #342). https://www.catholicworker.org/dorothyday/articles/342.pdf
52 Pirate Care. n.d. Coronanotes. https://syllabus.pirate.care/topic/coronanotes/
53 Hickley, C. (2021). Brussels Doctors Prescribe Museum Visits to Treat COVID-19 stress. *The Art Newspaper*. 9 September 2021. https://www.theartnewspaper.com/2021/09/09/brussels-doctors-prescribe-museum-visits-to-treat-covid-19-stress
54 Morton, T. (2013). Hyperobjects: Philosophy and Ecology after the End of the World. University of Minnesota Press. Minneapolis/London.

3 Museums as spaces of well-being

When we approach the idea of well-being in museums, even perhaps an imagined *museum of well-being*, we are spatially working in the realm of the possible. Architecture has been described as "the simplest means of articulating time and space, of modulating reality, of engendering dreams."[1] Some may term such thinking utopian, and perhaps this is true. Alternatively the term heterotopia has been developed as a space which holds a mirror to the real, museums have been listed amongst the possible examples of heterotopias, whose existence constitutes "a place of all times that is itself outside of time and inaccessible to its ravages."[2] We would couple the idea of heterotopia with the idea of creating "beloved community,"[3] spaces in which welcome and belonging, no matter your background or difference, are assumed.

However, as words such as *social-distancing* slipped into our daily lexicon, the dystopian potential of space became evident. Suddenly sharing space, even with loved ones, had become a dangerous activity, and as the country closed down and went into lockdown, for many of us our space shrunk to the house in which we lived and its immediate vicinity, with a daily walk being the only permitted reason to be outside. The lockdown forced the closure of museums, and when they were to re-open, their spaces took on new forms, with a monitoring of touch points, reduction in hands-on didactics, enhanced cleaning routines and museum networks sharing systems for cleaning, improving air circulation and controlling visitor flow. What forms our future museum spaces will take in the "new normal" is still uncertain. We must also recognise that as the world begins to open, that enclosed public space may in fact be traumatic and triggering for many people.

Human-centred design proposes that "we must begin by understanding that every place is given its character by certain patterns of events that keep happening there,"[4] what we might in the well-being world refer to as practice. So what then is a museum space? What practice does the museum as a space represent? And does that practice positively or negatively impact well-being? It is clear the space of the museum is open to interpretation. It is a contested space. A space that is in flux. In this respect every gallery is a changing gallery. A space in which the past and present collide. Cultural background also plays a role in spatial understanding. Spatial understandings are often constructed in childhood and

DOI: 10.4324/9781003163480-3

conditioned by society, and moreover invisible spatial prompts are socially recognised, or misunderstood. The important point being that "the spatial and architectural needs of each are not the same."[5] An awareness of whose cultural understanding is being universalised is important if a space is to cater for diverse cultural backgrounds, as a museum often does. It is within this space of collision that we must seek to contribute to the well-being of those who spend time there. In reality the majority of the population "take it as axiomatic that the museums are full of holy relics which refer to a mystery which excludes them: the mystery of unaccountable wealth."[6] It is clear we need to look more deeply, both into these spaces and our own comfort, we need to problematise them in order to find places of "mutual stretching."[7]

Stretching

To feel included it is crucial to see yourself. Whether that's disability, race, gender, sexuality, class or anything else. The disability rights movement has the saying "nothing about us, without us," which is a useful approach, yet we must not forget that we don't need to wait but can actively create spaces in which a welcome and a right to self-representation is assumed; this doesn't mean you will get everything right for everyone, but it does mean you will be open to learning as you go. Forms of identity are often considered as intersecting points of oppression, they may also be considered as points of spatial exclusion. Perhaps the most egregious of these is basic physical accessibility. In 1990 the American Disabilities Act (ADA), mandated many changes across the USA which have also increasingly been adopted worldwide, with the UK catching-up with the Disability Discrimination Act (DDA) in 2004, later replaced (except in Northern Ireland) by the Equality Act (2010). The museum environment has had mixed quality of response. The physical modification of space, which is more self-evident and simpler to conceptualise, has seen significant adaptations; ramps are commonplace for wheelchair users, and many museums have systems to assist hearing aids, increasingly wider consideration has been given to things such as the height of vitrines and colour selection and contrast in texts and graphics. The social modification of space within museums is a rapidly developing field. This work has been especially important for education departments to think holistically about education and to make room to support those with special educational needs (SEN). Autism awareness has seen museums increasingly likely to have created a sensory map for the visitor's journey, and to have quiet times and sensory backpacks available to borrow. But we may ask how might the museum meet the challenge to "guarantee freedom from small talk, freedom from coercive visual distraction, freedom from enforced jollity, or coerced happiness"[8] How might museums think of well-being beyond patterns of extrovert supremacy? Representation in the present suggests being valued in the future, and in this way the museum must continue to allow people of all backgrounds the possibility of imagining worlds beyond those we find ourselves in today. The inevitability of conflict makes this a complex but rewarding task.

The museum itself is a physical entity and its architecture impacts well-being. Increasingly the importance for well-being of natural materials and views have been incorporated into architecture. Notes from patient observations at a Pennsylvania hospital made between 1972 and 1981[9] found that patients with natural views from their windows, compared to those who looked out at brick walls, received fewer negative evaluative comments in nurses notes and took fewer potent analgesics. The medical establishment was confirming the healing power of nature. The potential healing role of nature in architecture was to be further influenced by the book *Biophilia*, the title of which drew from an earlier use to describe a personality trait: "the passionate love of life and of all that is alive."[10] Architects began exploring the underlying architecture of human aesthetics built in our deep history, and how we preference these in our built environment, "people work hard to create a savanna-like environment in such improbable sites as formal gardens, cemeteries, and suburban shopping malls, hungering for open spaces but not a barren landscape."[11] We have already seen the mental health benefits of such preference for ordered space in the work with veterans post-WWI, and we can also witness this same aesthetic in the archetypal western museum; expansive yet ordered.

Museums and the street

When we talk of the street, we acknowledge its highs and lows, we acknowledge the liberatory potential of community, but also the danger on a personal level, of the misogyny, sexism, racism, classism and ableism that also demarks the street. For the street like the museum is a space of contention. The work of the Egyptian novelist Ahdaf Soueif most notably in her book *Mezzaterra: Fragments from the Common Ground*, and in her later book *Cairo: Memoir of a City Transformed* we believe offers an interesting conceptual model for museums and well-being. Soueif describes her vision of a Mezzaterra, as a common ground in which people come together across their differences, "the ground where everybody is welcome."[12] This is a heterotopian vision built upon Soueif's childhood memories of Cairo. The idea is also hauntological, a longing for a loss experienced through divisions. This was a space in which the multiple identities of Muslim, Christian, Egyptian, Arab, African, Mediterranean, Non-Aligned, Socialist and small-scale capitalist, all existed together, in the space and within each individual, a space in which "chances were that you spoke English and/or French and danced to the [Rolling] Stones as readily as to Abd el-Haleem."[13]

In Tahrir Square, or more properly Mīdān at-Taḥrīr, we find Ahdaf Soueif reporting on the spirit coming to life in the people who have "discovered the vastness of the common ground they shared and the myriad meeting points between them and how much work they needed—and wanted—to do together."[14] The longing of the Mezzaterra is a love letter to the city street: "we fill our eyes with her beautiful, wounded face and whisper that her memories are our memories, her fate is our fate."[15] The love for the city streets and the people who occupy them drips off every page of Soueif's journal.

How might the museum be our common ground? How in fact can the museum build upon the positive elements of the street that is "by its very nature as shared space, the street lends itself to collective creativity."[16] It is this collective creativity that the museum can harness for our collective well-being. The alternative was highlighted by the Cantle Report after riots in Oldham in 2001, in which the phrase *Parallel Lives*, was used to describe the failures of multiculturalism. The report suggested the most likely solution was "greater knowledge of, contact between, and respect for, the various cultures that now make Great Britain such a rich and diverse nation."[17] Unfortunately, the report failed to account for contexts of state-sanctioned poverty and racist policing and gave a new expression, and validity, to an Islamophobic counter-extremism agenda. A missed opportunity for real learning. However, communities can and do come together across difference, and museums can and do play an important role in non-assimilationist community building, providing a space for intercultural education, storytelling, artistic expression, and creativity, in which community is "not so much a matter of a common voice but opportunity for different voices, leading to a shared space."[18] A form of community building in which "rather than 'integrated' communities, we require liberated communities."[19] This then is the concept of *interculturality* as opposed to *multiculturalism*; and we would propose this as a formal definition of the Mezzaterra.

A feminist museum space

Museum trends are in essence simply mirrors to wider society. For this reason it is clear that for a vision of a museum as well-being space to exist, it would likely only be found in such a place where society was concerned directly with our collective well-being, and as such it must be feminist. The idea of a feminist city has been described as an "ongoing experiment in living differently, living better, and living more justly in an urban world."[20] A challenge in a world in which "cities are patriarchy written in stone, brick, glass, and concrete."[21] When we offer the paradigm of the street, we are not aiming to imagine some illusory idealised version of the street, we do so with the express intention of bringing to mind the reality that the street offers both hope and fear, just like the museum, it is a space of collision. Our street honours those known and unknown who fall victim to it. A feminist reading of the city and street asks the important question of "who is missing from that picture of idealised city life."[22] Ultimately it's a question of whether all bodies can feel safe and trust the space. The policing and safety of women's bodies in the street is a central element of protests conducted by Sisters Uncut: "We wanted to show that safe spaces for the community are needed for our learning, healing, and support."[23] When we consider what a democratic and intersectional feminist space looks like, it is important that when asking women's questions to think beyond gender. For every feminist demand there are additional questions and reflections. How would mass transit accommodate strollers

and disabled access? How might concerns over safety lead to increased policing of communities of colour? How might claiming space as feminist harm indigenous efforts to reclaim land? Just like the museum, a feminist space is a space of collision, as such the museum is ideally suited to develop these ideas.

The feminist museum could be conceptualised as a museum of care. "We produce a cup only once, but we wash and dry it a thousand times."[24] Similarly the power of art is created not by the artist, or the work of art, but by those who care for the artwork over the years. Although the majority of working artists are male, the majority of those who take care of art, including museum workers and visitors, are female. It has been noted that "care has long been devalued due, in large part, to its association with women, the feminine and what have been seen as 'unproductive' caring professions."[25] The museum of care would be "a space that could be used as a space of care and a space for public wellbeing."[26]

It is this struggle of the streets that we need to bring into our museum spaces. Museums must be spaces for all people, they cannot be sights that some people simply drive by. The Nelson-Atkins Museum of Art discuss the history of racism and architecture, and the African-American tradition of "the Sunday drive"[27] to areas of cities usually considered as whites-only, in which museums such as their own would be viewed by the African-American community only from the window of their cars. The question being discussed is one of whether the museum will be a space or place, or whether it will be a sight. For there is a fundamental difference, as "sights do not possess that deep symbolic power which creates community. Sights are places one passes by. They do not permit any lingering or staying."[28]

Third place, third space

A metaphor more common than the *street* within museology has been that of *The Third Place*. This idea may be adaptable but not without problems. The third place is usually defined along the lines of a space that is "neither work nor home, the third place is a neutral community space, where people come together voluntarily and informally in ways that level social inequities and promote community engagement and social connection."[29] Originally influenced by the sociologist William H. Whyte[30] who researched the use of public space in Manhattan, and the writings of Ray Oldenburg[31] who discusses the significance of spaces for communities and civic life. The general view that third places provide positive social benefit has been influential in deliberate designing such places into existence. Most notably the idea was taken into museums by Elaine Heumann Gurian who noted that museums can play "an enhanced role in the building of community and our collective civic life,"[32] what we might otherwise define as our collective well-being. One of the results of the pandemic has been the erosion of the third place, as increasing numbers of people are working from home or living at work. However, it isn't just that home and work life have become mushed together,

the space in-between has also been lost. If work is home and home is work, there aren't three places.

Similar sounding, but perhaps more explicitly radical concepts to third place, are that of *Third Space* or *Thirdspace*, both of which merit some further exploration. The idea of thirdspace is the real and imagined space that we inhabit. The concept aimed to "open up our spatial imaginaries to ways of thinking and acting politically that respond to all binarisms, to any attempt to confine thought and political action to only two alternatives."[33] Which sounds a lot like the idea of third space developed in critical postcolonial studies: "The 'third space' which enables other positions to emerge."[34] Both of these terms reflect the space which bell hooks might have called the margin "the site of radical possibility, a space of resistance."[35] This is a space not of counternarratives, but of new narratives, potentially antagonist but not necessarily oppositional. It is perhaps a spatial representation of intersectionality. This space acts as an ambiguous area that develops when two or more individuals/cultures interact. Homi Bhaba asserts the necessity of a politics based on unequal, multiple, potentially antagonist, political identities, stating that "meaning is constructed across the bar of difference and separation between the signifier and the signified."[36] This is the space we are calling the Mezzaterra.

Some spaces are designed almost exclusively to function as a third place, such as St Katharine's Precinct Project.[37] This project currently houses a Yurt Café, reflective space, shipping container artist studios, and Community Hub, alongside a myriad of community projects. During the pandemic, one of the containers hosted a food bank and food delivery service, and the space housed Limehouse Aid, a mutual aid and distribution network. This space has successfully and consistently brought community groups together and improved community well-being. The project currently plans to make these temporary structures more permanent; it remains to be seen if such a temporary space can be translated into a more permanent architectural form and retain what makes it so special. The thriving nature of this space, created by a Church, is a useful model for museums, being as they are examples of third places that continue regardless of whether people are commuting to work. What makes museums such interesting spaces in discussions of third places is outlined in the *Future of Museums* document wherein it is emphasised that the third place can function as a social tool: "Not just a third place, but a third force if you will."[38]

Municipalism

In its ambition to create a built environment where "nothing is too good for ordinary people,"[39] post-war municipalism took on all forms of public architecture, however, it is probably social housing which is most illustrative of the approach. The most important spaces being neither private nor public, also described as "a third sphere."[40] This is the sort of space where one might find "public characters."[41] Ultimately municipalism is so intriguing to us because

care was a central element of its philosophies, the goal wasn't simply housing but also well-being. Today these ideas are widely lost or under attack. "The institutions that sustained a progressive 'municipal view of the world' have been destroyed: the last relics of the expansive, inclusive 'care-oriented' state are being shredded."[42] The memories of this municipalist society exist now as an almost hauntological dream state. Collectively our well-being suffers from living with the ghosts of this municipal past.

Space may also be defined by whether they are intended to be used. The distinction might be described as the difference between *invited* and *invented* spaces, the latter shaped "by defiance that directly challenges the status quo."[43] Intriguingly the most pre-eminent example of municipalism undertaken by the Greater London Council (GLC) is host to both. The Royal Festival Hall boasts a series of invited spaces and its grand foyer that were under the GLC opened to all. Below this though is the Undercroft, a space that skateboarders flocked to, inventing a space influential in the birth of the British street skateboarding community. When the Southbank Centre proposed closing the unofficial skatepark to make way for commercial ventures, a campaign was launched by the group Long Live Southbank to save the space. The campaign lent heavily on the intangible cultural heritage importance of the space, and street skating as "an art form based on the interpretation of space."[44] Ultimately the skaters won. In doing so they launched a political and intellectual culture of research around the use of space in the increasingly financialised city. "Organic creative spaces should be afforded more protection and longevity. Many organically developing spaces of creativity exhibit greater inclusivity and originality than those resulting from top down approaches."[45] For museums this invention of space is fundamental to consider, alongside allowing for the importance of what Long Live Southbank call *Blank slate site*s, spaces in which the user discovers a use. This development of new, perhaps unintended, spatial meaning as a necessary feature of the space's ability to improve well-being should give museum professionals pause for consideration.

Museums on LSD

Some trace the roots of many contemporary wellness practises to the counterculture.[46] Within this it is the role and the literature surrounding the use of LSD that has relevance for well-being and museology. In 1938 the scientist Albert Hofmann was investigating the black fungus ergot, looking for alkaloids that may prove as valuable as Ergotamine. On first isolating LSD-25, the twenty-fifth substance in a series of lysergic acid derivatives, he found it to have no useful properties, it was to sit on a shelf for a further five years until in a laboratory accident he was to feel its effects.[47] This accidental discovery was to pass through the pioneering work of Stanislav Grof,[48] a Freudian psychoanalyst, into the counterculture where it was to become an essential component of working with the mind in both a clinical and recreational environment. In terms of the

counterculture's use of LSD, the most crucial thing to emerge from the treatment of alcoholism by the drug was the concept of *set and setting*—the importance of a positive mindset and a comfortable physical environment. It "must be comfortable and quiet."[49] Amongst the useful therapeutic props recommended were paintings and photographs. The question being argued over then was whether a clinical setting or the counterculture was a more appropriate setting for the use of LSD-25, and the development of wellness. It's not clear if anyone suggested a museum might be conducive given its collections, but, whether we're talking about LSD or other well-being practises it is this idea of set and setting and the creation of appropriate environments that is a most interesting parallel.

Today *Set and Setting* is usually referred to by the phrases *safe spaces, holding space* or *container*. Ultimately safe space is the idea of inclusivity, it is linked with the practice of holding space, that is to be with someone without judgement. The location and the people within it act as a container for the practice and the community gathered. We mustn't assume that museums *are inherently* safe spaces,[50] only that such a potential does exist for museums to be a safe space of ideas and people, for developing free open approaches in which nonlinear emotional growth can take place.[51] In holding space we are often involved in getting comfortable with discomfort, in such circumstances the museum can act as a *safe space for unsafe ideas!*[52] This idea conceptualised the museum not only as a container for things, ideas and people, but also for conflict. There are numerous examples of projects developing these ideas, but one of the most explicit is the decision by the Hunterian, Glasgow, to employ a *Curator of Discomfort*, with the goal of designing and delivering interventions in the museum that take the institution beyond its comfort zone, recognising that "discomfort is necessary for genuine change."[53] This radical self-reflective work is necessary both individually and institutionally, if we are to address the true complexity and challenge of our collective histories.

Concluding space

Museums did not come about by chance. They had to be built, and their design says something about the purpose for which they were built. If we want to see museums as a centre of well-being, then we have to take into account their spatial function and how we invite and allow others to invent the use of space. Whilst this starts with a consideration of the architecture, and although we of course may not be able to change the museum as we find them, we can move into wider considerations of space and how we design additions and interiors. How we do this says a lot about how we envision spaces and those we choose to invite into them. We offered the street as a space of contestation, a heterotopian mirror to that of the museum, coupling the really existing traditions of municipalism, with the semi-imagined concept of the Mezzaterra, to conceptualise a heterotopian museum space—a progressive vision of the museum as a contested space. Ultimately we can't think

of a better way to end our thoughts on spatial well-being than these words from the art collective Bare Minimum Collective, who write in their manifesto: "We want space for pleasure. We want the abolition of everything but care, mutual aid and community."[54]

Notes

1 Chtcheglov, I. (1953). Formulary for a new urbanism. In: Knabb, K. (Ed.). (2006). *Situationist International Anthology*, (Revised ed.). Bureau of Public Secrets. p. 3.
2 Foucault, M. (1967). Of Other Spaces. *Diacritics, 16*(Spring 1986): 26.
3 hooks, b. (2009). *Belonging: A Culture of Place*. Routledge. New York/Abingdon. p. 183.
4 Christopher, A. (1980). *The Timeless Way of Buildings*. New York: Oxford University Press. p. 55.
5 Hall, E. T. (1990). *The Hidden Dimension*. Anchor Books. New York Reprint Edition. (originally Published Garden City, N.Y.: Doubleday, 1966) p. 140.
6 Berger, J. (1972). *Ways of Seeing*. BBC and Penguin. p. 24.
7 Lorde, A. (2017). *A Burst of Light and Other Essays*. IXIA Press, Mineola, New York. p. 10.
8 Ahsan, H. (2017). *Shy Radicals: The Antisystemic Politics of the Militant Introvert*. Bookworks. London. p. 20.
9 Ulrich, R.S. (1984). View from a window may influence recovery from surgery. *Science, 224*(4647): 420–421.
10 Fromm, E. (1973). *The Anatomy of Human Destructiveness*. Holt, Rinehart and Winston, New York. p. 366.
11 Wilson, E. O. (1984). *Biophilia*. Harvard University Press. Cambridge, Massachusetts. p. 110.
12 Soueif, A. (2004). *Mezzaterra: Fragments from the Common Ground*. Bloomsbury. London. p. 23.
13 Ibid., p. 5.
14 Soueif, A. (2014). *Cairo: Memoir of a City Transformed*. Bloomsbury. London. p. 72.
15 Ibid., p. 6.
16 World Commission on Culture and Development. (1995). *Our Creative Diversity: Report of the World Commission on Culture and Development*. UNESCO. p. 80. https://unesdoc.unesco.org/ark:/48223/pf0000101651.locale=en
17 Cantle, T. (2001). *Community Cohesion: Report of the Independent Review Team - 'The Cantle Report'*. London. Home Office. p. 10. https://tedcantle.co.uk/pdf/communitycohesion%20cantlereport.pdf
18 Khan, N. (2005). We Should Celebrate Diversity, Not Suppress It. *The Independent*, Friday 23 September 2005. https://www.independent.co.uk/voices/commentators/naseem-khan-we-should-celebrate-diversity-not-suppress-it-314453.html
19 Manzoor-Khan, S. (2022). *Tangled in Terror: Uprooting Islamophobia*. Pluto Books. London. p. 9.
20 Kern, L. (2020). *Feminist City: Claiming Space in a Man-Made World*. Verso Books. London. (unpaginated epub).
21 Darke, L. (1996). The Man-Shaped City. In: Booth, B., Darke, J., & Yeandle, S. (eds). *Changing Places: Women's Lives in the City*. Sage. London. p. 88.
22 Leslie, K. (2020). *Feminist City: Claiming Space in a Man-Made World*. Verso Books. London. (unpaginated epub).
23 Olufemi, L. (2020). *Feminism Interrupted: Disrupting Power*. Pluto Press, London. p. 117.

24 Graeber, D. & Dubrovsky, N. (2019). Museum of Care: The Women's Revolution of Rojava. *36C3: Resource exhaustion: The 36th Chaos Communication Congress*, Chaos Computer Club (CCC). Leipzig.
25 The Care Collective (Chatzidakis, A., Hakim, J., Littler, J., Rottenberg, C., & Segal, L). (2020). *The Care Manifesto: The Politics of Interdependence*. Verso. London and New York. p. 3.
26 Graeber, D. & Dubrovsky, N. (2019). Museum of Care: The Women's Revolution of Rojava. *36C3: Resource exhaustion: The 36th Chaos Communication Congress*, Chaos Computer Club (CCC). Leipzig.
27 Emmanuel Cleaver II. (2022). A Frame of Mind: A Beautiful Day in the Neighborhood. Season 1, Episode 2. January 7, 2022. The Nelson-Atkins Museum of Art. [podcast] https://nelson-atkins.org/nelson-atkins-at-home/listen-at-home/frame-of-mind/beautiful-day/
28 Han, B-C. (2020). *The Disappearance of Rituals: A Topology of the Present*. Polity Press. Cambridge, UK/Medford, USA. p. 45.
29 Pastore, E. (2009). *The Future of Museums and Libraries: A Discussion Guide (IMLS-2009-RES-02)*, Institute of Museum and Library Services, Washington, DC. p. 9.
30 Whyte, W. H. (1980). *The Social Life of Small Urban Spaces*. The Conservation Foundation.
31 Oldenburg, R. (1999). *The Great Good Place: Cafes, Coffee Shops, Bookstores, Bars, Hair Salons, and Other Hangouts at the Heart of a Community*. 3rd ed. Jackson, TN: Da Capo Press.
32 Gurian, E. H. (2006). *Civilizing the Museum: The Collected Writings of Elaine Heumann Gurian*, Routledge, London and New York. p. 99.
33 Soja, E. W. (1996) *Thirdspace*. Malden, MA: Blackwell. p. 6.
34 Rutherford, J. (1990). The Third Space: Interview with Homi Bhaba. In: Rutherford, J. (ed.). *Identity: Community, Culture, Difference*. Lawrence & Wishart, London. pp. 207–211.
35 hooks, b. (1989). Choosing the Margin as a Space of Radical Openness. (Chapter 24, pp. 203–209) In: Borden, I., Penner, B., & Rendell, J. (Eds.). (1999). *Gender Space Architecture: An Interdisciplinary Introduction* (1st ed.). Routledge. https://doi.org/10.4324/9780203449127 p. 206.
36 Rutherford, J. (1990) The Third Space: Interview with Homi Bhaba. . In: Rutherford, J. (ed.). *Identity: Community, Culture, Difference*. Lawrence & Wishart, London. pp. 207–211.
37 Royal Foundation of St Katharine. n.d. About St Katherine's Precinct. [website] https://precinct.rfsk.org/about/
38 Skramstad, H., quoted in: Pastore, E. (2009). *The Future of Museums and Libraries: A Discussion Guide (IMLS-2009-RES-02)*, Institute of Museum and Library Services, Washington, DC. p. 9.
39 Lubetkin, B. quoted in Cumiskey, L. (2018, October 31). Spa Green at 70 Shows How 'Council Housing Can Be the Best Quality'. *Islington Gazette*. https://www.islingtongazette.co.uk/news/heritage/history-spa-green-estate-was-uk-s-first-modernist-social-housing-1-5759303
40 Elmer, S. (2019, March 31). The Space of Community in Post-war Council Estates, a talk given at the Design Museum London. Architects for Social Housing. https://architectsforsocialhousing.co.uk/2019/03/31/the-space-of-community-in-post-war-council-estates/
41 Jacobs, J. (1962). *The Death and Life of the Great American Cities*. Jonathan Cape. London. p. 68.
42 Crewe, T. (2016, December 15). The Strange Death of Municipal England. *London Review of Books, 38*(24). https://www.lrb.co.uk/the-paper/v38/n24/tom-crewe/the-strange-death-of-municipal-england

43 Miraftab, F. (2004). Invited and Invented Spaces of Participation: Neoliberal Citizenship and Feminists' Expanded Notion of Politics. *Wagadu, 1*(Spring): 1–7. http://colfax.cortland.edu/wagadu/Volume%201/Printable/miraftab.pdf
44 Edwards-Wood, H. (Director). (2013). *The Bigger Picture* [Motion Picture]. https://www.youtube.com/watch?v=iFaKN98Xg3E
45 Woodhead, L. (2021). *Space and Why It Matters: A Long Live Southbank Report.* Long Live Southbank. p. 9.
46 Ingram, M. (2020). Retreat: How the Counterculture Invented Wellness. Repeater Books. London.
47 Hofmann, A. (1980). *LSD: My Problem Child.* McGraw-Hill Book Company.
48 Grof, S. (1975). *Realms of the Human Unconscious.* Viking Press. New York.
49 Chwelos, N. & Blewett, D. (1959). *Handbook for the Therapeutic Use of Lysergic Acid Diethylamide-25.* p. 19.
50 Hadi, S. A. (2020). *Take Care of Your Self: The Art and Cultures of Care and Liberation.* Common Notions. Brooklyn, NY. p. 43.
51 Brown, A. M. (2017). *Emergent Strategy: Shaping Change, Changing Worlds.* AK Press. Chico, CA and Edinburgh, Scotland. p. 105.
52 Gurian, E. H. (2006). *Civilizing the Museum: The Collected Writings of Elaine Heumann Gurian,* Routledge, London and New York.
53 Yeaman, Z. (2021). Curating Discomfort. The Hunterian Blog http://hunterian.academicblogs.co.uk/curating-discomfort/ 11th February 2021.
54 Bare Minimum collective. (2020). *The Bare Minimum Manifesto.* Medium. March 6, 2020. [blog post] https://medium.com/@bareminimum/the-bare-minimum-manifesto-bfedbbc9dd71

4 Work and the limitations of well-being

From the factory floor

This chapter is written from the factory floor of the museum. In the museum sector, workers have long identified with their work as a vocation, in this respect their activism has often focused on improving the museum field rather than their own material conditions. This has traditionally taken place within specialist interest groups within museum professional organisations; however, more recently a growth in grassroots organisations that don't seek to win favour but to act autonomously has developed, supported significantly by the reduction in barriers to participation afforded by social media.[1] These organisations, such as Fair Museum Jobs, Front of House in Museums, Museum Wellness Network and Museum as Muck, have sought to challenge gatekeeping practises and conduct independent quantifiable research, and promote best practice in order to create an inclusive, sustainable, and life affirming museum sector.[2] However economic fear is often used to create insecurity, and this decreases employee well-being.[3] Many museum workers in the UK and Europe are trade unionists, and recent years have seen a surge in union recognition in museums across the USA. There has been a realisation, that as much as you may love your work, your work won't love you back[4]. For many museum workers, there are two fronts on which we fight to better the world, and it is within these two fronts that we need to consider the questions of well-being at work.

As with many people furloughed or laid off during the pandemic, the world of work that we returned to had a new vocabulary. This strange new language had permeated everywhere and everything. Well-being had gone mainstream. A welcome new beginning, yet the cognitive dissonance was hard to look past. Whilst it was clear that there was a serious genuine concern for people's well-being, we were after all in the midst of a tragic and traumatic global event, such concern would be expected. However, the background to this concern was not solely the pandemic but also the unprecedented job losses, restructuring, the economic downturn into recession, not to mention a rising confrontation with racism, which was already the reality for so many. It was clear that well-being was being used as a salve to ease people back into work

and productivity. Peeling back the surface we find that within management theory and practice, these connections pre-date the pandemic. This earlier history is tied to the idea of a happy workplace being a productive workplace, and the connected assumption that well-being can be acquired and conversely that a lack of well-being can be viewed as a failure on a personal level. We'll explore this personalisation and embodiment of well-being further as this chapter unfolds. Now don't get us wrong, well-being at work, especially in a post-pandemic world, is essential, and we'd look askance at any company that was not prioritising well-being for its employees at this time, or indeed always. However, it is vital that if we are to work in, or even interact with, this field, we should have a critical eye and an understanding of the history of well-being within the workplace and the ideological function that has driven it into the mainstream. This critical comprehension is vital if we are to have an appreciation for the real, tangible, positive potential that these practises hold for us all.

Smiley happy economics

It is a widely believed truism that physical activity is good for you; and by association good for a workforce. Major government campaigns to "be active" would attest to this. The historical origins of many of our most famous sports clubs being associated with factories and/or trade unions are examples of this element of workplace well-being having a long and proud tradition, although it's hard to believe that a museum football club today might one day compete in the premiership. But workplace well-being does and has taken many forms associated with other elements of the Five Ways to Well-being, whether it was Lectores, readers, in a Cuban cigar factory entertaining workers by reading books or newspapers aloud, often left-wing publications, paid for by unions or by workers pooling their money,[5] as a way to Connect and Keep Learning. Or other examples of popular workplace well-being activities that might include a vast array of sports or activity clubs, as well as volunteering opportunities with a range of charitable causes as well as one-off volunteering days, to early morning pilates or Monday mindfulness sessions. Ultimately we are talking about the creation of rituals of the workplace. "We can define rituals as symbolic techniques of making oneself at home in the world... They are to time what a home is to space: they render time habitable."[6] As such they serve a much needed function for staff morale and the creation of a conducive, indeed productive, working environment.

Workplace well-being practises are typically organised through Human Resources departments who are applying ideas from the "booming field of management research on positivity at work," which ultimately aims to "keep employees working longer."[7] When Google and their "jolly nice fellow"[8] organise often wonderful lectures on mindfulness, or decide to install some infantilizing play equipment, or another up-and-coming tech start-up company decides to offer an on-site chef, they are taking part in what has become

known as *Happiness Economics*. That chefs are a part of this development of well-being in the workplace is due in no small part because this process has sat alongside a blurring of the boundary between work and home life in our always connected society. Amongst all the studies that support this thesis, one of the most significant findings is that "unemployment exerts a far more negative effect on people psychologically than the mere loss of earnings would suggest."[9]

It is interesting to note that the corollary that work makes workers happy has significantly less supporting evidence. However, what has been shown, and again this will likely come as no great surprise, is that "employee well-being is higher in employee-owned companies, where decision making is more participatory and authority more distributed, than in regular shareholder-owned firms."[10] The idea of Happiness Economics isn't as novel or ground breaking as former silicon valley executives turned best-selling authors would like you to believe. However, the thoughts and opinions of workers, unemployed or otherwise, are actively ignored, considered as unreliable and subjective voices, set against the objectivity of economics. Much of the business practises in this field are shaped by the ideas of Jeremy Bentham and his "entangling of psychological research and capitalism"[11] as well as his "emphasis upon the brute reality of physical pain and his distrust of language"[12] what workers said about their well-being, or pain, could not be trusted.

Systems of data collection, collation and analysis needed to be developed. Measuring the human responses to stimuli became increasingly important and the process ramped up by gamifying data collection in the age of wearable smart tech. This data mission more than anything else has been a key driving force in management theories and practises that have led us to Happiness Economics. This approach has received criticism: "a science built on the study of white rats, combined with clever tools for peering at our eyes and other body parts, is not, in the final instance, adequate for selling products. Less still is it adequate for the management of human beings in workplaces."[13] However, in reading most current books on workplace motivation studies of white rats, and analysis of brain chemistry, are frequently referenced.

The individualisation of well-being within the workplace has deep history and can be traced back to the self-help ideas of Samuel Smiles who said, "It is not tools that make the workman, but the trained skills and perseverance of the man himself."[14] Today this has found form in the accepted truism that happy workers are productive workers. The thought leaders in this field are often known as "happiness gurus" and draw much of their ideas from the positive psychology behind the Austerity Gospel. Although the underlying brutality of austerity can also be seen in the work of some of the most famous of these happiness gurus, like Tony Hsieh, founder of Zappos. Hsieh argued that the goal of his organisation was "Delivering Happiness."[15] also the title of his inevitable book. In his view, happiness was so essential that he controversially advised businesses to identify the 10 percent of employees who are least enthusiastic towards this happiness agenda and lay them off, the belief being that the remaining 90 percent will become super engaged.[16] The difference, significant as it obviously is,

between happy workers and compliant workers doesn't seem to factor heavily in the thinking in this field.

Biomorality

How did we get here? Let us take a step back to the collapse of the 1970s' counterculture, as many would-be dudes took Lebowski's[17] advice and got jobs instead. Something strange happened as the counterculture collapsed and entered into the workplace. Instead of joining trade unions or getting involved in workplace politics, people began to seek out individual projects of self-actualisation. People began "taking lessons in ballet or belly-dancing" or "immersing themselves in the wisdom of the East."[18]

The strangeness was that at the same time that this generation gave up resisting the workplace, the workplace began to adapt their slogans and ideas of creativity, flexibility, communication and liberation. These became the watchwords of the corporate world. Work had gone from being alienating to self-actualising. Work became a source of happiness, and as such, inherently a good thing. This re-conception of work quickly attached itself to the idea of *Biomorality*, the idea that personal morality is intimately connected with personal happiness and being healthy, as determined by cultural ideals. Work and life became entwined around the economics of happiness.[19] Inevitably such a moral imperative to be happy and healthy at work all the time hit an obstacle in the form of sickness. The management theorists, positive psychologists, of the counterculture were now in a position to offer their solution; well-being. If you weren't happy, the gurus could deliver that happiness to you.

It has been argued that "Capitalist development is subordinate to working-class struggles; not only does it come after them, but it makes the political mechanism of capitalist production respond to them."[20] In considering well-being in the workplace, we can see the assertion that capitalism incorporates the form of resistance into its new form of exploitation quite clearly, workers resistance prefigures the capitalism that will exploit them. Although in this case the battlefield may be psychological, the results demonstrate that the theories and methodologies of the capitalist factory can be applied in all workplaces. "Management, which originated as a technique for controlling slaves on plantations, and developed as a means of running heavy industrial corporations, had become a 'soft', social and psychological skill."[21]

We saw also during the pandemic how workers fought for safer working environments such as working from home, and for sufficient sick-pay provisions. As workers struggle to take on biomorality, we can see in real time how capital has split over how to respond, some realising quickly that productivity didn't dip with working from home, whilst other sections of capital fighting tooth-and-nail for the continuation of their commercial rental income. The structural changes, such as working at home, that many companies undertook to enable continued profitability are unlikely to be fully rolled-back. For many workers this is a huge boost to well-being in the reduction of the daily

commute, potentially freeing up hours of previously unpaid time. However, as predicted, the technological fix by capitalism of management's digital surveillance has been introduced, and so the cycle continues.

Spiritual violence

Happiness Economics and Biomorality have taken over management theory spread by the personality cults of the entrepreneurial happiness gurus. This obsession with a healthy image is especially prevalent amongst tech companies executives. One particularly widely reported example is executive Nilofer Merchant who coined the phrase "sitting is the new smoking"[22] suggesting replacing meetings with walking meetings, somewhat indicative of the thought that goes into inclusivity within the tech world. As if this fad wasn't ludicrous enough, biomorality in the workplace has also given us "the treadmill desk and its close cousin, the bicycle desk."[23] However beyond tech companies, the development of workplace well-being programming has become almost universal, and there's been significant growth during the pandemic. Many of those who run well-being courses in the workplace parrot their favourite guru's mantras of productivity and self-actualisation, whilst also giving out step monitoring devices, offering to do annual measurements of body mass index and other elements of biomorality.

Sadly well-being in the workplace has become a part of the spiritual violence of working a bullshit job.[24] In our affluent societies the very act of work comes with a series of underlying stresses, the boredom, social isolation and the realisation of contributing to environment destruction: "many people for most of their lives begin their days in traffic jams or overcrowded trains and buses, and then spend much of the rest of them glued to the computer screen, often engaged in mind-numbing tasks."[25] It has been suggested that after the daily grind of a menial job 360-plus days a year, especially if you see no useful function in it, "some kind of repetitive injury of the spirit sets in."[26] These are the sort of jobs that those people undertaking them are sure don't need to happen, that serve no useful function not only to society as a whole but to the company specifically, or that if they do have any useful function it could be completed in a tiny fraction of the time. Such jobs often exist simply to make a company, or a particular manager, seem more important due to the number of staff employed. In today's world many, if not most, jobs fall into this category, the main exception being those jobs that are involved in the care of people, places and things. Most, but not all, museum folk would fall into these latter categories.

The other element of the thesis was that all jobs are undergoing a process of bullshitisation, that is to say that even useful jobs are having to undertake increasingly bullshit tasks and wasting increasing amounts of time doing so, metrics and mindfulness seminars being some of the most ubiquitous examples of bullshit tasks. "Feel stressed by having too much work, or insecure at the prospect of an upcoming restructuring exercise, all you need to do is clear

out the cacophony of negative thoughts, breathe deeply and focus."[27] This approach to mindfulness, sometimes termed "McMindfulness,"[28] has been noted as the "perfect ideological supplement"[29] to neoliberal capitalism in its method of "shifting the responsibility for social ordeals back onto the individual."[30] This then is the *spiritual violence* or emptiness of meaning in bullshit jobs "it's as if they first forbid you to admit you are engaged in empty ritual, then force you to attend seminars where hired gurus tell you, 'In the final analysis, isn't everything we do just empty ritual?'"[31]

Fit to work

It is no wonder that wellness and sickness have become a front in conflicts in the workplace, it is the inevitable form of workplace resistance that a biomoral workplace would engender. In most cases of reported sickness, the person has an illness or stress that makes working impossible. However, with the decline in union membership and limited options for collective action, working conditions declined, the growth of "the sickie" or "mental health day" as a necessary means to taking back time for self-care, began to be seen, correctly or not, by the professional managerial class as individualised resistance to the workplace. This was, in other words, a problem to be solved. Sickness has been described as the body "going on strike"; sickness allows us "to clock off, at least for a moment."[32] But it isn't just work that our body is striking against, but the gym, life coach session or myriad other well-being practises that we feel we need to undertake to function in society. "By surrendering to our illness, we are both following and reversing one of the central commands of biomorality—'listen to your body.'"[33] It is perhaps this rebellion against the ideology of biomorality that concerns the managerial class as much as any perceived loss in working days. Ultimately the question is one of whether we have the right to be ill.[34] Our belief is that well-being practises properly constituted would assert this right in defiance of biomorality.

This then is the ideological fear that has gripped managers and policy makers, that of ennui: "what if the greatest threat to capitalism, at least in the liberal West, is simply a lack of enthusiasm and activity? What if, rather than inciting violence or explicit refusal, contemporary capitalism is just met with a yawn?"[35] In this scenario illness is seen as a fifth column as well as a personal moral failure. Well-being in this scenario is about creating a virtuous cycle of active, fulfilling commitment, both to health, well-being and work. But there's no carrot without a stick. As sickness has become a front in this real and imagined confrontation, policy makers and politicians have found it necessary to conscript doctors into battle. A government campaign was launched to coincide with the enforced changes to how doctors record workers' sickness. A subtle linguistic change from *sick-note* to *fit-note*. Doctors could no longer sign a patient off from work as being too sick to work, instead they were to list all the ways the patient might continue to be fit-to-work given the specificity of their particular sickness. Inevitably these changes have led

to benefit sanctions and loss of income, and have been particularly difficult for disabled and chronically ill people.[36]

IAPT–CBT

In the time before austerity, the Labour government had a happiness tsar, who launched the idea of Increasing Access to Psychological Therapies (IAPT) programme and the practice of Cognitive Behavioural Therapy (CBT). These were lauded as a panacea for common mental health conditions, destined not only to help many suffering people, but crucially also to save the government money and get people off of benefits and back to work. The business case was that an investment by the NHS into mental health would save the government money in the long run. IAPT/CBT with its central role played by assessment sheets was a process intentionally well designed to meet the box ticking funding review process, seeing its funding quadruple as other services have been cut. The system has become "an empire, offering assembly-line state therapy."[37]

In many respects this is a huge improvement on the right to access mental health care compared to what came before. However, it's all about how it's applied. For example, the decision to threaten disability claimants with losing benefits if they didn't attend CBT sessions, a move critiqued as "psycho-compulsion,"[38] seems questionable at best. The real challenge lies ahead in whether IAPT is able to cope with the impact of long COVID, increasingly understood as "one of the largest mass disabling events in modern history,"[39] an event that will no doubt have mental health consequences for many. Moreover, there is significant disagreement as to whether this increase in mental health support access has been a net positive or negative impact. However, what is less in doubt is the health and well-being impact upon those who work in IAPT. Atkinson reports[40] that one staff well-being survey found 50 percent of respondents to be depressed, 92 percent were finding work stressful, 90 percent felt under pressure to meet targets, and 56 percent felt under pressure to work longer hours, while another study found that two-thirds of staff were suffering from burnout; all issues that IAPT claims to be able to solve. If it wasn't so tragic, it'd be a comical situation for a mental health organisation to be in. At any rate it's not a shining example of workplace well-being.

Museum as refuge

The well-being potential of the museum, as a place of refuge and respite from the world, is far easier to believe for the visitor than it is for those who work in the museum. After all, the place of work clearly cannot be a refuge from your place of work, no matter what the happiness gurus may wish you to believe. The question for museum workers, just like any other worker, is ultimately: what's in it for us? Well-being practises cannot, in themselves,

function as a salve to work issues, and it is the attempt for them to do so that is at the heart of the battle line in workplace relations over health, well-being, sickness and care. Thus far the well-being gurus have served at the behest of the managerial class, but there is of course another way. If well-being practises can make more productive workers, they can also provide the sustenance needed, and perhaps even the impetus, for long-term engaged organising and struggle in the workplace. In which we see the point of well-being "isn't to return to work refreshed and ready to be more productive, but rather to question what we currently perceive as productive."[41] Well-being may offer us the means to improve our workplaces by doing fewer bullshit tasks.

Abolitionism

Doing nothing is an active force in society. The abolitionist position that states "Museums are to the Art World as Prisons are to the Police State"[42] offers us a way forward. Abolitionism is a position that proposes the removal of all forms of coercive power structures. From our perspective it seems self-evident that this must be a critical element of any proposal for creating collective well-being in society. For museums to no longer be places of productivity for some and respite for others, in other words for museums to be places for our collective well-being, a new position is necessary, one in which the abolition of the binary between visitor and worker can be extinguished. We again have a hereotopian vision here in the Soviet system of Proletkult. "Rather than making rarefied objects for museums or the beautification of private spaces, the advocates of this approach believed that proletarian artists should turn their attention to the public sphere."[43] The idea was that everyone, no matter their background, could be a cultural creator and develop their artistic creativity. That ultimately the relics of the mystery of unaccountable wealth be revealed to be a common treasury for all. Amazingly this system, despite the many changes since the Russian revolution, continues to exist today. "Like well-written computer code or beautiful urban planning, Proletkult turned out to be so tightly sewn into the social body that it is almost impossible to unravel it."[44]

A part of this abolitionist position must be a confrontation with biomorality. Collective well-being entails the well-being of *all* bodies. Our mental and physical health is important, but it must be on our own terms, and cannot be a universal ideal. This has been posited as an *Against Health* position.[45] At its core though what this provocative stance is really suggesting is that we must support the right to be sick and we must support body positivity; healthy can and must mean many things, but it mustn't be related to our ability to work.

This becomes ever more important when we consider how during the pandemic the intersections of ageism, capitalism, anti-Blackness, islamophobia, ableism, as well as fatphobia led to plainly eugenicist triage policies in which marginalised patients were more likely to die from the virus. In response, campaigns such as the No Body Is Disposable Coalition[46] were formed,

focusing on medical advocacy for fat and disabled people. A similar position has also been elucidated as *Sick Women Theory:* "What is so destructive about conceiving of wellness as the default, as the standard mode of existence, is that it invents illness as temporary."[47] The sick woman in this theoretical construct is not a gendered individual, but is anyone who does not have a guarantee of care. As we see it the fit-note needs to be re-defined away from fit-to-work, towards fit to play, fit to love, fit to honour ancestral traditions and ways of being. Fit to be in beloved community, and to find in the museum a space, physical or virtual, that is refuge for all. In short, in our understanding of well-being it is ok to be sick.

By way of closing

Our thinking on the issue of workplace well-being has undergone a rethink as we wrote this book, particularly as a result of witnessing the conflation of redundancies and concern for staff well-being across the museum sector. The question remains: can you really be truly happy at work? And for those organising workplace well-being, is it possible to offer a space free from ideology that serves the needs of the workforce when they may at times be counter to management? We realise too that "no government, political party, or corporation is going to care for us, so we have to remember how to care for each other."[48] This goes for the workplace as much as for the wider community. When well-being is seen in this collective light, workplace well-being starts to develop new ideas, approaches, and ways of being understood. This framing is far more radical than that often envisioned in lunchtime yoga, journaling, walks or similar. Such framing also goes beyond antagonistic class politics. Instead, well-being in the workplace comes to necessitate nothing short of an investigation into, and thorough questioning of, the meaning of productivity and the nature of work, and workers. Such workers' inquiry gives way to something new, tactile and malleable, we begin to imagine the spaces, for every*body*, in which we work as collaborative participants in co-creation that may have value in our collective well-being. The museum, but reconsidered.

Notes

1 Shirky, C. (2008). *Here Comes Everybody: The Power of Organizing Without Organizations.* Allen Lane. London.
2 Tregaskes, W., Hibbins, A., Jenkins, S., & McGrath, M. (2020). Power to the Roots. *Museums Association Conference 2020.* https://www.youtube.com/watch?v=CxjKXbcKPPw&t=34s
3 hooks, b. (2000). *Where We Stand Class Matters.* Routledge. London. p. 46.
4 Jaffe, S. (2021). *Work Won't Love You Back.* Bold Type Books. New York.
5 Dolgoff, S. (1976). *The Cuban Revolution: A Critical Perspective.* Black Rose Books. Montreal.
6 Han, B-C. (2020). *The Disappearance of Rituals: A Topology of the Present.* Polity Press. Cambridge, UK/Medford, USA. p. 2.
7 Segal, L. (2018). *Radical Happiness: Moments of Collective Joy.* Verso Books. p. 14.

8 Tan, C-M. (2012). *Search Inside Yourself: The Unexpected Path to Achieving Success, Happiness (and World Peace)*. HarperCollins Publishers Ltd. London.
9 Davies, W. (2015). *The Happiness Industry: How Government and Big Business Sold Us Well-Being*. Verso Books. London and New York. p. 252.
10 Ibid.
11 Ibid., p. 25.
12 Ibid., p. 19.
13 Ibid., p. 104.
14 Smiles, S. (1986). Self-Help (Library of Management Classics, Abridged Version). Sidgwick and Jackson, London. (first published in 1859). p. 91.
15 Hseih, T. (2010). *Delivering Happiness: A Path to Profits, Passion and Purpose*. Grand Central Publishing. New York. Boston.
16 Davies, W. (2015). *The Happiness Industry: How Government and Big Business Sold Us Well-Being*. Verso Books. London and New York. p. 113.
17 Coen, J. & Coen, E. (1998). The Big Lebowski. [Film]. USA/UK.
18 Lasch, C. quoted in: Carl Cederström, C. & Spicer, A. (2015). *The Wellness Syndrome*. Polity Press. Cambridge. p. 14.
19 Zizek, S. (2008). *In Defense of Lost Causes*. Verso Books. London. p. 30.
20 Tronti, M. (2019). *Workers and Capital*. Verso. London (Original published as Operai e capitale by Einaudi, Italy, 1966). p. 65.
21 Davies, W. (2015). *The Happiness Industry: How Government and Big Business Sold Us Well-Being*. Verso Books. London and New York. p. 124.
22 Merchant, N. (2013). Got a Meeting. Take a Walk. TED2013. February 2013. https://www.ted.com/talks/nilofer_merchant_got_a_meeting_take_a_walk
23 Cederström, C. & Spicer, A. (2015). *The Wellness Syndrome*. Polity Press. Cambridge. p. 36.
24 Graeber, D. (2018). Bullshit Jobs. Allen Lane. London
25 Soper, K. (2013) The Dialectics of Progress: Irish "Belatedness" and the Politics of Prosperity, *Ephemera*, 13: 249–267.
26 Ehrenreich, B. (2001). *Nickel and Dimed: On Not) Getting by in America*. Henry Holt and Company. New York. p. 106.
27 Cederström, C. & Spicer, A. (2015). *The Wellness Syndrome*. Polity Press. Cambridge. p. 25.
28 Purser, R. (2019). *McMindfulness: How Mindfulness Became the New Capitalist Spirituality*. Repeater Books. London.
29 Žižek, S. (2001). From Western Marxism to Western Buddhism. *Cabinet: A Quarterly Magazine of Art and Culture*, 2(Spring).
30 Cederström, C. & Spicer, A. (2015). *The Wellness Syndrome*. Polity Press. Cambridge. p. 25.
31 Graeber, D. (2018). *Bullshit Jobs*. Allen Lane. London. p. 173.
32 Cederström, C. & Spicer, A. (2015). *The Wellness Syndrome*. Polity Press. Cambridge. p. 120.
33 Ibid.
34 Halasz J. (2018). About the Tight to Be Ill. *Medicine, Health Care, and Philosophy, 21*(1): 113–123. https://doi.org/10.1007/s11019-017-9790-1
35 Davies, W. (2015). *The Happiness Industry: How Government and Big Business Sold Us Well-Being*. Verso Books. London and New York. p. 105.
36 Ryan, F. (2019). *Crippled: Austerity and the Demonization of Disabled People*. Verso Books.
37 Atkinson P. (2020). Marketising the Mental Health Crisis: How the CBT Empire-Builders Colonised the NHS. *Novara Media*. 17 February 2020. https://novaramedia.com/2020/02/17/marketising-the-mental-health-crisis-how-the-cbt-empire-builders-colonised-the-nhs/
38 Ibid.

39 Lowenstein, F., & Davis, H. (2021). Long Covid Is Not Rare. It's a Health Crisis. *The New York Times*. 17 March 2021. https://www.nytimes.com/2021/03/17/opinion/long-covid.html
40 Atkinson, P. (2020). Marketising the Mental Health Crisis: How the CBT Empire-Builders Colonised the NHS. *Novara Media*. 17 February 2020. https://novaramedia.com/2020/02/17/marketising-the-mental-health-crisis-how-the-cbt-empire-builders-colonised-the-nhs/
41 Odell, J. (2019). *How to Do Nothing: Resisting the Attention Economy*. Melville House. London. p. xii.
42 Dubrovsky, N. & Graeber, D. (2020). Another Art World, Part 3: Policing and Symbolic Order. *E-flux Journal,* (113), November 2020. https://www.e-flux.com/journal/113/360192/another-art-world-part-3-policing-and-symbolic-order/
43 Mally, L. (1990). *Culture of the Future: The Proletkult Movement in Revolutionary Russia*. University of California Press. Berkeley. p. 150. http://ark.cdlib.org/ark:/13030/ft6m3nb4b2/
44 Dubrovsky, N. & Graeber, D. (2020). Another Art World, Part 3: Policing and Symbolic Order. *E-flux Journal,* (113). November 2020. https://www.e-flux.com/journal/113/360192/another-art-world-part-3-policing-and-symbolic-order/
45 Metzl, J. M. & Kirkland, A. (eds). 2010. *Against Health: How Health Became the New Morality (Biopolitics: Medicine, Technoscience, and Health in the Twenty-first Century)*. NYU Press; 1st edition. NYC and London.
46 [website] https://nobodyisdisposable.org/
47 Hedva, J. (2016). Sick Woman Theory, *Mask Magazine*, 1: 12. http://johannahedva.com/SickWomanTheory_Hedva_2020.pdf
48 Brown, A. M. (2017). *Emergent Strategy: Shaping Change, Changing Worlds*. AK Press. Chico, CA and Edinburgh, Scotland. p. 113.

5 Introduction to the Five Ways to Well-being toolkit

Envision what a future museum with well-being at the heart of its mission might look like.

There are numerous ways of approaching well-being depending on the availability of resources and staff at an institution. Choosing from the array of options can be challenging, especially because, "Decisions become ever harder to make when one is perceived as being the master of one's fate, of one's own well-being and the well-being of those close to us: our children, for example."[1] At this time the Five Ways to Well-being[2] are the most accessible and applicable toolkit for museum practitioners to frame programming. There are vulnerabilities in every model of well-being, and any method should and could be modified to be suitable to a place and time. I have been particularly interested how the Wheel of Well-being takes the Five Ways and adds one additional element to create a framework for training and application.[3] Adding an additional element to the Five Ways to create programming specific for the institution could be an option for a museum as they add well-being programming to their repertoire.

Well-being models

First, let's outline the well-being models that have been built upon to make the Five Ways to Well-being. The tripartite model of subjective well-being measures subjective well-being from life satisfactions, positive affect and negative affect. Subjective Well-Being (SWB) was revolutionary because it placed people at the centre of measuring their well-being, instead of measurements like educational achievement, material well-being, employment or crime.[4] Person-centred approaches are also called nondirective in psychotherapy, and they refer to therapy during which a counsellor will encourage a client to expound upon what they have said by repeating back what the client has said to the counsellor. This method avoids interpretation or suggestions and instead allows a client to explore their thoughts through dialogue.

The six-factor model of psychological well-being proposed by Ryff, in response to the SWB measurement, considered six (and now seven) measures.[5] The SWB model relied on hedonic happiness, which considered happiness by

DOI: 10.4324/9781003163480-5

measuring how good or pleasurable a person felt. The six-factor model was a eudaimonic measure of happiness or contentment, asking if an individual experienced meaning and purpose in their life. Ryff's model asked participants to report presence or absence of six dimensions of well-being: self-acceptance, positive relations with others, autonomy, environmental mastery, purpose in life and personal growth.[6] Then these areas are plotted to determine the overall sense of well-being for an individual. Ryff explains that many of these measures are limited by class and culture, being mainly dimensions that are present in middle-class individuals. The focus on individual experience in these models means they can be great for measuring well-being, but would not be possible as means of creating museum programming around a model that relies on individual experience.

The UK Office of National Statistics (ONS) Personal Well-being Score (PWS) measures current levels of anxiety, happiness, worthwhile and life satisfaction. The ONS also considers economic and financial concerns of individuals in relation to their overall well-being. The most current analysis shows that in April 2021 the effects of the Covid pandemic were still being felt on the well-being of individuals who had been affected financially by the pandemic.[7] Negative financial well-being was especially prevalent from those in the lowest income brackets, whilst those in the highest income brackets reported negative impacts on their working life and working relationships.

Influencers

Positive Psychology is a concept that Martin Seligman suggests can offer amelioration from misery as well as optimising experiences for people who are more optimistic. Seligman's ideas could be applicable in museum programming, but it does not offer a robust structure around which diverse programming could be built. Positive Psychology as described in Seligman's TED Talk, recognizes that happiness is one type of life that can be achieved, but it relies mainly on genetics as to whether a person is a happy person. There are two other lives that are achievable if a person is genetically pessimistic or introverted. Those are the engaged life, meaning a life with satisfaction in work, play and love, and the meaningful life, which has the elements of the engaged life as well as connecting a person to a higher purpose.[8]

The positive psychology concepts Seligman presents of gratitude and flow are everywhere. In online culture there are numerous content creators who focus on well-being as one area they consistently post about. I have been interested in the lifestyle designer Lavendaire[9] since I found her videos on YouTube. She reminds me of the type of content that Meghan Markle was sharing on her platform before she closed "The Tig" to focus on other projects. Why does advice from these individuals feel easier to me than advice from Martin Seligman? I can imagine there are many reasons, mainly in that I can see myself more easily in individuals like Lavendaire or Markle than I can in Seligman. It may also be that they offer actions for me to complete or

accomplish like a game they are also participating in, and connect me to a community which also encourages my participation in activities that have the potential to make me feel better.

However, Lavendaire is not a psychologist, and when she suggests to her followers to try out a new technique like gratitude journaling, they do so without any critique of the technique. There are problems with the promise of wellness, when promised by individuals with no qualifications, or when cures to illness are promised through positive thoughts. It is important to be sceptical of current trends in wellmania, especially when costly or focused on a short period of time like a detox. The goal of well-being is the creation of positive habits, and this will not be accomplished in a short period of time but instead is reinforced over years. It is also worth being more curious about why so many people desire to feel differently about their situation and perhaps there is something about our collective situation that could be changed instead of changing our individual minds.

Museum toolkits

University College London (UCL) has created a museum well-being toolkit that gives detailed advice about how to measure the impact of well-being in museums. The toolkit has detailed systems for individual reporting about how the individual's well-being has been positively or negatively affected.[10] The toolkit is useful for reporting, but does not seek to outline how well-being programming could be structured. It is part of a larger project called Museums on Prescription, which involved three years of research into how heritage encounters could be valuable for social prescribing.[11] Social prescribing is connecting a patient to a link worker who then can signpost the patient to non-medical services and resources available to them for improving their well-being. This programme has been successful at the Royal Ontario Museum (ROM) and the ROM continues to offer social prescription visits that are distributed through community organisations, these give free visits to the ROM for up to four visitors for purposes of health and well-being[12]. Offering social prescribing services and resources is a first step for heritage sites.

Within the museum sector, the Happy Museum Project has developed their own proprietary model known as the Six Happy Museum Principles, which has been utilized by museums they work with. These principles are similar to the Five Ways, but more conversational and "create the conditions for well-being, value the environment and be a steward of the future as well as the past, be an active citizen, pursue mutual relationships, learn for resilience and measure what matters."[13] The Happy Museum Project seeks to have more engagement in the museum environment through programming that centres community well-being, and specifically the feeling of happiness, as the goal. The Happy Museum proprietary model relies heavily on a partnership with a museum that is authentic as well as engaging, both of which will have limitations in any museum or gallery.

Applications

Authenticity is a concept that is often mentioned in relation to the experience at a museum or heritage site, especially in relation to perceptions about the collection. As Heritage Tourism expands, "Each heritage tourism destination should tap into its inherent tangible and intangible qualities as a basis to satisfy tourists' higher-level emotional needs and increase their satisfaction."[14] A museum relies on a certain assumption that what they display is authentic. Then the authentic material will lead to an experience that is engaging. This is something that has been explored by Modern and Contemporary artists extensively. Icons of artwork in the 20th century like *Fountain* (1917) by Marcel Duchamp, were specifically created for a discourse about inauthenticity and disengagement in art. The reception of this work as a valuable commodity meant that Duchamp stopped making art and played chess instead. It also demonstrated that the museum and gallery are not capable of dealing with inauthenticity or disengagement. Authenticity and engagement are abstractions that cannot be part of the consideration of a museum, and in a way the discussion around these topics can feel like a justification for museum hierarchies and practises that cannot be justified in any other way.

Similarly, promotion of wellness or well-being can be fraught with contradictions and difficulties. Telling someone who is stressed or over-worked that they need to add meditation to their schedule puts the burden on that individual for their own well-being and likely will make them more stressed or over-worked. Well-being can feel like an endless maintenance schedule and sometimes it is when we are feeling unwell that we make the demands that we actually need for our self-care. Matt Haig notes that, "Illness has a lot to teach wellness."[15] For example, I am writing this paragraph whilst stricken with a horrendous cold and in bed. I asked to have time and space to be alone and fall in and out of sleep whilst I recover. I managed to do some paperwork that was vital and managed to do some housework that was also needed, but beyond that I let the piles of papers and list of tasks go undone. My head is pounding and I feel awful but I also feel a gratitude that does not have a real name or word for it. Is this my privilege for a comfy bed and the ability to shirk off work? Yes. Is it also something we all have done to some extent? Yes. Which brings us to the idea of work.

Much of the discussion around well-being focuses specifically on productivity as the goal of well-being, you don't need to work harder, you need to work smarter.[16] This even continues in a book about altruism that suggests that you need to work in a job that will pay you the highest income or allow you to make the biggest impact through monetary decisions, like politics.[17] Well-being can also be sold to companies as a way to prevent employee absenteeism. This is probably the approach some well-being practitioners took after the 2007–2008 financial crisis when governments, companies and individuals noticeably stopped spending money on preventive health measures. However, it fails to address when a person is so unwell that they are not

at work or at school that the time they are spending recovering is wasted. Some positions involve measurable tasks but many, including education, do not. It is possible that taking a break from the structure of a work/school day would lead to better work/learning when a person returns.

Public health and well-being

The Five Ways to Well-being is the model that has gained the most traction both within museums and wider society, likely due in part to its simplicity, adaptability and scale-ability. This model was developed by the New Economics Foundation (NEF) after their initial launch by Foresight in a 2008 report (NEF). Since its inception this model has been successfully applied in public health policies, as a population-wide approach to mental health. For example, Somerset Public Health recommended using a Five Ways to Well-being app,[18] which has gamified the Five Ways so that a goal is set to meet one of them, then when it is accomplished the app user receives a trophy or another reward. The app user then will continue to build on these habits, making them stick, and will benefit from overall improved well-being.

Focusing on the mental health of the entire population means creating programming that is accessible to a majority of the population instead of focusing on the mentally ill. The goals of such programming is to narrow well-being inequalities and raise the overall well-being for an entire population. This is important because mental illness can and often is a lifelong condition. The presence of positive psychological experiences which lead to habits can improve well-being for a range of neurodiverse individuals. In this way, applying the Ways of Well-being model can reinforce positive psychological experiences for an audience that could include a spectrum of mental states and allow for the continuation of experiences whilst the audience may move between different mental states.

The Five Ways to Well-being offers specific actions, or combinations of actions, utilising the history and philosophies of mental, social and physical approaches to the well-being of the body and mind. Importantly for museum practitioners, this framework does not require specialist medical, sociological or psychological training to implement, and the programming developed may be directly or indirectly focused or marketed on well-being. Partnering with other organisations is frequently how well-being specific programming is delivered by larger institutions, and this offers an opportunity for a museum to work with the community locally and regionally.

Museums

It is possible that there is already programming running that incorporates all of the Five Ways to Well-being, and would only need minor changes in the intentionality of the programming to be considered as well-being programming. Most museums have a walking tour which includes being active, keeping learning,

taking notice and connecting to culture or history or the natural world. The elements are all there but the museum and the individuals leading tours would need to be further informed about how the tour is a well-being practice and how they can support participants in a way that encourages positive well-being experiences. It will be important to re-evaluate all programming for well-being benefits instead of only having a yoga or meditation session as the only way to include well-being in a museum's space.[19]

The Five Ways to Well-being toolkit is already used by museums and heritage organisations in the UK, including the National Trust and the Wellcome Collection, notable for these being the largest and most specifically focused upon well-being, respectively. These two organisations also continue to use well-being as a goal for programming or outreach. They have accomplished some interesting and successful programming, and they continue to build upon that to create stronger and more diverse experiences. In many cases all of the programming at a museum could, indeed should, have a well-being consideration, improving the health of participants through connecting and helping others, learning, taking notice and being active in the museum space.

Our early training in art conservation was in the conservation and restoration of ceramics. Ceramics are funny things when they break, they rarely go back together perfectly, something is always slightly out of alignment. It is called sprung where the pieces join together but do not align. It can be very frustrating re-assembling a ceramic that will not form a perfect shape. After a few years I took the approach that "better is the enemy of good." This means that while I am in the process of re-assembling a ceramic, if I can reach a good point, there is little to be gained by trying to make it better. Oftentimes it is in trying to make something better when damage happens, or as one of my colleagues said to me, "you can keep fiddling with that handle until it is perfect or until it breaks, whichever comes first." This is my advice for well-being, that the endless pursuit of better can ultimately be damaging. Years after completing a restoration and seeing the artefact again, I can never tell where the area that I had been obsessing about existed, if it ever existed at all. You are doing better than you think you are in your process, give yourself time to recognize that.

Notes

1 Salecl, R. (2011). *The Tyranny of Choice*. Profile Books. pp. 11–12.
2 New Economics Foundation (NEF) on behalf of Foresight and Government Office for Science. 2008. Guidance: Five Ways to Mental Well-being. https://www.gov.uk/government/publications/five-ways-to-mental-wellbeing
3 Spain, D., Stewart, V., Betts, H. *et al.* (2021). Wheel of Well-being (WoW) health promotion program: Australian participants report on their experiences and impacts. *BMC Public Health,* 21: 2037. https://doi.org/10.1186/s12889-021-12076-x
4 Waldron, S. (September 2010). Measuring Subjective Well-being in the UK: Working Paper. Office for National Statistics.

5 Ryff, C. D. (2014). Psychological Well-Being Revisited: Advances in the Science and Practice of Eudaimonia. *Psychotherapy and Psychosomatics, 83*(1): 10–28. https://doi.org/10.1159/000353263
6 Ryff, C. D. "Happiness Is Everything, or Is It? Explorations on the Meaning of Psychological Well-Being," 1989.
7 *Personal and Economic Well-Being in Great Britain - Office for National Statistics.* (May 2021). https://www.ons.gov.uk/peoplepopulationandcommunity/wellbeing/bulletins/personalandeconomicwellbeingintheuk/may2021
8 Seligman, M. (February 2004). *The new era of positive psychology.* TED Talk. https://www.ted.com/talks/martin_seligman_the_new_era_of_positive_psychology
9 Xu, A. (2022). *Home - Lavendaire.* https://www.lavendaire.com/
10 UCL. (2017, February 12). *UCL Museum Well-being Measures.* UCL CULTURE. https://www.ucl.ac.uk/culture/projects/ucl-museum-wellbeing-measures
11 UCL. (2017, February 12). *Museums On Prescription.* UCL CULTURE. https://www.ucl.ac.uk/culture/projects/museums-on-prescription
12 *ROM Community Access Network (ROMCAN).* Royal Ontario Museum. https://www.rom.on.ca/en/visit-us/accessibility/community-access-network
13 Principles – Happy Museum Project. (2013). https://happymuseumproject.org/about/why/principles/
14 Wu, D., Shen, C., Wang, E., Hou, Y., & Yang, J. (2019). Impact of the Perceived Authenticity of Heritage Sites on Subjective Well-Being: A Study of the Mediating Role of Place Attachment and Satisfaction. *Sustainability, 11*(21), 6148. p. 15. https://doi.org/10.3390/su11216148.
15 Haig, M. (2018). *Notes on a Nervous Planet.* Canongate Books. p. 174.
16 Headlee, C. (2020). *Do Nothing: How to Break Away from Overworking, Overdoing, and Underliving.* United States: Harmony/Rodale.
17 MacAskill, W. (2015). *Doing Good Better: Effective Altruism and a Radical New Way to Make a Difference.* United Kingdom: Guardian Faber Publishing.
18 *Five Ways to Wellbeing app | Mental Health Partnerships.* (2013, September 27). https://mentalhealthpartnerships.com/resource/five-ways-to-wellbeing-app/
19 Mitchell, B. (October 2019). Well-being and Wellness - How Theme Parks, Museums and Aquariums Are Offering More Health Services Than Ever. Blooloop.com

6 Connect

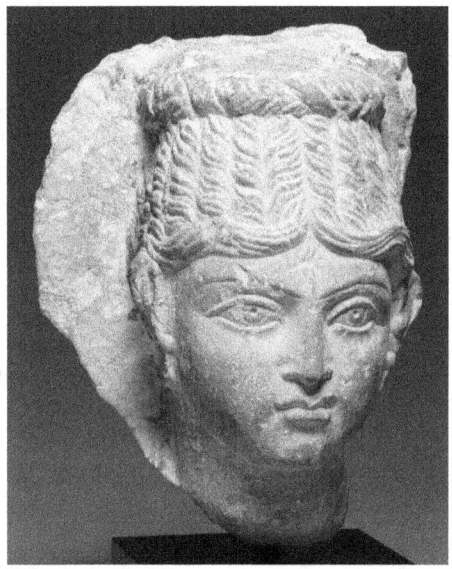

Figure 6.1 Palmyran Sculpture Fragment, A.D. 150–160, Limestone. Object Number: 81.AA.170. Dimensions: 16.5 cm (6.5 in.). Digital image courtesy of the Getty's Open Content Program.

The first of the Five Ways to Well-being that is covered is *Connect*. This seeks to address how we interact by being part of a community of people, of cultures, of history, as well as how we connect with the natural world. Close relationships to each other and to a community or natural world (biophilia) are beneficial to individual and community well-being. In a way it is a natural start to well-being because all of the Five Ways are connected and function in connection with each other. Museum collections connect to history and culture, and this can lead to a reduction in stress and improvement of well-being[1]. Each of the following chapters will be illustrated first by an artefact to

DOI: 10.4324/9781003163480-6

connect to that Way to Well-being, and then the discussion will broaden to include more about how the particular Way could be included in museums.

The artefact chosen to illustrate connection is this Palmyran Sculpture Fragment from the Getty Museum. It is a relief carving fragment, which is slightly raised on the figure's right side, perhaps indicating that the figure would have been illustrated slightly turned towards a figure on the left.[2] The fragment contains the face and neck of a woman, and it may have originally included her shoulders. The woman has a direct stare and very detailed eyes and eyebrows, it feels as if she still sees us. Her nose is wide and her mouth is closed with her lips slightly pursed, her expression is neutral, or perhaps it is an expression we do not have a word for today. She wears earrings and has an elaborate hairstyle, with rows of braids pulling her hair up into a high cylindrical crown braid that is decorated with a thick ribbon. On her forehead two loose strands of hair are divided and swept across and tucked behind her ears, a small curl drops down her forehead and rests between her eyebrows.

This woman has no clear racial identity. Palmyra in AD 150 was probably similar to Los Angeles today. Los Angeles is a city at the crossroads of Latinx, Asian and American cultures, Palmyra was at the crossroads of Roman, Aramean and Arab cultures.[3] Palmyrans did not have the social constructs and institutional systems that rely on the definition of race that we have today so it is impossible to know what they thought of race or if it existed to them at all. This liberates us from crass stereotypes, allowing us to look at this woman and see a human who could have looked like many of us, and it connects us to her even though she lived almost two-thousand years ago.

This artefact further illustrates Connect in a variety of ways. Museums keep detailed collection records, and until recently (the 1990s in the USA and the 2000s in the UK) most of those records included a carefully photographed gelatine silver developed-out-print. This photographic process was specifically chosen because it is particularly archival. The way the sculpture fragment is lit and positioned in the photograph is also important from an archival perspective. This image is positioned in a ¾ view, which allows for a majority of the information to be conveyed in a single image. This image is lit using top-left lighting, using two lights, the centre of the forehead is slightly overexposed and the areas on the sides of the face and underneath the chin are in shadow. Top-left lighting is in which the key light is angled 20–30 degrees left of the vertical. This is more pleasing visually, and this may also be a factor in why museums documented their collection in this way.[4] The details of the carving are most noticeable on the left side of the photograph where the lighting is angled which highlights the intricate carving of her hair.

This image is three times removed from the sculpture. It is a digital scan of a photograph of a sculpture fragment. We do not consider the hand of the person who scanned the photograph, we do not consider the hand of the person who took the photograph, and we do not know the hand of the person who created the artefact. As a scan it is detailed and beautifully executed. As a photograph it is beautifully lit, and the dark areas of a photograph are a

true deep black, the range of tones it displays shows that the person who took it was exact and precise. And as a sculpture it is a fascinating fragment of the past and a beautiful example of precise stone carving. As a digital reproduction of a paper and photography process of an artefact, this can give us time to explore the purposes of documentation across time and culture. There is a connection in the dramatic way the fragment is photographed, an intangible feeling of drama and history. Current documentation techniques are less focused on creating that feeling of drama and more focused on collecting as much data about the image as possible. While the data is an important gain for collection documentation, it is clear that some connection to the collection is also being lost.[5]+

Fragments

Artefacts from antiquity all the way to contemporary artworks are involved in the discussion of fragments.

> Grammatically, "fragments," can be both noun and verb. An artist fragments the picture plane into several related shards, layers or pieces. These fragments can be either physical (pictorial space, literal subject matter) or metaphorical (depicting fragments of memory, or symbolic remnants of our subconscious).[6]

Connecting to take notice, we can begin to see how the mind processes fragments and makes something close to, but never quite becoming, a whole. This could apply to memory, subconscious and daily experience of the world.

The sculpture is a fragment consisting only of the head and neck of the figure. The museum displays this as a fragment, without attempting to fill in the missing areas. There continues to be discussion during restoration decisions about when and how missing elements of an artwork or artefact should or could be replaced. In art museums, artefacts that served a utilitarian purpose like jars, cups or bowls often have areas of loss filled and painted in to make the artefact appear whole. The reason for this is that a cup or bowl which is presented whole will have its use more easily understood. However, famous incomplete sculptures from antiquity like the *Venus de Milo* (c.150–125 BCE) would not be considered for this type of completion because it would require a re-interpretation of the artefact. Sculptures, especially those that depict an image of a person, are considered whole even if they have very large losses that can limit the narrative of the sculpture. For example, the *Venus de Milo* is missing both arms, which makes the gesture of the figure impossible to determine. However, the absence of these elements in this sculpture does not detract from the importance of the sculpture, and it can allow for further discussion about how the sculpture could have appeared as originally intended. The fame of a sculpture like the *Venus* is also a factor in determining whether a restoration to completion would create something radically new instead of removing a visual distraction.

In 2005, Marc Quinn was commissioned to design an artwork for the Fourth Plinth in Trafalgar Square. He chose for the design a marble sculpture titled: *Alison Lapper Pregnant* (2005). It was a sculpture of the artist Alison Lapper, who was born with absent arms and shortened legs.[7] The sculpture referenced these fragmentary sculptures from antiquity while also opening a discussion about how disabled people are not represented as contemporary examples of beauty and strength but classical statues which often have the same elements missing are. Marc Quinn is showing that disabled people are similar to classical heroic sculpture because they are: "People who instead of conquering the outside world have conquered their own inner world and gone on to live fulfilled lives."[8] In this way ancient culture connects us to modern cultural struggles for accessibility and recognition today. Connect acts like a thread bringing artefacts and culture together.

Identity

The Connect thread also weaves through the other Five Ways, for example, while we keep learning we join a community of learners, while we are active we join a community of exercisers and while we meditate (take notice) we join a meditation community. Identity could be a list of words and descriptions that a person applies to themselves, words they apply to other people, or words other people apply to them. Identity will change when we change the words or when we stop connecting to others, it may become something different. Human connection is after sleep on the list of human needs: food, water, shelter, sleep, human connection, novelty.[9] In our society the first three needs are typically fulfilled by earning money through work, the last three needs are unconnected with work entirely, although all six of them do not require work. This brings up a point about time, work and leisure. Perhaps there are human connections at work that were missed because of COVID restrictions to work at home. However, perhaps that human connection and the subsequent identity that comes in connecting is still happening while work is physically separated from colleagues.

Identifying as a member of a community is the difference between a writer and a person who writes or a photographer and a person who takes photographs. There is someone who in doing these things identifies a part of themselves with the action. A struggle between the individual and community in feminism shows an example of some of the confusion around identity and identity politics. Questioning women "Are you a feminist?" could function as a dispossession of their autonomy.[10] White American class-based feminism has undermined the assertion that men of the white patriarchy had the power to determine who was a "true woman" and could therefore use that power to further disenfranchise women, especially women of colour.[11] Currently, some women have taken on this job and decided that they can determine who is a true woman. These women then lean into difficult behaviours and then when described as difficult, challenge the description as a violation of their right to be difficult.[12] This excuses the behaviour of women who support exploitative systems by somehow re-branding

those systems as good for those women, therefore good for all women and inherently feminist. The lineage of feminism is ignored and instead anything done by a woman could be interpreted as feminist. This obvious spurious claim that would then determine the 19th and 20th century women's anti-suffrage movement, women who were against women's right to vote, was feminist because it included many women. Resistance and collective action, leading to horizontal organisational structures that benefit everyone is where feminism currently functions, not with personal decisions and feelings.[13] Identity is the term and identity politics is how that term is then applied. The purpose of feminism is collective freedoms of men and women and therefore cannot be represented by *individual* choices.

A cult of busyness has come to be seen as a positive thing, while connection demands time spent in community. This culture of busyness has seen a steady decline in participation and membership to community organisations. PTAs, unions, clubs, environmental groups, political parties and churches have fewer members or parishioners[14,15]. It can be interpreted as a symbol of personal importance that someone is "too busy" to participate in one of these groups because of work commitments.[16] However, less participation in these groups makes more demands on everyone's time. Meaning, fewer people who are involved in a union gives more power over the working conditions, including time to the employer and less power to the unionised employees. The fewer people who are involved in a school or church means the services these organisations offer of socialising and teaching children must be taken up by the uninvolved individuals, making more demands on their time. Busyness as an excuse to disengage with your community could actually be a laziness about improving working conditions for everyone, or a selfishness about teaching and socialising "other people's" children.[17] The outcome is that busyness creates a public persona at the loss of hobbies and community involvement which enrich our well-being and possibly the well-being of those in our community.

Busyness is also a state and issue that leads directly or indirectly to the deterioration of cultural heritage. Jenny Odell notices that:

> In an endless cycle where communication is stunted and time is money, there are few moments to slip away and fewer ways to find each other. Given how poorly art survives in a system that only values the bottom line, the stakes are cultural as well.[18]

Museums can be involved in the programming of leisure activities where connection is encouraged and then subsequently encourage their staff to participate in leisure activities, either at the museum or not, through the encouragement of increased leisure time outside of work.

Belonging means not changing yourself, it is different to fitting in or assimilating which require change to fit into a group.[19] Connecting therefore takes place on an individual and group level, starting with those closest such

as family and continuing to an entire community. Connecting can be on a superficial level and usually that is how it begins and occurs daily, and connecting is a daily practice when we choose to see and show our true selves to others. The connections made between strangers can be profound connections, perhaps because the other person is willing to show their true self for a moment to another person. Some of the barriers to connection—trying to fit in, seeking approval and the fear of standing alone—are sometimes not present in interactions with strangers. The museum as a beloved community creates a container in which we feel safe to connect.

Duality and collectivity

A group that meets consistently at a museum could build up connections with each other and the collection. This could include art therapy projects that focus on self-exploration and analysis of the group-dynamic. In art therapy, there is a project where participants are given a box and asked to design the interior of the box to represent how they see themselves and the exterior of the box to represent how others see them.[20] This opens up conversations about duality and identity. This can be reinforced by examining the collection and looking at artists like Bob and Roberta Smith, who are the singular artist Patrick Brill, and examining Bob and Roberta Smith's publications that focus on well-being such as: *You are an artist* (2020) or *The secret to a good life* (2018). Other artist-led projects include the Icarus Project which "believes that humans are meaning makers, that meaning is created through developing intrapersonal and interpersonal narratives, and that these narratives are important sites of creativity, struggle, and growth."[21] The Icarus Project originated in the USA sought to improve mental states through increased social support, leading to collective liberation.

The self exists in an ego-centric or socio-centric way depending on how your culture approaches mental illness. In the USA, mental illness is mainly treated and healed at an individual level. In other cultures mental illness is a community experience and will be treated and healed through processes that involve the community.[22] Museums offer the opportunity to examine across cultures what the human experience of mental illness could be and how it could be healed. The reaction to trauma is also a cultural experience, and there are instances where psychologists apply a therapy to a community that is ultimately ineffective. An example of this is that after the 2004 tsunami in Sri Lanka, American psychologists who came to offer trauma support through talk therapy and individual support failed to recognize that in Sri Lanka it is through caring for others in the community that bonds are reinforced, not through self-care. This can go against the American psychological approach that you have to take care of yourself before you can have a relationship with other people.[23]

Symptom pools are a way to channel internal distress into an expression, because you are part of a community, the symptoms of your mental illness

will be an expression of the norms in your community.[24] This is how psychologists observe clusters of people who have the same symptoms, but in these cases the symptoms are what is treated, and until the cause is uncovered a pathological diagnosis is not helpful or meaningful. This is also why people involved in similar activities like heavy users of social media, will have a similar diagnosis. Current epidemics of depression, anxiety, ADHD or body dysmorphia may be more of an attempt to relate to others instead of a genetic or brain chemistry cause than we have come to believe.[25] Perhaps this is a conflict between ideas that are explored in criminology and psychology about the genetic inheritance of mental illness or criminality, and ultimately the data doesn't measure up. This is further examined in books like *The Waves* by Virginia Woolf, when she states the interconnectedness we experience through memory, "It is not one life that I look back upon; I am not one person; I am many people; I do not altogether know who I am—Jinny, Susan, Neville, Rhoda, or Louis; or how to distinguish my life from theirs."[26]

Why museums

It's important that connecting with others cannot intentionally be about wellness or well-being, which can feel strange in a book about well-being.[27] Connecting around wellness could lead to competitive wellness or narcissism instead of connecting, which can undermine the community or connection that the museum is trying to create.[28] Connecting should be like play or fun, something done in small amounts and often. It isn't about seeking a breakthrough, even though after so many COVID restrictions for such a long time, it may feel like a breakthrough to connect with anyone or anything for any amount of time. But, building up a practice of connecting will be more effective through small and frequent connections. There is a difference between knowing that connection is good for your well-being and being part of a practice of connection for your well-being.

Collections have so much information that can be shared and explored in a variety of ways by museum visitors. The artefact will have information about its materials, manufacture, use or disuse. The artefact will further have information around the context in which it was made and used, why it was collected and how it is now displayed. Each of these elements gives us insight into the people and culture involved in the biography of the artefact. This can be further explored through peer-to-peer learning in museums. If there is a group that meets every month and a member of the group is given time to present about an artefact in the collection, this collective learning will benefit all who participate.[29] Like a book club for the collection. Similar to the point Leo Tolstoy makes in his short story "The Three Questions," the most important time is now, the most important person is the person you are with, because you do not know if you will ever be with another, and the most important thing to do is to do good for that person.[30]

Challenges

In museums, there are many opportunities to connect to others, but often times they lack the structure to be effective. Art museums have openings in evenings to bring people together, taking this practice from commercial galleries which have openings to encourage visitors to purchase art after having a few glasses of wine. The purpose of openings could be construed as an opportunity for making connections in a museum. Openings are welcoming for people who are available in the evenings and enjoy experiencing art while having conversation and a glass of wine. Openings are marginalising for people with poor social skills or those who do not want to be at events that are loud or serve alcohol. To reach these audiences other events could be offered.

Diversifying event programming is a growing trend in museums; to reach out to an audience that would benefit from your programming but does not typically visit museums. Audience segmentation and research strategies offer the opportunity to tailor programming specifically to address barriers to participation and connection; whether social or neurological, as has been outlined in the UCL Museums on Prescription project.[31] Examples of projects around connection in art therapy include making large mandalas, murals or collages where each person has a specific contribution to the entire work.[32] Highlighting items in a collection that are made collectively can also bring up discussions about connecting and cooperation.

It is necessary, and relatively simple, to be creative in how events are modified so that more people will be able to connect to each other, and how having a common goal or activity that has a participatory element could increase the level of connection. The collection is a powerful tool for connection. "To see the thing itself, with one's own eyes and in a public place, surrounded by other people having some version of the same experience can be enchanting."[33] Art speaks from a place of bravery, and a wildness that is not attempting to fit in or seek approval. Perhaps utilising artworks from a collection that includes outsider art, folk art or works by historically underrepresented artists. Artists who make artwork because they are compelled to express themselves in that way speaks about the condition of being human and the desires and passions that are universal; such art seeks to connect.

Addiction and recovery

We are interested in communities that are created around recovery from addiction. These communities are very strong and non-judgemental, and they remind us of chosen families.[34] Perhaps it is this acceptance that makes these communities so strong, because those who are members are supported through some of the most difficult phases of their life. This phase can be the addiction, but it is also the recovery, the addiction acts as a delusion from other issues, and during recovery the delusion will no longer function, and the

individual must deal with the issues that led to the addiction in the first place. This is not to say that all behaviours are accepted, the community will police itself and will ask members to act in a way that is respectful for everyone. The individual and overall well-being of the group and the community benefit because "For better or worse, our well-being is hugely dependent on what others think we are."[35] There is a power in the repeated practice of connecting to others. In support groups people come together who have something in common, and to participate in an activity together or reach a goal.[36] These groups are similar to the long-COVID support group we were directed to by our health service.

Social capital

One of the interesting developments from COVID lockdown has been the lack of casual connection with co-workers and the increase in casual connection with neighbours on the street. This connection builds up "social capital," a term coined by Jane Jacobs in her book *The Death and Life of Great American Cities* in 1962.[37] Social capital is the everyday activities that build up a network of relationships and provide a foundation for mutual trust, collaborative efforts and resilience. Belonging to something, and connecting to others builds a community of diverse relationships upon which we accrue social capital. Social capital includes the power of our connections, the power of the knowledge they bring and the opportunities they open for us. In this book she also uses the terms "mixed primary uses" and "eyes on the street" to discuss how urban spaces become functional through the presence and interactions of people in those spaces. The same can be said for museum spaces. It is through interactions in these spaces that the space is defined. Jacobs came to these conclusions through extended observation, in what would now be called the user experience of the space instead of the design purpose for the space.

Culturally, cities adore those who bring intimacy to them. In Virginia Woolf's essay "Portrait of a Londoner" we are brought up the stairs to see the Londoner Mrs. Crowe, "But it is with the front drawing-room that we are here concerned; for Mrs Crowe always sat there in an armchair by the fire; it was there that she had her being; it was there that she poured out tea."[38,39] Mrs. Crowe makes the city of London into a village, she knows all, she sees all, she is what Jacobs would describe as "eyes on the street." From her front drawing room she reveals an intimate knowledge of London and Londoners. Every place has a Mrs. Crowe, a person who is the source of information about the people, place and things around her. Woolf's ideas about isolation and loneliness were explored more recently in a play set when 67 million people were in lockdown, called *Mrs. Delgado*. The one-woman show's protagonist is a young woman following the rules of lockdown whilst she becomes increasingly frustrated about what she perceives as breaking of lockdown rules by her octogenarian neighbour.[40] Mrs. Delgado could be a reference to *Mrs. Dalloway*, Woolf's novel examining the juxtaposition of internal lives and external actions. Both works seek to understand how we are

connected to one another and the creation of community. In many ways, these topics are revisited and remixed like the artefacts in a collection, and each time there is something new to discover, some new ending to the story they tell.

Collective joy

Ceremonies or traditions are occasions that encourage connecting to another person or connecting to a group of people. These connections can include moments of collective joy, as outlined in Barbara Ehrenreich's book *Dancing in the Streets: A History of Collective Joy*. In the book Ehrenreich methodically details the history of rituals and celebrations that include dance or costume from the neolithic times to the current day. These rituals take place in a variety of forms and involve seasonal or calendrical events or a milestone in a person's life.[41] She proposes that perhaps the reason for an epidemic of depression from the 1600s until the late 1700s, was that there were less opportunities for collective joy and celebration. Whether this was caused by an increase in melancholy in the general population (depressed people did not desire to celebrate) or if the limitations placed on celebrations were a factor in the increase of depression cannot be determined. She goes on to argue that the rise in the identity of the self that occurred in the 16th and 17th centuries amongst the general population also contributed to this rise in depression.

Ehrenreich's cultural study of collective joy highlights how allowing space and time for community celebration can undermine a culture of marketing and advertising which seeks to encourage purchasing as the means of self-actualization. Specifically, music allows for a release from daily struggles and can create a space internally and externally that exists temporarily and can be filled with joy. This can be true of any genre, even Blues music:

> If anything can truly be said to be the philosophical core of the blues, it is this: when you suffer, you can at least boogie, and when you boogiein', you ain't sufferin'... Once you've acknowledged your pain, you can get to dealing with it.[42]

There is definitely a place for more exploration of collections through music, and as this quote about the blues illustrates, even music associated with difficult emotions can also be about the joy experienced in sharing those emotions together. In our experience as art conservators, we've asked contemporary artists about what music they listen to when they create, and on one occasion we listened to that music as part of the restoration of the artefact.

What connection in a museum could be like

After obtaining a degree in Art History in the USA, I travelled throughout Europe. I found I could enter a museum in Spain or England and immediately feel at home. The calm atmosphere, the artworks or artefacts that I had

experienced through reproductions in books or online were a comforting presence in a foreign country. I would meet others who spoke English and tour around museums with them, talking about what I knew. Some experience the world through reading and losing themselves in a book. I experienced the world through looking and seeing and walking the landscape of museums.

Museums such as Yorkshire Sculpture Park are well-suited to offer opportunities to continue to connect as part of their well-being programming since they have outdoor spaces that were still accessible under some COVID restrictions. They suggest visitors: "Connect: experience art and nature through your senses. Share your experiences with others."[43] Their collection of around 100 sculptures in the open air is unique in scope and size, but not in the intention or experience. A visitor could have this type of connection at other museums but does not have to be limited to those as there are sculpture parks, environmental sculptures, stone megaliths and land art throughout the world. Visiting these sites repeatedly can offer deeper connection to the land, culture and history that surrounds them. These sites may not be affiliated with a museum but museum visitors or members may be interested in experiences like visiting these sites that can be connected back to their experience of the museum space. Connection at heritage sites will improve well-being, and the positive spiral may be visiting more heritage sites.[44]

To connect means to be in the right relationship with each other. Good relationships build a sense of belonging, allowing individuals to support each other through difficulties and celebrate success together. Such relationships can also be developed to heal past societal trauma, and the museum has a potential role to play in social and racial justice work in this well-being arena. However, connecting can be a type of conflict, and does not always mean that the experience is a positive one. The Éist in Detroit, USA, and Derry, Northern Ireland, is an example of utilising media, culture and art to connect communities across space and time through their shared experiences of post-conflict transformative justice.[45] The Éist offers a blueprint for the type of future museum where well-being and healing is central to their mission. Many others in the museum field are also creating frameworks for action in response to moments of outrage and crisis that would be helpful to encourage more people to connect with the museum as a place for justice and healing.[46]

Notes

1 Thorpe, V. (2019, January 20). Forget yoga, under-30s use museums and galleries to de-stress. *The Guardian*. http://www.theguardian.com/culture/2019/jan/20/art-fund-young-people-de-stress-with-respite-at-galleries
2 Wight, K., Belloli, A. P., Koch, G. (1988). Roman Funerary Sculpture: Catalogue of the Collections. Egypt: J. Paul Getty Museum. pp. 108–109.
3 Veyne, P., & Fagan, T. L. (2018). *Palmyra: An Irreplaceable Treasure*. The University of Chicago Press.
4 Mcmanus, I., Buckman, J., & Woolley, E. (2004). Is Light in Pictures Presumed to Come from the Left Side? *Perception, 33*: 1421–36. 10.1068/p5289.

5 This discussion of documentation of sculpture will continue in Chapter 8, *Keep Learning*. While the image made for Chapter 8 was captured later than this chapter, this does not suggest a lineage of understanding of collection documentation, but instead collection documentation for a very different purpose.
6 *Fragments exhibition December 10, 2013 - January 11, 2014 Garvey|Simon*. (2013, December). https://www.garveysimon.com/exhibitions/fragments
7 Waddell, E. (2018, June 28). The (In)complete Marbles? Displaying the Disabled Body. *The Historian*: Published in London at QMUL. https://projects.history.qmul.ac.uk/thehistorian/2018/06/28/displaying-the-disabled-body/
8 "The Complete Marbles." http://marcquinn.com/artworks/the-complete-marbles.
9 Headlee, C. (2020). *Do Nothing: Break Away from Overworking, Overdoing and Underliving*. p. 118–119.
10 Holmes, A. (Director). (2018). *Maiden* [film]. New Black Films
11 Jamieson, E. (2018). Systemic Racism as a Living Text: Implications of "Uncle Tom's Cabin" as a Fictionalized Narrative of Present and Past Black Bodies. *Journal of African American Studies, 22*(4), 329–344. http://www.jstor.org/stable/45200266
12 Tolentino, J. (2019). *Trick mirror: Reflections on self-delusion*.
13 Federici, S., & Valio, L. B. M. (2020). Na luta para mudar o mundo - In Struggle to Change the World: mulheres, reprodução e resistência na América Latina. *Estudos Feministas, 28*(2), 1–12. https://www.jstor.org/stable/26965085
14 Lewis, P. (2016, November 22). Unions, Clubs, Churches. Joining Something Might Be the Best Act of Resistance. *The Guardian*. https://www.theguardian.com/commentisfree/2016/nov/23/unions-clubs-churches-joining-something-might-be-the-best-act-of-resistance
15 Headlee, C. (2020). *Do Nothing: Break Away from Overworking, Overdoing and Underliving*. Piatkus. p. 90–91.
16 Ibid.
17 Doyle, G. [@GlennonDoyle] "Let us never forget there is no such thing as other people's children. Join us now. http://on.fb.me/1LGjXRV" Twitter. 22 October 2015. https://twitter.com/glennondoyle/status/657006555016073216?lang=en
18 Odell, J. (2019). *How to Do Nothing: Resisting the Attention Economy*. Melville House. Brooklyn. p. 9.
19 Brown, B. (2017). *Braving the Wilderness: The Quest for True Belonging and the Courage to Stand Alone*. Ebury Publishing. United Kingdom.
20 Buchalter, S. I. (2004). *A Practical Art Therapy*. Jessica Kingsley.
21 DuBrul, S. A. (2014). The Icarus Project: A Counter Narrative for Psychic Diversity. *Journal of Medical Humanities, 35*(3), 257–271. https://doi.org/10.1007/s10912-014-9293-5
22 *Is The Rest Of The World "Crazy Like Us"?* (12 January 2010). NPR.org. Retrieved January 10, 2022, from https://www.npr.org/templates/story/story.php?storyId=122490928. Transcript and at 19:00–21:00.
23 *Culture & PTSD: Lessons from the 2004 Tsunami | Psychology Today*. (4 October 2013). https://www.psychologytoday.com/us/blog/talking-about-trauma/201310/culture-ptsd-lessons-the-2004-tsunami
24 *Is The Rest of the World "Crazy Like Us"?* (12 January 2010). NPR.org. Retrieved January 10, 2022, from https://www.npr.org/templates/story/story.php?storyId=122490928.
25 *Ibid*.
26 Woolf, V. (1933). The Waves. Leonard & Virginia Woolf at the Hogarth Press. London. p. 276.
27 Wilson, L., Bryant, W., Reynolds, F., & Lawson, J. (2015). Therapeutic Outcomes in a Museum? "You Don't Get Them by Aiming for Them". How a Focus on Arts

Participation Promotes Inclusion and Well-being. *Arts & Health, 7*(3), 202–215. https://doi.org/10.1080/17533015.2015.1046891

28 Cederström, C., & Spicer, A. (2015). *The Wellness Syndrome*. Polity Press.
29 Simon, N. (2010). The Participatory Museum. United States: Museum 2.0.
30 Tolstoy, L. (2003). *Walk in the Light and Twenty-Three Tales* (L. Maude & A. Maude, Trans.). Orbis. pp. 347–351.
31 UCL. (2017, February 12). *Museums on Prescription*. UCL CULTURE. https://www.ucl.ac.uk/culture/projects/museums-on-prescription
32 Buchalter, S. I. (2004). *A Practical Art Therapy*. Jessica Kingsley.
33 Conn, S. (1998). *Museums and American Intellectual Life: 1876–1926*. Univ. of Chicago. Chicago. p. 262.
34 Jackson Levin, N., Kattari, S. K., Piellusch, E. K., & Watson, E. (2020). "We Just Take Care of Each Other": Navigating 'Chosen Family' in the Context of Health, Illness, and the Mutual Provision of Care amongst Queer and Transgender Young Adults. *International Journal of Environmental Research and Public Health, 17*(19), 7346. https://doi.org/10.3390/ijerph17197346
35 Bering, J. (2019). *A Very Human Ending: How Suicide Haunts Our Species*. http://www.vlebooks.com/vleweb/product/openreader?id=none&isbn=9781473542280
36 Many museums in the USA have also addressed the Opioid epidemic through exhibitions and programming to address the collective experiences of addiction in their communities. See: FIX: Heartbreak and Hope Inside Our Opioid Crisis - Indiana State Museum. (2020, August 1). https://www.indianamuseum.org/experiences/fix-heartbreak-hope-fix/ and *Human Impact: Stories of the Opioid Epidemic*. (2019, August 28). Fuller Craft Museum. https://fullercraft.org/event/human-impact-stories-opioid-epidemic/
37 Jacobs, J. (1962). *The Death and Life of Great American Cities*. Jonathan Cape.
38 Woolf, V. (2017). The London Scene: The Essays. Musaicum Books. Germany.
39 Woolf, V. (2004, August 11). Portrait of a Londoner. *The Guardian*. https://www.theguardian.com/books/2004/aug/11/virginiawoolf
40 *Mrs Delgado, Mike Bartlett's timely drama about playing by the rules during lockdown, tours to Bath's Ustinov Studio - Visit West*. (2022, January 17). https://www.visitwest.co.uk/news/read/2022/01/mrs-delgado-mike-bartletts-timely-drama-about-playing-by-the-rules-during-lockdown-tours-to-baths-ustinov-studio-b2086
41 Ehrenreich, B. (2007). *Dancing in the Streets: A History of Collective Joy*. Granta Books. p. 17.
42 Murray, C. S. (2000). *Boogie Man: The Adventures of John Lee Hooker in the American Twentieth Century*. Penguin. p. 8.
43 *Art & Wellbeing*. https://ysp.org.uk/learning/artandwellbeing
44 Wu, D., Shen, C., Wang, E., Hou, Y., & Yang, J. (2019). Impact of the Perceived Authenticity of Heritage Sites on Subjective Well-Being: A Study of the Mediating Role of Place Attachment and Satisfaction. *Sustainability, 11*(21), 6148. https://doi.org/10.3390/su11216148
45 *Éist*. (n.d.). Éist. https://www.eistworks.org
46 Benetua, L., Simon, N., Thompson, R., & Mossey, M. (2020, February 6). *A Framework for Action in Response to Moments of Outrage & Crisis*. OF/BY/FOR ALL. https://www.ofbyforall.org/updates-feed/2020/6/2/taking-action-or-not-in-moments-of-national-outrage

7 Be Active

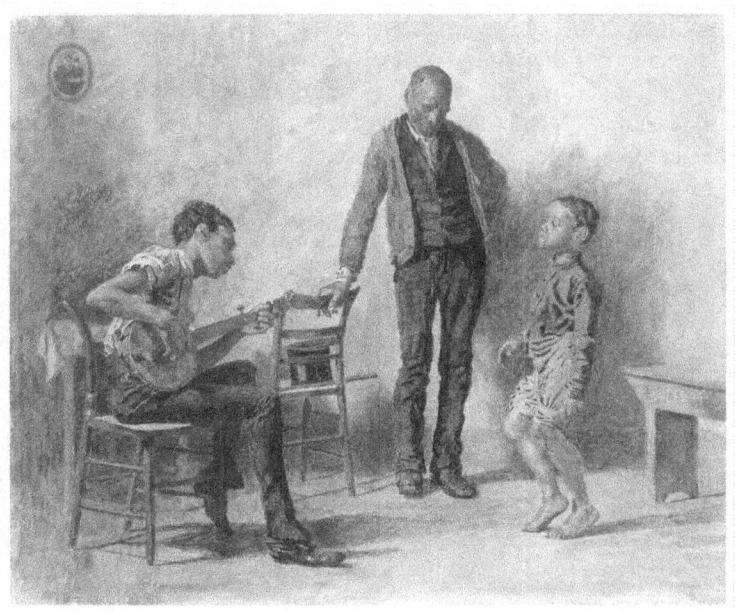

Figure 7.1 The Dancing Lesson, 1878, Thomas Eakins (American, Philadelphia, Pennsylvania, 1844–1916). Watercolour on off-white wove paper. Dimensions: 18 1/16 x 22 9/16 in. (45.9 x 57.3 cm). Metropolitan Museum of Art. Open access/public domain.

Be Active is a command to remind us that well-being consists of actions and activities. This is particularly important in intangible cultural moments such as listening and reacting to music. In *The Dancing Lesson* (1878) by Thomas Eakins, three male figures listen and respond to the sound of a banjo playing. They are in a bright interior with a few chairs, a bench and a table. On the wall is a framed photograph of Abraham Lincoln with his son Tad. The figures are two black men and a black boy, with dark skin and dark hair, the

DOI: 10.4324/9781003163480-7

older man is balding. The banjo player is seated on the left side of the image. Centrally and slightly to the right is an older man standing against the back wall, tapping his foot, and further to the right in the foreground is a younger boy standing turned towards the banjo player and dancing. The photograph of Lincoln and Tad indicates that this was painted after Emancipation and may suggest that these three black figures are from a family, representing three generations. All three figures are focused on their task, the banjo player's head tilts down so his ear is close to the banjo, the older man's head is tilted in the direction of the banjo whilst his eyes are focused on the boy dancing. The boy is attentive, on the balls of his feet and he appears to be moving gently with the music.

The interior is bright, and the image is active. The figures create a pyramid or triangle shape, the banjo player and small boy anchor the sides and the man standing in the centre holds up the pinnacle. They are listening and feeling the sound of the banjo music. The overall feeling of the painting is of warmth—of familial warmth and the warmth of the space. The red cardigan on the older man is a real focal point of the image, it is a strong colour when the other colours in the image are more muted, and it adds to the overall feeling of warmth that permeates the painting.

This watercolour painting is by Thomas Eakins, a Philadelphia realist painter who was active from the 1870s until the 1910s. He painted hundreds of portraits of Philadelphians and many scenes with numerous figures involved in an activity either outdoors in bright light or indoors like one of his most famous paintings: *The Gross Clinic* (1875). His interest in anatomy includes studies of doctors and surgeries and studies of the human form in motion like *The Dancing Lesson*. Preservation concerns about this artefact would be the fugitive nature of watercolours, they are applied thinly, and the pigments can be made of materials that could fade or discolour when exposed to light, fluctuations in humidity, pollutants in the air or could even change in total darkness. The other preservation concern is that of the intangible properties of the experience of this artefact. Preservation of tangible artefacts relies on storage, and preservation of intangible artefacts relies on the preservation of knowledge and experience. In the painting the banjo is representative of the intangible element, as the audience for this painting would have been familiar with the sound of a banjo playing. To understand the experience of this painting the sound of a banjo playing could be seen as an element that would need to be experienced.

In 1780 the Pennsylvania General Assembly passed the Gradual Abolition Act which established that children born to slave mothers would become free as adults in Pennsylvania. This meant that by 1810 almost 97 percent of the black population in Pennsylvania were free blacks and that by 1860 no slaves were listed as residents of Pennsylvania[1]. The Emancipation Proclamation on January 1, 1863 declared an end to slavery in the United States, and the proclamation was universally applied by the ratification of the 13th Amendment on December 6, 1865. *The Dancing Lesson* (1878) includes a famous photograph of Abraham

Lincoln and his son Tad, which sets the time and place as after Emancipation. The painting demonstrates the liberation that music and emancipation bring together, and by showing three generations it gives a sense of the possibility of turning and being in the light of liberation through the active expression of culture.

Dance and liberation

We've danced together and apart in many museums. Christmas parties were of course in the atrium and we danced the electric slide at one institution as was their tradition. One of our colleagues studied African, Caribbean and African-American dance. She introduced us to Haitian dance traditions including the taking on of different characters during dance. As a dancer plays the character of the dead during some dances, this character is liberated from the anxieties of life, they drink and smoke and party unconcerned about the consequences. The pleasures of living as experienced by the dead is another way of releasing the ones we've lost to an eternity that could be better than the world we currently experience. Liberation expressed with music and through dance gives the sensation of leaving this mortal world through rhythm and melody as translated in the body is a powerful form of intangible culture.[2]

In this painting and more widely there are activities to be participated in. Viewing is active, dance is active, painting is active, playing music is active and liberation is active. How do museums tie personal and collective liberation together through culture? The active nature of liberation can move through a cultural lens. Revolutionaries have embraced dance as a liberation from oppression, including Emma Goldman who said, "I want freedom, the right to self-expression, everybody's right to beautiful, radiant things."[3]

Space

Being active in a museum re-interprets the purpose and use of the museum space. Movement through or in a space is ultimately about movement and allows the space to become a different landscape and be interpreted for the purpose of movement. What makes a space vibrant is the diversity of use and the potential for those in the space to support each other when needed.[4] Being active requires going into and getting out of ourselves, interacting with our surroundings and that includes the museum architecture, collection, and other people in the museum space.

Being active is for some a new (form of) religion, alongside the secularisation of physical activities like yoga and tai chi, singing and chanting which historically took place in places of worship and now takes place in secular locations such as museums[5]. For museum practitioners they further offer the opportunity for a routine, or festival, of practises, intensive or sustained. Being active requires accountability to create habits and it is the habit of

activity that will lead to better well-being. Focused activity can provide a release from some of the overstimulation of daily life and a museum space which may already have curated the mental inputs can be an ideal space for that release.

Museum conservators are concerned about vibrations on artefacts as part of controlling the museum environment in the continual pursuit of lessening damage or deterioration of the museum collection. There are risks from vibrations because of building construction, seismic activity or visitor movement. All of these can lead to damage and they can be addressed through different modifications of the display and storage. This is why activities that are low impact on the body are also low impact for the museum collection. Even circulating a museum could lead to damages:

> Ambient vibration levels from visitor circulation on wooden floors approach the damage levels identified and could pose a risk in some instances. Knowledge of the damage levels, combined with vibration-absorbing mounting systems and sympathetic design, can allow even particularly vulnerable material to be safely displayed.[6]

Before a programme of activities is begun, a risk assessment for the space and for the participants will allow damages to the collection or the participants to be mitigated.

Active viewing

We have considered a type of viewing in museums that we have called *active viewing* of an artwork that could be one of the first ways of being active in a museum. Active viewing involves moving yourself around the artwork, looking at it from very different angles and lights, returning to the artwork to see again if there is something you've missed or gained in the time not viewing it. It can also include looking at one work and then choosing others to examine and then returning to the first to see how your viewing has changed. Examine an artwork with consideration as to colour, shape, material and technique and then examination of other artworks that are similar to the first in these ways, then return having seen and re-seeing. In *The Dancing Lesson* by Eakins active viewing considers the activity of painting brushstrokes, the activity of movement in the image and mirroring that activity in the museum space, and perhaps the activity inspired by the painting, how seeing and feeling and moving are all connected.[7]

Activity will include the mind as well as the body and is linked to Taking Notice, as the mind is trained at the same time as the body. Active viewing is the beginning of Keep Learning as the viewer dives deeper into understanding what they see and then layering this experience with other chances to see more examples then returning to the first artwork and seeing differently. Art historian T. J. Clark encourages this type of active viewing and returning to an artwork multiple times to determine how your personal narrative engages with the artwork in

physical space.[8] Clark notes that the light will be different every time he views an artwork, and that he will be different every time, and in noticing this change in himself he will feel drawn to different areas of the artwork.

Roland Barthes considers an active way of viewing photographs in his book *Camera Lucida*. He refers to the overall interest without special focus as *studium*, a Latin word related in English "to study."[9] Studium is a general feeling about a photograph, one can like or dislike a photograph with studium, in this way it is an inert material upon which to gaze. There is in some photographs a studium which has been disturbed by *punctum*, another Latin word that means "to pierce or sting."[10] Punctum cannot be explained to another person, it is a unique puncture of an individual, explaining it would mean changing it to studium as it is something that cannot be put into words. Studium is the functionality of the photograph and from viewing it perhaps the intention of the camera operator can be determined. Both studium and punctum are present in a collection and an experience of active viewing could include a series of gestures or physical movements that correlate to the viewer's experience of studium and punctum.

Barthes died before *Camera Lucida* was published; it is up to the reader to determine if a collection can have studium and punctum applied to materials other than photography. I believe it is, I believe a sculpture or artefact can have the same piercing effect upon me that I have felt when viewing a photograph. Artists and artworks are often concerned with creating an unsettled environment, with knocking or waking up a viewer. Artefacts as well, connect us to a past that has long gone but remnants or fragments of it are contained in our lives. The material world is a complicated one, and taking time to physically be in it will be a physical as well as mental exercise.

Performance art

It is through movement that change happens in a person's mental, physical and emotional states. The intersection of the body and the museum has a long history and includes performance art as a way of re-examining movement and the body in a space. Performance art was first described by the Dadaists, as an anti-art movement, anti-literary and anti-poetry. They sought to re-define and re-evaluate the existence of art, poetry and literature and performance is a new way of experience they utilised to delineate themselves as different from other movements that incorporated art, literature and poetry. Performance art is site and time specific, and must be created and re-created, and invited into spaces. The museum can encourage performance as new ways of actively engaging in museum spaces.

Measuring activity

Physical activity is one of the most measured activities in all of the Five Ways of Well-being. Recent trends in measuring physical activity which we participated

in began with 10,000 steps. It was impossible to get away from step counting apps and Fitbit watches that promised once 10,000 steps were reached we were healthier for that amount of movement. It was a good idea because a majority of people no matter how fit they were or where they lived, could set the goal and accomplish walking 10,000 steps, which is around five miles, each day. It is also one of those lifestyle changes that include taking the stairs instead of an escalator that leads to better habits and better health. This was a good time in health and fitness, sharing your number of steps with friends, workplaces doing programs, it felt like almost everyone could participate, and many people did. I could reach 10,000 steps walking aerobically outside, or slowly puttering around the house.

Then, perhaps our competitive nature set in and started to optimise. While companies structured business models around constant growth and constant quarterly returns, exercise as well saw the opportunity to hack your workout.[11] So, if 10,000 steps were good, then aerobic exercise was better, and the metric of measurement became *active minutes*. Active minutes meant that all steps were not equal, and only steps taken as part of aerobic exercise (exercising at 70–80 percent of your maximum heart rate) counted. It was another way to measure something, and it relied on time during which we weren't really doing anything else. Taking 10,000 steps is almost two hours of moving, but then workouts became 15 minutes, then 7 minutes.[12] Perhaps exercise will find another metric, and if it is focused on the idea that any movement is better than no movement, hopefully it will. It would be ideal if a museum metric could be how many artefacts were seen, or how many rooms, or how many moments of studium or punctum were experienced, if any at all.

Time in general has changed dramatically during the COVID-19 pandemic. For months millions of us were in lockdowns around the world, either because of requirements from a government or self-imposed. Time moved slowly and quickly at once. We remember the clock tower in the village where we lived stopped, the metaphor was not lost on us, it hasn't yet started again, and the village has been at either noon or midnight for over two years now. Has the measure of time become too rigid, compartmentalising only had a few minutes for enjoyable activities and then over-scheduled less-enjoyable activities. I had an anxious way of fretting about being late for anything, in a way I wonder if this is why it was easier to log into social media than it was to go out and actually meet people face-to-face. Maybe a consideration of how programming in museums is delivered and whether the participants can drop in any time could be more appealing, or whether an individual is comforted by knowing that they will enjoy going but will only be committing for a set amount of time. In many ways, our anxieties have been amplified by the COVID-19 pandemic and perhaps experimenting with programming to encourage fewer visitors over a longer period of time will improve the overall visitors' experience and well-being.

Walking

Perhaps most simply walking in museums, and walking in general, is one popular way of being active. Museums have a wonderful way of stopping time for visitors and allowing them to wander. All of the clocks in paintings and photographs are frozen, so time has stopped for those depicted in these images as well. The outside world is limited in the amount of sunlight and windows which is beneficial for lowering light levels for the collection, as well as allowing a visitor to lose track of time whilst in the galleries. Artefacts speak without language and have a power they exercise without words. Artefacts are grouped together to create a narrative that takes the viewer on a journey with them.

Uncertainty about time in a museum is purposeful, as it allows us to consider the uncertainty in the collection we walk through, in the same way a walk in a landscape will be uncertain because the landscape is in a constant state of change. A museum presents an uncertain environment and also manages to maintain an environment that changes very little, depending on how ambitious that museum's exhibition schedule. In Rebecca Solnit's book *Wanderlust*, considered how walking could be interpreted, "Thinking is generally thought of as doing nothing in a production-oriented culture, and doing nothing is hard to do. It's best done by disguising it as doing something, and the something closest to doing nothing is walking."[13] There are tangible benefits to walking through a gallery, especially if you count steps or seek to exercise yourself by standing and walking. However, it is perhaps the intangible benefit of having time to exercise your mind, by thinking which could be a more valuable part of your activity.

Many contemporary artists reference or utilise walking in their work. Richard Long has explored walking and it was through walking that he reconnected art with living.[14] The art he produces could be a sculpture, photograph, map or text, and the walk he references could traverse a precise landscape or be a universal experience of walking. More recently, and especially during lockdown, when walking was one of the few forms of exercise permitted, artists and creators experimented with new ways of experiencing walking. For example:

> A sound walk, or walking piece, is any walk that focuses on listening to the environment, with or without the use of technology, or adds to the experience through the use of sound or voice. This can include a scripted or choreographed score or work that has additional audio elements.[15]

It is notable that many sound walks include cultural history of the walk as the defining factor for place at the intersection of sound–place–technology. Current mobile technology that allows for sound to be played back at specific points dovetails with the experience of visual sensations in a museum on a sound walk. The potential for sound walks to improve active experiences in museums while learning about the collection could be explored further.

Fatigue and the body post-COVID-19

In our experience of post-COVID-19 fatigue, building up our stamina requires a careful and measured approach. It was not possible to push to a place outside where we were comfortable. We needed to be able to carry on a conversation throughout whatever activity we were participating in. If we tried more high intensity, it would exhaust us easily and we would need days or weeks to recover. There are numerous suggestions for high intensity training as the best way to begin to recover from periods of inactivity, but as we discovered, bodies that have experienced COVID-19 are not the bodies that advice is meant to address.

Museums are where the body is on display, the bodies displayed there are from a limited segment of the population and are not representative of the population. These idealised bodies can lead to an idealised way of being an active person. The idealised male or female body displayed in a museum is frequently young, thin, white, able-bodied and cis-gendered. Therefore many in the population will be unable to identify themselves with these bodies. Including more varied representation of the body[16] in the museum collection will be important to encourage and support more members of the population to see themselves in that space.

Within a museum setting Be Active as a Way of Well-being is often combined with others then it becomes more about practice and less about competitive physical accomplishments. In this way being active in a museum allows the space to unlearn, or question, some ideas about what activity is and who participates in it. This is why gentle yoga or walking is popular as these activities will not cause significant vibrations in the gallery spaces, they can be practised by many people at different levels of fitness, and they can be practised at a safe distance from artworks.

Yoga

Colonialism is and continues to be a factor in how museums gain and maintain a collection. It is possible to re-contextualize a collection through interactions with activities such as yoga. It is also possible to continue practises of de-contextualization and exclusive access through yoga as well. In these cases intention, impact and transparency matter. Studies of the body in colonial times that included gymnastics went on to influence transnational anglophone yoga.[17] Transnational anglophone yoga is therefore a direct consequence of colonialism, and the failure to recognize this history can lead to a cultural appropriation or culturally inappropriate practice. Yoga instructors like Jessamyn Stanley explore yoga from an intersectional and body positive perspective, challenging the ideas around the power of the instructor in the practice.[18]

In seeking insight into how our yoga practice could be better informed, we found a book with a chapter by Harish Trivedi which included this passage:

Some of the more radically deconstructive strands of postcolonial discourse appear to institute a kind of ex post facto discursive parity between the colonizer and the colonized, the ruler and the ruled, the centre and the periphery, and indeed between and similar "binary," purportedly because of the inherent ambivalence of all experience, representation and meaning-making... Inequality, however, has been a constant fact of human history, and of colonial history in particular, and no amount of ready political correctness can, or should be allowed to, erase it or write it off the record.[19]

This beautifully written paragraph has deeply informed our yoga practice. The continued, sustained process of recognition of inequality and remedy for it in any way we can is a part of our current yoga practice.

Expectations

For a program that has a focus on being active, an element of the program will be about unlearning or questioning the expectations that surround any form of activity or exercise. Expectations have two facets—they can involve magical thinking whereby an individual believes that thinking of something is all they need to do to make it happen. This is often demonstrated by children who can believe their thoughts create their entire reality. This is also the premise behind "the law of attraction" which states that if you expect something to happen, it will.[20] In being active, I could expect my body to drastically change into some sort of ideal, but that expectation is more likely to turn into resentment than become a reality. Expectations are crucial to well-being, and economists have postulated that *"well-being = reality minus expectations."*[21] This equation could go on to explain why unequal societies are ones in which there is reduced well-being across the entire population.[22]

Personally, expectations are key in living with a mental disorder. If the expectation is to not have a mental disorder, well-being will be very low. However, if I expect anxiety or depression and expect them in the way I would expect a visit from a friend, I can then go out to meet them whilst they are on their way instead of hiding from them, and in realising or meeting this expectation I will be in a better place to manage it. The conflict becomes when my expectation is of an ordered experience of this life that I have with a mental disorder, that will never be realised. Museums are involved in celebrating the divine disorder that is present in art and artefacts and how that can lead us to accept the disorders in our minds and in our world.[23]

Risks for physical activities

Risk assessments are important for conducting physical activities in any space. All instructors will need to carry insurance and have some qualification or relevant experience. Before an activity, all participants will need to fill out

a participant questionnaire (PAR-Q), which will seek to identify any underlying physical limitations that the participant may have, which will allow the instructor to determine what is an appropriate level of activity for that group. The PAR-Q can also identify what the participant hopes to gain from the activity, in some cases, if the overall goal is not improved physical fitness but instead a desire to relax, the instructor could entirely modify the class to focus on relaxation. The PAR-Q is valid for 12 months and then a re-assessment of all participants should take place.[24] As well as risk assessments for the participants, it is necessary to have a risk assessment for the museum space and the artefacts within it and that risk assessment includes input from the instructor and is known by the participants.

Preservation and access as activities

Preservation generally means keeping something in as close to the authentic experience, for as long as possible. Almost every museum will have a mention of preservation in their mission statement. Access includes the physical or virtual visitor and the access to information about the artefact. This is why it has been important for museums to publish their collections in books or online, and why so many artefacts are available in the public domain so people like us can research them and write a book that includes reproductions of them. Access is also usually implied or directly mentioned in the mission of a museum.

Preservation and physical access can be synchronous or diametrically opposed in how they are achieved. While display allows for more physical visitors to access a collection, damage caused by display will mean that future physical visitors cannot access the same collection. However, since collections can also be damaged or deteriorate in storage, there is not a guarantee that forbidding access is going to be better for long-term preservation. There is also a difference between the artefact and the information in the artefact, and allowing access to one can restrict access to the other.

Preservation and access are actions, active, activities. There is a myth that dusty storerooms exist filled with artefacts in pristine condition that have not seen a human hand in millennia. Academic conservators can refer to this as "benign neglect," and for a small number of artefacts it could be true. But, in my experience collections have people who know them, people who are part of the biographies of the collection, and preservation or access activities initiated by those people will ultimately be the reason these collections are still around.

Notes

1 Berlin, I. (2003). *Generations of Captivity: A History of African-American Slaves.* Harvard University Press, United Kingdom.
2 Ehrenreich, B. (2007). *Dancing in the Streets: A History of Collective Joy.* Granta Books.

3 Shulman, A. K. (1991). Dances with Feminists. *Women's Review of Books, IX*(3). https://www.lib.berkeley.edu/goldman/Features/danceswithfeminists.html
4 Jacobs, J. (1962). *The Death and Life of Great American Cities.* Jonathan Cape.
5 Singing Museums to Life: Improvised Opera, Audiences and Collections. (2018, January 10). *Museum-ID.* https://museum-id.com/singing-museums-life-using-improvised-opera-engage-audiences-collections/
6 *Vibration Damage Levels for Museum Objects.* (2002). 13th triennial meeting, Rio de Janeiro, 22–27 September 2002 / ICOM Committee for Conservation: preprints, London. https://www.icom-cc-publications-online.org/2198/Vibration-Damage-Levels-for-museum-objects
7 Westover, A. (2014, August 27). *Art for the Whole Body.* Getty Iris. https://blogs.getty.edu/iris/art-for-the-whole-body/
8 T. J. Clark on Poussin. (27 June 2016). https://soundcloud.com/the-getty/tj-clark-on-poussin-and-the-sight-of-death
9 Barthes, R., & Howard, R. (2020). *Camera lucida: reflections on photography.* p. 32.
10 Ibid., p. 33.
11 Headlee, C. (2020). *Do Nothing: Break Away from Overworking, Overdoing and Underliving.* p. 81.
12 Parker-Pope, T. (22 January 2021). The Standing 7-Minute Workout. *The New York Times.* https://www.nytimes.com/video/well/100000007527127/standing-7-min-workout.html
13 Solnit, R. (2007). *Wanderlust: A History of Walking* (New ed.). Verso Books. p. 5.
14 Long, R., Waldman, D., & Fuchs, R. (1986). *Richard Long.* Solomon R. Guggenheim Museum. United Kingdom.
15 *Walk · listen · create.* (n.d.). https://walklistencreate.org/
16 See Marc Quinn in the previous chapter Connect.
17 Hauser, B. (2013). *Yoga Traveling: Bodily Practice in Transcultural Perspective.* Springer International Publishing. Germany. p. 38.
18 Stanley, J. (2021). *Yoke: My Yoga of Self-Acceptance.* Workman Publishing Company.
19 Fraser, R. (2008). *Books Without Borders, Volume 2: Perspectives from South Asia.* Palgrave Macmillan UK. United Kingdom. p. 12.
20 Johnson, J. A. (2018, February 17). *The Psychology of Expectations | Psychology Today United Kingdom.* https://www.psychologytoday.com/gb/blog/cui-bono/201802/the-psychology-expectations
21 Malleret, T. (2021, July 27). *Happiness and Subjective Wellbeing Are All about Expectations.* Global Wellness Institute. https://globalwellnessinstitute.org/global-wellness-institute-blog/2021/07/27/happiness-and-subjective-wellbeing-are-all-about-expectations/
22 Wilkinson, R. G., & Pickett, K. (2019). *The Inner Level: How More Equal Societies Reduce Stress, Restore Sanity and Improve Everyone's Well-being.* Penguin Books, Random House.
23 *NCPTT | Divine Disorder.* (n.d.). https://www.ncptt.nps.gov/blog/tag/divine-disorder/
24 Bredin, S.S., Gledhill, N., Jamnik, V.K., Warburton, D.E. PAR-Q+ and ePARmed-X+: New Risk Stratification and Physical Activity Clearance Strategy for Physicians and Patients Alike. *Can Fam Physician, 59*(3): 273–277.

8 Keep Learning

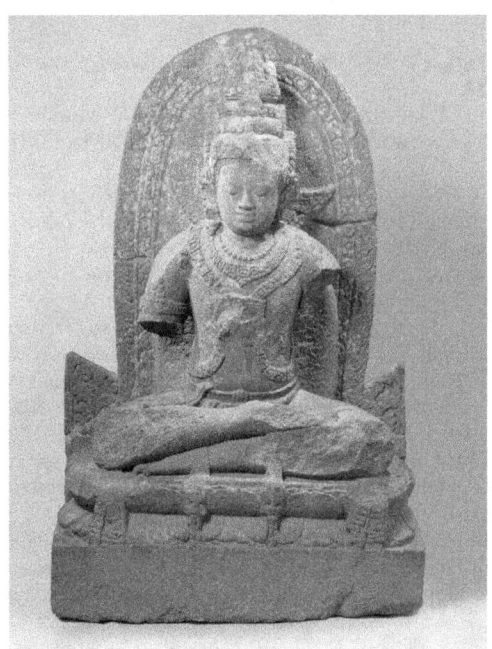

Figure 8.1 The Bodhisattva Mañjuśrī, c. 800 – c. 900, Candi Plaosan. Object number AK-MAK-240. Measurements height 138 cm × width 90 cm × depth 60 cm × weight 663 kg. Rijksmuseum. Copyright public domain.

This *Mañjuśrī* (circa 800–900) is a stone sculpture of a seated male figure, with legs crossed and stacked in front of him, and behind him is a decorated area that comes to a point like a leaf or petal. His head has a crown, he wears many necklaces and his arms have arm bands. His eyes are half-closed and his earlobes are elongated to indicate that he is an enlightened follower of the Buddha, a master who has fully trained his mind, a bodhisattva.

The sculpture has been removed from its original context and is missing some elements. The arms are missing on the proper right side below the shoulder and

DOI: 10.4324/9781003163480-8

on the proper left side above the elbow. His legs are weathered and missing the knees and his right foot. The head has a loss at the front on his left side in the hair and headpiece. The stone is volcanic andesite and shows signs of a history that probably included time spent outdoors, there are white accretions or discolourations on the surface that likely occurred whilst the sculpture was outdoors for a long period of time.

Andesite is a volcanic blueish/grey stone. It is found frequently in volcanic areas and commonly mined in the world of Minecraft[1] where it can be used as a decorative stone for building.[2] The name andesite was derived from the Andes mountains in South America where the meeting of the Pacific and North American plates creates andesite volcanoes. Andesite commonly forms at a subduction plate zone when an oceanic plate melts then the magma from the melted plate is released as volcanic magma and upon solidifying into rock becomes either andesite or diorite. Diorite has larger crystal inclusions and is formed from magma that cools slowly whilst andesite has smaller crystal inclusions and is formed from magma that cools quickly, from an eruption. There is a line of andesite observed along the Pacific Plate from as early as 1911, and this geologic information can now be used to identify the boundaries of the earth's plates.

The figure of Mañjuśrī is the bodhisattva of wisdom and insight, key aspects of learning. Buddhism is usually divided into schools of thought, determined by their approaches to training the mind and learning. Mañjuśrī was first referred to in the Mahayana sūtras such as the Prajñāpāramitā sūtras, symbolising embodiment of *prajñā* (wisdom or knowledge) and pāramitā (perfection). In Vajrayāna Buddhism, Mañjuśrī is regarded as a yidam (meditation deity) and a fully enlightened Buddha. Today there are numerous schools of Buddhism in Indonesia; the earliest schools were associated with Vajrayāna Buddhism, which is likely when this sculpture was created.

Today the predominant schools of Buddhism in Indonesia are Theravāda and Mahayana, drawing their influence from Sri Lanka/Thailand and China, respectively. The earliest Indonesian school was probably Vajrayāna Buddhism, which co-existed and borrowed from Hinduism until the decline of the Majapahit empire in the late 15th century. By the end of the 16th century, the archipelago had converted entirely to Islam and that remained the case for the next hundred years. Buddhist and Hindu temples remained intact but ceased to be used. Chinese settlers brought Mahayana Buddhism in the 17th century, building temples and re-introducing Buddhist practice to Indonesia. Sculptors decorated and adorned the temples' various galleries before everything was covered with paint and stucco. In Hindu tradition, Mañjuśrī has been depicted as a manifestation of Shiva. Shiva is one the oldest gods and is the god of destruction, transformation and regeneration.[3] Shiva can be represented as a human, animal or abstraction and with a facet of his being like the lord of the yogis, where he is represented as an ascetic, or like the lord of destruction, where he is represented as a terrifying being.[4]

Mañjuśrī was portrayed as a youthful handsome man with the palm of his hands tattooed with the image of a flower. His right hand would be facing down with an open palm while his left-hand held a blue lotus. The lotus portrays the blossoming of wisdom. He also wears numerous necklaces including one made of tiger teeth. In other depictions of the Mañjuśrī he holds a flaming sword in his right hand to cut down ignorance and the ego in the search for knowledge and wisdom. This is an active representation of learning and the search for knowledge and wisdom and to train the mind.

Today, a seated figure meditating has become the standardised depiction of the Buddha. Early depictions of the Buddha were of feet, a wheel or an empty cart. The development of portrayals with an individual figure emphasises individuality, and the practice of grouping many of these figures together in caves or temples emphasises community. There is discussion around Western and Eastern art and who was the first to portray the human figure. It is commonly accepted that Greek sculptors invented sculpture in the round, meaning a figure you could walk around completely. However, an argument could be made that these depictions from Eastern cultures are the earliest form of figurative sculpture and Greek sculptors were copying them, and riffing on what they made. This compounds by further study during the Enlightenment which sought to create a canon that only considered Greek sculpture as worthy of study. These narratives continue today lending support to those in power and consolidating power in specific cultural norms.

Interpretation and re-interpretation

The third way to well-being is Keep Learning. A key word here is *Keep* Learning, which indicates a continuity, in much the same way we learn about ourselves, we can always discover something new or different. Learning for well-being would involve the higher levels of Bloom's Taxonomy: create, evaluate, analyse and apply.[5] It would also be collaborative learning so that accomplishments will be realised by a group instead of individually. In this regard it may be informal, and this type of learning must take into account people who have had experiences at school that were overwhelming negative and reinforced their powerlessness in institutions.[6]

Creating and passing on knowledge is a fundamental role of the museum. Such knowledge creation, generation and distribution is a form of mental stimulation that is central to the mission of the museum, and positively impacts on the lives of researchers, staff, volunteers and visitors alike. Museums have had Education/Learning Departments focused on learning to support school curriculum or with the goal of enrichment. However, learning for well-being would have to appear different to traditional learning curriculum because those who are accessing the service are not often coming for a traditional learning experience.

Well-being programming could encompass learning as an outcome, and conversely all forms of learning that take place in the museum, within and

beyond learning departments, could re-orientate their approaches to explicitly pursue well-being outcomes. The main emphasis is learning through experience and exploration. This includes training the mind to be more curious, or training the mind to be more present, things that do not have a tangible goal, and one can return to them time and time again to continue to learn.

Therapeutic learning

Art therapy can be divided into two strands: art as therapy and art in therapy. It can be a type of psychotherapy that communicates through art media and practice, involving both the process and products of image making.[7] Through the sustained practice of making and creating individuals can contain feelings in a tangible form, in the same way that journaling benefits individuals through having space to express feelings through language. Creating art and reflecting on art products and processes can increase awareness of self and others and let people better cope with symptoms.[8] This establishes a focus and allows for development in ways that talking therapy does not, and for learning about ourselves through the language of imagery.

In art therapy the exploration and representation of intense emotional states can be observed and discussed while being removed from those intense emotional states. This could relate to art that depicts different emotional or mental ideas like the conscious and unconscious, dreaming, fantasy, play, religious or spiritual ideas.[9] This could also include art made by artists who explored neurodiversity either through their own experience or through their experience in art-making.

For art to be produced as part of art therapy in group work, there should be opportunities for sharing. The sense of self should not be overwhelmed by input from others. Awareness can be brought to the interaction of the self with others. Therapy could be long term over years or short term over one to twelve sessions or more. The process could include moving from isolation to relation, and there are many themes that can be explored in a group setting. Ideally, art therapy in a museum could be accessible to a variety of individuals with mental disorders or without. A variety of exercises could include: examining a collection item and then trying to imagine what occurred before or after the image or object was created, or looking at a detailed image and completing it by exploring what could be at the end of a path, or around a corner or just outside of the frame.[10] There are larger group projects like collaboration in creating a sculpture, a mandala, collage or mural. Sessions can include a warm-up art process, creating art inspired by the surroundings, and modifying the environment through listening to music, or creating sensory experiences like smelling a scent.[11] So many of these activities are about seeing potential or seeing differently which improves our imagination and builds our resilience.

The German psychiatrist Hans Prinzhorn explored how art could be a release for urges that have no other outlet. These urges include "the urge to express, the urge to play, the urge to ornament, the tendency to order, the

urge to imitate and the need for symbols."[12] Prinzhorn chose to write about the merits of the art of the mentally ill, even identifying ten schizophrenic masters of art and collecting thousands of artworks created by hundreds of patients at the Heidelberg Psychiatric Clinic. By choosing to write from an artistic and not a medical perspective, he re-evaluated this form of art in a positive way. Painting and art-making have continued to be a part of patient treatment, and in Germany today almost all clinics offer art therapy in addition to psychotherapy and medication.[13]

Making art is similar to bringing attention to the breath in meditation, it connects the conscious and unconscious mind. "Breathing is a nonconceptual process, a thing that can be experienced directly without a need for thought."[14] The ideas that Prinzhorn presented in his book were influential on psychology in the 20th century and beyond. Sigmund Freud, who of course had a famous collection of antiquities,[15] believed the free association involved in art making allowed for accidental marks interpreted by the conscious mind could give insight to the unconscious. Carl Jung felt that art making was an important path to psychological awareness.[16]

Pioneering art therapist Irene Champernowne was the founder of the Withymead therapeutic community in Devon, an experimental community where patients, artists and therapists lived together starting in 1942. This was a precursor to the many therapeutic communities established during the years of the counter culture. In contrast to later communities founded on LSD and primal screaming, the Withymead community focused specifically on art therapy and included pottery, painting, music and movement.[17] The centre also offered spaces to local students, especially after the bombing of Exeter when many people were re-located outside of the city. Champernowne said:

> It may here be emphasized that we recognise no dividing line between patients and students. [Students] recognize in art expression a valuable means of integrating the inner conflicts which are common to all. The same may be said also of many who have resided at Withymead and whose lives are outwardly seemingly so well-adjusted as to make the word "patient" an unsuitable designation.[18]

Her approach saw the humanity in people through the process of creating artwork. Further remarks around that time noted that the role of the instructor was to "stimulate, receive and not to teach or analyse, but to observe" and how different that is to the role of a teacher traditionally.[19] It was a great example of how "patients" learned about themselves but also how "therapists" did as well.

Psychology keeps learning

One of the realisations when we consider the keep in Keep Learning is that it is not just individuals who continue to learn, but institutions and society as a whole. Ideas change over time. There were some theories presented in art

therapy at the beginning of the 20th century that have subsequently been thoroughly disproven. However, as these theories have been influential on our understanding of art, so they need to be discussed. Cesare Lombroso, who is responsible for the belief that biological determinism means a person born left-handed will become a criminal, wrote *The Man of Genius* in 1889, where he claims that artistic genius is closely related to inherited madness.[20] This theory persists in the study of art, and there are artists who behave in ways that placed them outside of society, but this theory ultimately creates an othering of all art, it allows the viewer to disengage from the artwork or claim not to "understand" it. The tortured artist who struggles with mental instability is also an archetype that exists today and is damaging to the mental well-being of aspiring artists. Moreover, it is also damaging to viewers of artworks as it allows them to dismiss what they are seeing or feeling.

Another outdated theory was that visual images could be used as a depiction of psychopathy; claiming a diagnosis could be made from the examination of artworks produced by the mentally well or ill.[21] Based on earlier, now disproven theories, the Rorschach Test developed in 1921 was meant to be a diagnostic test for schizophrenia. Rorschach died the year after publication and the method was later developed to provide data about cognition and personality. During the test, a psychologist shows 10 standard cards with inkblots on them to a person and asks the person to describe what they see.[22] The content of the image, however, is not the most important interpretation of the test, but it offers a chance for a psychologist to converse with the person being tested and to further examine their personality through how they take notice of the world. This test is still used by psychologists in the USA and in Japan, but it is not popular in the UK.

In the 1960s a critique of psychiatry called anti-psychiatry moved in two directions. One was outwards, encouraging social action as a means of engagement with a society which may have contributed to mental disorders and through this engagement gaining more control over an individual's mental well-being. The other direction was inwards, having psychological experiences to raise consciousness, expand, alter or transform yourself as an individual. Part of this criticism was the realisation that psychiatric diagnosis is culturally biased and potentially harmful to members of certain religious and ethnic groups.[23] This is similar to the understanding of the intersectionality of oppression, and has been further examined through the power dynamics of early asylums, for example, why the doctors were predominantly men and the patients were predominantly women. Women who acted outside of the incredibly narrow social norms were placed in these asylums "in which the goal was of course less to cure but 'to correct.'"[24]

Self-care is community care

Audre Lorde wrote about self-care: "Caring for myself is not self-indulgence, it is self-preservation, and that is an act of political warfare."[25] However,

despite this radical edge, self-care has become more and more marketed through products which can remove the connection to a community that is involved in self-care. It is not necessarily taking a bubble bath. Seeking pleasure whilst avoiding pain is not possible nor is it taking care of yourself. The lessening of the suffering of other sentient beings, to borrow a phrase from Buddhism, is self-care and this could mean that you suffer or feel pain through this process.

> Tonglen practice, also known as "taking and sending," reverses our usual logic of avoiding suffering and seeking pleasure. In tonglen practice, we visualize taking in the pain of others with every in-breath and sending out whatever will benefit them on the out-breath.[26]

This also relates to the focus that we must make on the process instead of the results of self-care. It is not something that can be achieved but is something that we will continue to strive for in every moment. This is something we must keep learning to do, in these habits we create a practice whereby caring for ourselves is caring for all.

Museums keep learning

A most interesting way in which museums and heritage Keep Learning about themselves is shown by the Colonial Countryside report from the National Trust.[27] This report made links between the country houses and wealth in these houses and collections, and how that wealth was acquired, which included colonialism and historic slavery. The fact that there was an outcry from conservative media in the UK demonstrates that people are still uneasy with the origins of their wealth being scrutinised. Perhaps it is time to admit that behind every great fortune is a great crime, and therefore behind the facade of every great country house or folly is a darkness and criminality that is not separate from it but an integral part of it.

We visited Beckford's Tower, a folly outside of Bath (built 1826–1827) recently and agreed to participate in a visitor's survey about how the collection could be further interpreted. William Beckford who built the folly was the great-grandson of Peter Beckford, the acting governor of Jamaica in 1702, the Beckford wealth was entirely from trans-Atlantic slavery. William Beckford was newly wealthy and longed to be accepted by the aristocrats, to the point that he engaged in exploitation of himself and others as a way of proving his worth to a group of people whom he should have realised would never accept him as one of their own. During the survey and subsequent interview, I mentioned that the history of slavery and wealth in the 17th century was something that we would have expected to be explored in any re-interpretation. The interviewer informed us that this was something their visitors were not interested in learning about. I asked impetuously, "When people visit these huge estates that were built from the 1600s to the 1800s, where do they think the money came from?" In my experience, visitors do understand the

connection between wealth and exploitation, and how that connection is something that continues to this day and is not something that was resolved during the abolition of the trans-Atlantic slave trade. Museum collections frequently originate from "the mystery of unaccountable wealth."[28] Indeed, a requirement of the abolition of slavery, was that slave-owners were all compensated for the losses of their "property," whilst those who were enslaved entered a world that was set-up to continue to exploit them until the present day. Spaces built on the profits of slavery are perhaps the ideal location to learn and to allow for intercultural dialogue around the need for reparations.

The problem when the only people in charge of a narrative are from a particular race, social class or gender is that it undermines learning itself. Now we have a language that includes "un-learning" as part of the exploration of racism historically and contemporarily. The stretching of a narrative surrounding American slavery at sites like Monticello or Mount Vernon, which I visited in the 1990s, included the slave quarters as an example of the benevolence of Thomas Jefferson and George Washington, respectively. These sites presented a narrative about happy slaves living in good conditions, which showed that these historic house museums had no interest in an authentic experience of history, but were more concerned with the assumed comfort of certain visitors. Once the authority of a museum is undermined on the topic of history and racism, should the authority of a museum be trusted on anything else? It is our understanding that both of these historic house museums have since done extensive work to re-contextualize their collections to more accurately portray the experience of all of those who lived on these estates. Which again demonstrates the role of Keep Learning in well-being practice, self-care and community care.

Learning to understand

UNESCO has recently been researching how education and learning are beneficial for populations of migrants. They report that: "For those denied education, marginalization and frustration may be the result. When taught wrongly, education may distort history and lead to misunderstanding."[29] However, there are examples where education

> can bring out the best in people, and lead to stereotypes, prejudices and discrimination being discarded for critical thinking, solidarity and openness. It can offer a helping hand to those who have suffered and a springboard to those who desperately need opportunity.[30]

This is an example of how when a community keeps learning about themselves they care for that community, and in this way museums could offer a space where this learning can take place. Museums offer a location where people can be self-directed learners, active in their own education. Museums also offer a space outside the formal education system that can be for lifelong education and learning.

Learning to see

Museums are full of things to see. However, this is also one of the barriers to learning, particularly museum-based learning. While people learn more than half of what they know from visual information, it is not a subject directly taught in schools. Skills such as learning to examine and appreciate visual arts are only taught at advanced levels if at all. This leaves people and communities that have not been instructed in how to look feeling that museums are not for them. In the BBC series" Ways of Seeing", children have an almost innate gift for being able to read artworks, suggesting that the fear and reluctance adults have is learnt behaviour, conditioned also by the obscuration practised by museums.[31] This actually goes against the responsibility of every museum to research the artefacts in their collection.[32] Museums are interesting places to explore learning because they hold so many forms of documentation which can be examined to witness the progression of time. Every image or artefact is from the past, whether recent or ancient, and that tells us about ourselves today. Artists reference time through the balance in an artwork or the repetition of an artwork to show that time is cyclical, and we can see the constraints artists feel when trying to capture a moment of it.

Contemporary art

Attempts to limit possible interpretations is very common in the discussion of contemporary art. Contemporary art can come with explanations that seek to rationalise the experience of viewing it, therefore disarming the viewer by dictating how the art should be viewed.[33] In these situations artists who mean to have work viewed irrationally start to work outside the parameters of the art world and outside of language as well, by avoiding openings and interviews. Just because art can be discussed through language doesn't mean it has to. This ability for disengagement is essential to the understanding of history and society, the ability to be outside of artworks and experiences. Museums have long created safe spaces for white, middle-class, cis-gendered and able-bodied individuals, and a part of dismantling those spaces is the requirement for disengagement with the museum and the narrative it promotes as it is and bringing in a view that is both critical and outsider.

This disengagement is important in a post-COVID context. While in lockdown we lived in a type of stasis, but we still developed, whereas museums constantly seek engagement with audiences as the only means of audience development when perhaps disengagement has an equally valid place. This can be disruptive, but the audience can still be in control.

Final thoughts

The illusion that personal productivity correlates with personal well-being is a difficult thought pattern to break. In learning there has been an adoption of

technology for documentation because recording a lecture will have 100 percent of what is said recorded, typing on a laptop can have up to 80 percent, but handwriting will only record up to 50 percent.[34] Instead of the goal being learning, the goal becomes the most productive way to record everything that is said. Sometimes the disconnect between writing or typing and listening is noticeable as well. These are different tasks and switching between them means that the attention on both will be divided. Time and focus are essential for learning, while speed and efficiency are the opposite. But there may be something more insidious as well, as we struggle to understand complex processes like the COVID-pandemic we can quickly become overwhelmed with information that we haven't understood or learned completely. Then some of the conclusions we come to will be informed not by having learned about COVID but by having retained pieces of information. This demonstrates the need for a national education service for all citizens.[35] Learning to learn in a critical way is going to be a challenge throughout the future and museums could lead in this area.

There is also an ignored element of learning which is the processing and contextualising of new information. This learning is performed when the mind is at rest, or when a person feels bored. When a mind is allowed to relax and rest, the mind goes back to the "default network" where the brain sorts through new information and connects it to what is already known.[36] This time for reflection and imagination opens new directions for the information in the mind to be organised. Without this time, a person is functioning at the lowest levels of Bloom's Taxonomy: remember and understand.[37] The higher levels of Bloom's Taxonomy: apply, analyse, evaluate and create, all require the mind to have time to take in information and sort through it.[38] Leisure time is a requirement for individuals to have the time available to keep learning. Leisured learning is indeed most of how the artefacts in museum collections were created, "The wise use of leisure, it must be conceded, is the product of civilization and education."[39] Museums can encourage learning by supporting policies that encourage an increase in everyone's leisure time.

Notes

1 Minecraft is a trademark or registered trademark of Mojang Synergies AB. It is a sandbox adventure game, and one of the main activities in the game is mining.
2 Cull, E. 2022. Personal communication
3 Patel, S. (2006). *The Little Book of Hindu Deities: From the Goddess of Wealth to the Sacred Cow*. Plume.
4 Shoemaker, M. (1981). Manifestations of Shiva. *Art Education, 34*(3), 31–32. https://doi.org/10.2307/3192492
5 Bloom, B. S. (1956). *Taxonomy of Educational Objectives, Handbook I: The Cognitive Domain*. David McKay Co Inc. New York.
6 Lareau, A. (2003). *Unequal Childhoods: Class, Race, and Family Life*. University of California Press.
7 Edwards, D. G. (2014). *Art Therapy* (2nd edition). SAGE.
8 Ibid.

9 Wood, C. (Ed.). (2011). *Navigating Art Therapy: A Therapist's Companion*. Routledge.
10 Silverstone, L., & Thorne, B. (2009). *Art Therapy Exercises: Inspirational and Practical Ideas to Stimulate the Imagination*. Jessica Kingsley Publishers.
11 Buchalter, S. I. (2004). *A Practical Art Therapy*. Jessica Kingsley.
12 Prinzhorn, H. (2013). *Artistry of the Mentally Ill: A Contribution to the Psychology and Psychopathology of Configuration*. Springer Berlin Heidelberg. Germany.
13 Hauschild, J. (2013, November 28). Masterpieces from the Prinzhorn Collection by Psychiatric Patients. *Der Spiegel*. https://www.spiegel.de/international/zeitgeist/masterpieces-from-the-prinzhorn-collection-by-psychiatric-patients-a-936148.html
14 Venerable Henepola Gunaratana Mahathera.(1991). Mindfulness in Plain English. The Corporate Body of the Buddha Educational Foundation, Taiwan. p. 71.
15 *Freud Museum London - The Home of Sigmund Freud*. Freud Museum London. https://www.freud.org.uk/
16 Edwards, D. G. (2014). *Art Therapy* (2nd edition). SAGE.
17 Champernowne, H. I., *The Development of Art Therapy and the Withymead Centre 1941–1966*. Wellcome Collection. https://wellcomecollection.org/works/xcfr7egb/items
18 Ibid., p. 4.
19 Edwards, D. G. (2014). *Art Therapy* (2nd edition). SAGE. p. 26.
20 Ibid., p. 30.
21 Ibid.
22 Rorschach test. (2022). *Wikipedia*. [website] https://en.wikipedia.org/w/index.php?title=Rorschach_test&oldid=1064277152
23 Edwards, D. G. (2014). *Art Therapy* (2nd edition). SAGE.
24 Michel Foucault. (1988) *Madness and Civilization: A History of Insanity in the Age of Reason*. Vintage Books, New York. p. 49.
25 Audre Lorde (2017) *A Burst of Light and Other Essays*. IXIA Press, Mineola, New York.
26 Chödrön, P. 2022. How to Practice Tonglen. Lions Roar. https://www.lionsroar.com/how-to-practice-tonglen/
27 *Addressing Our Histories of Colonialism and Historic Slavery*. (n.d.). National Trust. https://www.nationaltrust.org.uk/features/addressing-the-histories-of-slavery-and-colonialism-at-the-national-trust
28 Berger, J. (1972). *Ways of Seeing*. BBC and Penguin. p. 24.
29 *Migration, Displacement and Education: Building Bridges, Not Walls: Global Education Monitoring Report 2019*. (2018). UNESCO.
30 Ibid.
31 Dibb, M. (1972). Episode 1 (1.1). *Ways of Seeing*. BBC. https://www.bbc.co.uk/programmes/b00dtnvm
32 Ambrose, T., & Paine, C. (2012). *Museum Basics* (3rd ed). Routledge. p. 190.
33 Herbert, M. (2016). *Tell Them I Said No*. Sternberg Press. Berlin.
34 Headlee, C. (2020). *Do Nothing: Break Away from Overworking, Overdoing and Underliving*. p. 84–85.
35 Benn, M. (2018) *Life Lessons: The Case for a National Education Service*. Verso. London.
36 Headlee, C. (2020). *Do Nothing: Break Away from Overworking, Overdoing and Underliving*. p. 127.
37 Armstrong, P. (2010). *Bloom's Taxonomy*. Vanderbilt University Center for Teaching. https://cft.vanderbilt.edu/guides-sub-pages/blooms-taxonomy/
38 Ibid.
39 Russell, B. (1932, October 1). In Praise of Idleness. *Harper's Magazine*. https://harpers.org/archive/1932/10/in-praise-of-idleness/

9 Give

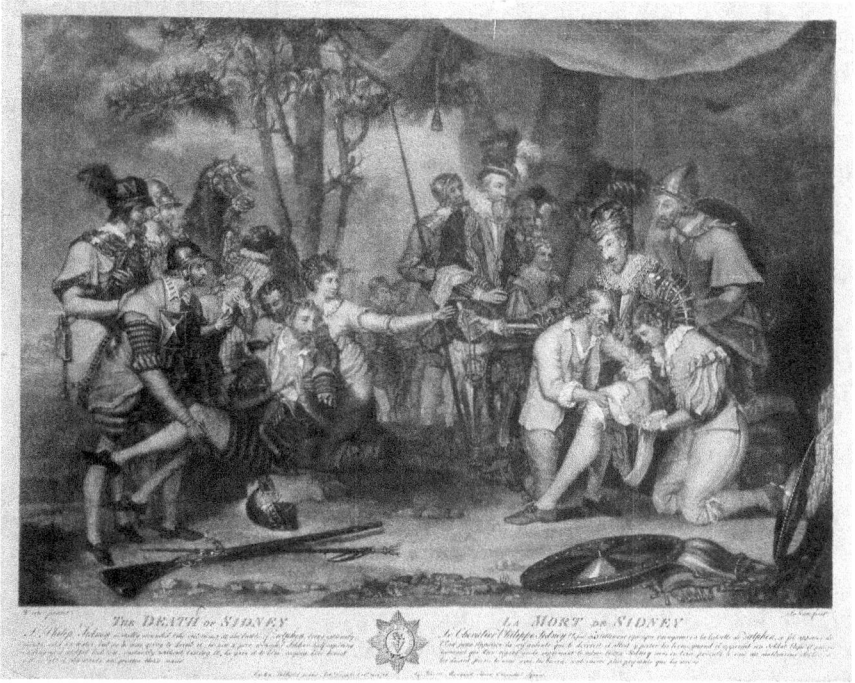

Figure 9.1 The Death of Sir Philip Sidney at the Battle of Zutphen: He Passes a Water-flask to a Fellow Soldier. Mezzotint by J. Jones after G. Carter, 1782. Wellcome Collection. Public Domain Mark 1.0.

Here, we give you: *The death of Sir Philip Sidney at the battle of Zutphen: He passes a water-flask to a fellow soldier* (1788) by Francesco Bartolozzi. This is a mezzotint of a dark and dramatic scene. One the right side of the image is a man in armour with a large white starched Elizabethan collar sitting under a canopy and being treated for a wound on his left thigh. On the left side of the image is another man, who is attired plainly and without armour or collar,

DOI: 10.4324/9781003163480-9

and is underneath some trees but not covered by the canopy, being lifted and perhaps removed from the scene off to the left side. The man on the right appears more brightly lit, there are more high tones and whites in this side of the image. The man on the right reaches out with his right hand to pass a flask to a woman who is treating the man on the left. The man on the left presses his fingers together in a gesture of thanks. All this occurs in the foreground; in the middle ground are other figures, one covers his eyes in an expression of dismay. In the background are more figures of soldiers indicating a battle may be in progress.

Mezzotint is a printmaking process that was very popular beginning in the mid-18th century in the UK, especially in making reproductions of paintings and for portraits. The mezzotint process uses a textured copper plate; texturing the plate is very labour-intensive, and once it is textured the image it will create would be a pure black image. Then using scrapers and burnishers image highlights are brought out. The artist is working from a dark or pure black palette and removing dark to bring out white. Mezzotint was so popular because this ability to use a tonal range was new; previously dark tones or shadows could only be created by cross-hatching or stippling because previous processes worked from light to dark. The transitions in Mezzotint are subtle and the blacks are dark and velvety. Faces and figures and even the things in the image are bright at the front as if they are directly being lit or as if bringing light to the image.

The subject of this image is a story, the narrative of which is clarified by the text at the bottom of the image, which tells this story in English and French. The narrative places Sir Philip Sidney as the autonomous actor or hero of the story. He goes to battle, is mortally wounded, and upon seeing another wounded and dying man, offers his flask of water to him. The key elements of the story are that Sidney has a flask of water, and that the man did not ask for it. This shows the Elizabethan natural order, that some should have and others should want. That those who want should not ask for their needs to be met. That those who have are the only judge of who should receive. The gift in this image is the acceptance and maintenance of continued inequality. Sir Philip Sidney was knighted in January 1583, and not because he had performed any outstanding accomplishment, but so he could stand in for his friend Prince John Casimir, who was to receive the honour of admittance to the Order of the Garter but was unable to attend the ceremony.[1] This recognition was another gallant gift that was bestowed upon the aristocracy like Sidney and Prince Casimir.

The battle of Zutphen was a conflict in the undeclared Anglo Spanish War (1585–1604) during the Eighty Years' War (1568–1648) when 17 provinces of the Holy Roman Empire under Spanish rule revolted and fought for their independence. One outcome of the wars was the founding of the Dutch Republic (1588–1795). These provinces today make up the countries of the Netherlands, Luxembourg and Belgium. The conflict in which Sidney was killed was an attempt to disrupt a convoy of supplies.[2] This disruption of the

supply chain was ultimately unsuccessful by many accounts at the time. One account states that the convoy continued on their way after the English retired to their camp to celebrate their victory. Another account suggests that the convoy was returning after already having delivered supplies. In all the many accounts of the gallantry of Sir Sidney recorded on that day, and there are many accounts by many sympathetic eyewitnesses, there is never a mention of Sidney giving his flask of water to a dying man. The anecdote about Sidney and the gift was written by Fulke Greville, a close friend of Sidney, who was not in the Netherlands at the time, written 25 years after the event occurred.[3] The story reinforces that a person improves the world by a single action or moment, instead of through a way of living and being.

Altruism and kindness

Giving may be interpreted as helping others or altruism. At its essence it is about other-regarding, being emotionally kind and charitable in actions towards others without feeling overwhelmed. In contemporary culture, individuals are portrayed as entirely selfish, or self-interested, and because of this it is necessary for society to create systems that reward self-interested behaviours.[4] The belief is that it is human nature to be self-interested. Of course once these systems are created, the tendency for people to behave in a self-interested way is cited as one of the reasons these systems are effective. If you know the only way for everyone to benefit is if you make sure you benefit first, then you'll act in a way that benefits yourself before others. However, we enjoy giving and helping each other, "Doing good typically feels good because it *is* good."[5] Meaning, we will survive longer if we help each other, so of course we would enjoy being helpful.

However, a majority of people are or behave in ways which could be described as sympathetic, empathetic, compassionate, kind, loving, nurturing or giving. The rationale for behaving in a way that is self-interested is due to others behaving in that way or because it is the way that results in rewards. When we peel back this rationale, we realise that cynicism can be a type of laziness, a way of going against our natural inclination to think the best of a person.[6] The other insidious thing about cynicism is that it sets up a false narrative of winners or losers when in actuality, situations and policies where everyone benefits are the ones that gain the support from communities and will ultimately be the most successful.

So if human nature isn't just self-interest, what is it? It is possible to evidence the giving and kindness in human nature. Rutger Bregman does so in the book *Humankind: A hopeful history*. Bregman chooses examples of moments when humans help each other without seeking any reward or recognition for their actions.[7] It is a compelling book that challenges one to choose to believe that everyone is doing the best they can with the tools and talents they are given. The book does not address the intersectionality of oppression and the shadow of past exploitation. Bregman does not address directly how systems of patriarchy or

institutional racism create an environment where abuse against women or people of colour is tolerated and encouraged. However, it does address human needs and that, "our need for love and friendship is more human than any inclination towards hate and violence."[8] People who act in ways that are monstrous, may see their actions as making them a joiner of a larger movement of which they are a fanatic, "He did evil because he believed he was doing good."[9]

A giving person

Giving is often considered more of a personality trait than an action. A giving person is the opposite of a selfish person, and the way these describe a person would seem to indicate a binary whereby a person is one or the other. Giving your time, attention, skills or money are all types of giving. And giving as a proportion of what you have is important to understand the different levels at which people will give. In the Gospel of Mark, when a poor widow gives a small sum it is more valuable than when a rich person gave a larger sum, because she gave all that she had whilst they gave from their surplus.[10] The message is that those who have an abundance are not better than those who have very little, even if they give large amounts, they are not as aware of their gift as someone who could only give a small amount. This theme comes back throughout the Bible, that personal wealth is a barrier to the kingdom of heaven and only through giving away wealth can a person overcome this barrier. Following these teachings, the wealthy who fashion themselves as contributing some intangible form of goodness to the world that does not of course involve the redistribution of their wealth are prohibited from understanding the power of a gift. Lack of money is a barrier for most goods, services or activities, but the presence of wealth brings other intangible or psychological barriers to participation in giving, which can lead to being unwell and wealthy.

Society has taken characteristics of employees and applied them to personal relationships, not the other way around. The characteristics of stable, hardworking, independent could describe an employee or a husband, sibling, or friend.[11] This leads to applying theories and metrics of productivity to areas of life like hobbies or pastimes, which by their very definition are ways to pass time, not to make money. This creates the definition of the deserving poor, meaning the poor who deserve assistance, who are hardworking. The presence of groups of people who cannot afford housing or food is not solved by dividing and determining which of those people should be helped, but by helping all of them. It is not a gift if a person has to earn it or spend it in a particular way. Productivity and biomorality cannot be involved in helping others.

Forgiving

The most compelling examples of giving are examples of forgiving. A person feels the negative actions of a person or system, and choses to move on from that pain and suffering and to forgive themselves and the person or system

that hurt them. In forgiveness we can see that defining a person by their actions and therefore limiting their future freedoms, such as through the incarceration system, is ultimately unfair because it does not offer them the opportunity to act in a different way in the future. Forgiveness of a system of oppression is allowing ourselves the chance to write a new narrative about our lived experience, and combining forgiveness with helping others through the same system ultimately is what can lead to system change.

Suicide

Suicide is like throwing a rock into a pool of water, the ripples out from that action will touch every corner of the pool. We have both had our lives touched by the suicide of a friend, and that is something we return to, to remember who we were at that time and who they were. Suicide belongs here because it is a decision by a person that the world will be better if they are no longer in it. In that sense it is a person giving their absence. It has been around 20 years since our friends died, and sometimes we need to talk to each other about it, maybe as a way of remembering or as a way of not forgetting. Suicide cannot be left to be the elephant in the room, or dismissed as a topic that can only be discussed with a therapist because that misses the social element of our collective self and how the loss of a person will be felt by many other people for a very long time. In a way it is important to talk about suicide in a broad way, to avoid focusing on the act of the individual and to allow ourselves to see how this human choice affects all of us.[12]

Gift exchange

What will not lead to system change is the idea of effective altruism as presented by William MacAskill in his book *Doing good better: Effective Altruism and a radical new way to make a difference*.[13] This book is influential on philanthropy, including in museums, where donors may request evidence of the impact of their donations.[14] In the book, MacAskill challenges the reader to consider placing a value on every choice in their lives, then using the limited data available about return on investment on that choice to make decisions about what career to pursue or how to donate money. The suggestion is that wealth redistribution through personal choices allows Westerners to pursue high-paying careers and offset their complicity in a system that is exploitative by choosing particular charities for their giving. The claim that everyone living in a Westernized country has a high level of disposable income feels harsh in a book that is published after five years of British austerity. The author also relies on data about the Quality Adjusted Life Year (QALY) as a type of objective analysis of the amount of good provided by a choice, when in practice it is a subjective assessment that preferences neuro-typical able-bodies. It was a metric similar to QALY, combined with a very early understanding of COVID-19 that led to decisions about triage and treatment during the

pandemic. Decisions about the QALYs of people who worked or lived in care homes meant patients who were in hospital were not tested for COVID-19 before discharging them to these care homes that were also not provided with personal protective equipment (PPE).[15]

To fully embrace Giving, it is necessary to redefine transaction (or trans-action). Instead of an exchange, often on financial terms, a trans-action is also defined as a social interaction, such as eye contact, verbal communication or touch. The issue with a society that is based on purely financial measurements is that it will de-value what cannot be bought.[16] So how can value be placed on a smile, eye contact and a cheerful "Good Morning!"; is it worthless? The sense of achievement will only come from results and the subsequent recognition for achievement, which then detaches us from the experience of striving, arguably the more important experience. When a stranger asks us for directions, or when we ask for or give advice, we do not charge a price for this knowledge or these services. In reality most of our trans-actions are part of a gift economy. We rely on help from others so frequently we probably do not realise that we are partaking in a trans-action or gift of knowledge when we ask if someone has the time or knows a good local restaurant. Conversation naturally offers a back and forth dialogue between two people, whether they are strangers or intimate friends with no financial outcome to the process at all.

Tolstoyan gifts

Leo Tolstoy, writing in 1903, discusses the confusion around the best way to help others in his short story "Three Questions."[17] It begins with:

> It once occurred to a certain king, that if he always knew the right time to begin everything; if he knew who were the right people to listen to, and whom to avoid, and, above all, if he always knew what was the most important thing to do, he would never fail in anything he might undertake.[18]

He asks his advisors, When is the best time to do things? Who are the most important people? What is the most important thing to do? The answers from his advisors are conflicting so the king disguises himself and seeks out a hermit who lives alone in a remote place. Over the course of an afternoon and short summer night, the king experiences a revelation and understands the answers to the three questions. Tolstoy elaborates that the most important time is now as that is the only time we have any power, the most important person is the person you are with, and the most important thing is to do right by the person who is with you. Tolstoy was familiar with the inequalities in Russian society and he was born having more money and power than most. As a youth, Tolstoy "observed the life of Russian society while embracing its excesses to the full."[19] However, he did not conclude that he was capable of saving or protecting the lives of others through his wealth and influence. He

was aware of the constraints of his humanity and his social environment, but was hopeful that Christian-anarchism ideas could be the means by which he helped others.[20]

Tolstoy gives us the parameters by which we can Give to others. By focusing on what we are accomplishing now, we can clear the mind from distractions or conflicting ideas and try to make a real difference in the lives of those around us. Tolstoy would have been aware that he could have given money to charity or helped others through his money. But the conclusion he came to was that the entire system needed to change and that could only happen through helping the people he was with at the time he was with them. Outcomes are like photographs, they are only taken once and they only capture a single frame.

Winners and losers

There is a tension created in storytelling around the community compared to the individual. This is especially interesting in Korean contemporary culture. The television series *Squid Game* offers a study in different types of altruism.[21] In the series, players compete to the death in a series of re-imagined children's games for the chance to win a cash prize. A majority of the players have entered the game alone, and the first game they play is a game that relies on individual accomplishment, but even within the game the players begin to help each other. Subsequent games reinforce the need to function as a team, either through trying to outwit the game creators by predicting the next game, or to work as a unit to win the game. Trust is a common theme, that players must trust each other and the players who do are ultimately the ones who progress the furthest in the game. Players acts of altruism include protecting each other from physical attack, verbally standing up for each other, sharing resources, building protective barricades, and offering emotional support through listening and sympathising. One thing all players give and receive in the game is the gift of survival.

The narrative arc reaches the highest point in episode 6. After the viewer has emotionally committed to numerous players, the game sets them up against each other. This is when sacrifice and betrayal are pushed to extremes and when the brutality of the game and of the characters are revealed. The individual is forced to triumph over the collective. The attack on the collective is felt by the viewer as a greater loss than the life of any individual player. Subsequently, Sae-byeok, who struggles the entire series to trust anyone, reaches out to Gi-hun and entrusts him to look after her family in the penultimate episode. In this action it is demonstrated that trusting others can be our salvation in a game that sets us up against each other.

Squid Game leads us back to the artwork *The death of Sir Philip Sidney at the battle of Zutphen: He passes a water-flask to a fellow soldier*. This artwork memorialised the myth of an Elizabethan gentleman. Sidney's death too symbolises something greater than himself—the embodiment of the death of

chivalry, his community. This is portrayed through this depiction of him dying and passing his bottle of water to a fellow soldier who is of lower rank. The eye is drawn to the two hands reaching out to each other in the centre of the artwork. A comparison to *The creation of Adam* (Michelangelo, c. 1512) reveals aggrandisement, Sidney is positioned on the right, like God. The myth of the altruistic Elizabethan aristocrat was and remains an important part of modern European Identity. Similar to the themes of sacrifice in Squid Game, the individual's true self is revealed whilst dying, and an act of sacrifice whilst dying can ultimately redeem a character's previous misdeeds, like the sacrifice from Sang-woo at the ending so that Gi-hun wins the game.

Gift economy

In the gift economy, "We recognize and reproduce our common wealth, which is intangible but of real and incalculable value. Gift exchange turns a vicious circle of downward-spiralling competitive individualism towards violence into a virtuous cycle of upward-spiralling cooperative social solidarity."[22] This was especially visible during the COVID-19 pandemic when we collectively gave confidence to medical experts and gave consent to restrictive rules about socialising and living to benefit the most vulnerable in our society, who we may not even know. Perhaps the trans-action of this giving is that others will give to us what we need when we need it, or perhaps it is about creating a world where everyone can have their needs met.

Museums receive from the gift economy in a few ways. Firstly, they receive gifts for the museum collection. Secondly, they receive gifts from the social dividend, the re-investment of collective wealth into collective property, through tax status and government investment. Cultural heritage is collective property in the same way that common land is collective property. Museums also reflect the relocalisation of resources, because museums receive local skills and materials through volunteer programs and donations. Relocalisation could include the use of local/community currency like the Bristol Pound, which seeks to keep money in the community and to support community-based organisations. In time bank projects the currency is a unit of time, usually an hour, which can be given and received for help. Time banks are effective at reaching communities who typically do not volunteer. They encourage reciprocal volunteering, community participation and active citizenship in the local community.[23]

To many who work in museums, these programs may already be running, so this isn't new. In some museums, there may be types of programs that are similar to these that need to be joined-up to other community organisations to reach a wider audience. It may be too difficult to set up these types of programs, and a museum may not have the staff or resources to run them. However, if time banks or other relocalisation programs are already running in the local area, the museum could offer a space for community programming to take place or a space for those who participate in community

programming to explore as part of their exploration of the locality. Participation in these programs increases community resiliency and will guide a community through a period of change. As Charles Eisenstein says in *Sacred economics*: "By changing our everyday economic thinking and practices, we not only prepare ourselves for the great changes ahead; we also set the stage for their emergence."[24]

The gift economy is an older form of economics that has continued despite attempts to end its practice in favour of the market economy. In this economy, competition is expressed by how much one person can give, instead of how much one person can accumulate.[25] This is expressed in the heritage collected by a museum:

> In fact, even when objects of great value change hands, what really matters is the relations between the people; exchange is about creating friendships, or working out rivalries, or obligations, and only incidentally about moving around valuable goods. As a result everything becomes personally charged, even property: In gift economies, the most famous objects of wealth—heirloom necklaces, weapons, feather cloaks—always seem to develop personalities of their own.[26]

The collection of a museum allows for study of these gifts and how the act of giving will create a more important artefact. In our experience in collections that included American Indian drums, the drum is given a spirit as part of its use, and the spirit can also be taken away and given to another drum, as part of the biography of the artefact.

The Preston Model and localisms

The other way in which museums are involved in giving is in their budgets. Museums have choices of where and how they spend their budgets, and there is a model in the UK called the Preston Model that details how local spending can build community wealth.[27] The Preston Model creates dense local supply chains which will be more stable than long supply chains, through a focus on local spending for procurement. Fair employment from recruitment from lower income areas, then positions that pay a living wage and progression routes for all workers addresses inequalities in the local economy and keeps money locally.[28] The Preston Model actually works to increase the wellbeing of a community. While there are other models out there, including effective altruism, their end point seems to be to save lives in faraway communities so those lives can then be spent working in sweatshop labour, and does not address the well-being of communities instead.[29] Museums are situated to serve local communities and, "there is a potential for museums to be mobilised in powerful ways as part of emerging alternative localisms."[30]

Giving builds connections and social capital, which are important benefits for any museum visitor or staff member. But the benefits are not just for

museums, volunteers have reported a greater sense of well-being as a direct result of volunteering. By giving ourselves and what we have, we connect to other people and to community, and this puts us in touch with a higher goal. It is in fact through participating in a higher goal or cause that we truly achieve a real sense of purpose and belonging. Such an experience is often brought out in society at large during disasters or periods of crisis such as COVID-19. Museums can offer such a sense of purpose.

Notes

1. Ringler, W. Andrew (2021, October 13). Sir Philip Sidney. *Encyclopaedia Britannica*. https://www.britannica.com/biography/Philip-Sidney
2. Sidney, P. (1986). *Sir Philip Sidney: 1586 and the Creation of a Legend*. Sir Thomas Browne Institute. Netherlands. p. 21.
3. Ibid., p. 7–8.
4. Bregman, R. (2020). *Humankind: A Hopeful History*. Bloomsbury Publishing. United Kingdom.
5. Ibid., p. 384.
6. Ibid.
7. Ibid.
8. Ibid., p. 173.
9. Ibid., p. 171.
10. *The Holy Bible: Containing the Old and New Testaments with the Apocryphal, Deuterocanonical Books*. (1995). Oxford Univ.-Press. Mark 12:41–44.
11. Headlee, C. (n.d.). *Do Nothing: Break Away from Overworking, Overdoing and Underliving*. p. 87.
12. Bering, J. (2018). *A Very Human Ending: How Suicide Haunts Our Species*. Penguin.
13. MacAskill, W. (2015). *Doing Good Better: Effective Altruism and a Radical New Way to Make a Difference*. Guardian Faber Publishing. United Kingdom.
14. Wilkening, S. (2017). Effective Altruism. American Alliance of Museums: Center for the Future of Museums [Blog]. Posted on 18 April 2017. https://www.aam-us.org/2017/04/18/effective-altruism/
15. Clarke, R. (2021). *Breathtaking*. Little, Brown Book Group Limited. United Kingdom.
16. Hochschild, A. R. (Ed.). (2013). *The Outsourced Self: What Happens When We Pay Others to Live Our Lives for Us*. Picador.
17. Maude, L., Tolstoy, L. (1998). *Walk in the Light & Twenty-three Tales*. The Plough. United States. 347–351
18. Ibid., p. 347.
19. Christoyannopoulos, A. (2020). *Tolstoy's Political Thought: Christian Anarcho-Pacifist Iconoclasm Then and Now*. Routledge. p. 5.
20. Tolstoy, L. (1894). *The Kingdom of God Is Within You*. Cassell Publishing Co. New York.
21. Dong-hyuk, H. (creator). (2021). *Squid Game* [TV Series]. Netflix. www.netflix.com/
22. Hughes, I., & Keohane, K. (2020, June 14). *The Gift: Rebuilding Society after Coronavirus*. OpenDemocracy. https://www.opendemocracy.net/en/transformation/gift-rebuilding-society-after-coronavirus/
23. Seyfang, G. (2004). Time Banks: Rewarding Community Self-Help in the Inner City? *Community Development Journal, 39*, 62–71.
24. Eisenstein, C. (2011, July). Chapter 18, Relearning Gift Culture. In *Sacred Economics. Sacred Economics | Charles Eisenstein*. https://sacred-economics.com/sacred-economics-chapter-18-relearning-gift-culture/

25 Graber, D. (2000, August 21). *Give It Away*. In These Times. https://inthesetimes.com/issue/24/19/graeber2419.html
26 Ibid.
27 What Is Preston Model? (2022). Preston City Council. https://www.preston.gov.uk/article/1339/What-is-Preston-Model
28 Jones, F., & Leibowitz, J. (2019). How we built community wealth in Preston. CLES - Centre for Local Economic Strategies. https://www.preston.gov.uk/media/1792/How-we-built-community-wealth-in-Preston/pdf/CLES_Preston_Document_WEB_AW.pdf?m=636994067328930000
29 MacAskill, W. (2015). *Doing Good Better: Effective Altruism and a Radical New Way to Make a Difference*. Guardian Books.
30 Morse, N. & Munro, E. (2018) Museums' Community Engagement Schemes, Austerity and Practices of Care in Two Local Museum Services, *Social & Cultural Geography*, 19(3): 357–378, DOI: 10.1080/14649365.2015.1089583

10 Take Notice

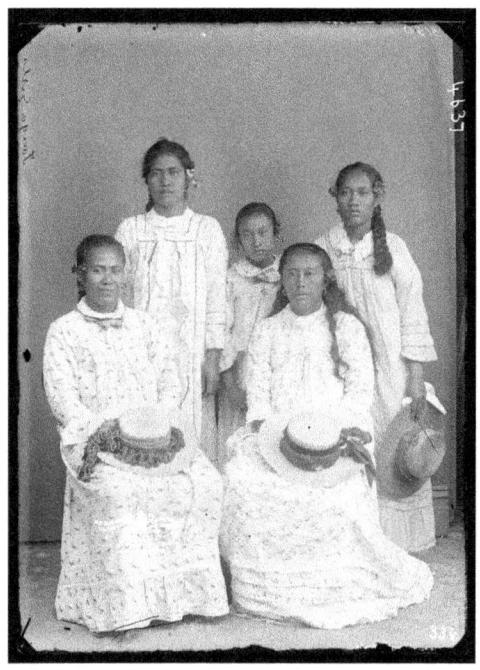

Figure 10.1 Five Girls, 7 January 1903, New Zealand, by Department of Tourist and Health Resorts, James McDonald. Te Papa (B.079478). No known copyright restrictions.

Take Notice of this photograph, *Five Girls* (January 1903) of five Māori women and girls, three are standing in the back and two are seated in front of them. The women have dark skin and long dark hair. The two who are seated appear older and are taller, and the three standing behind them are shorter and appear younger. All of the figures wear long dresses of white printed calico cotton, and three of the figures hold straw boater hats decorated with ribbons or scarves. Four of the figures appear recessed and are all gazing

DOI: 10.4324/9781003163480-10

ahead, towards the camera, while one figure on the left of the image is further forward than the rest of the group, her stare is off to the left of the camera and she smiles an enigmatic smile. You are left wondering what she has noticed.

This is a gelatin glass negative, which were used from the 1870s until the 1940s by professional and amateur photographers. Unlike the previous wet collodion plates, gelatin plates were dry and retained sensitivity to light for months, which made them ideal for photographers working in the field. They could also be developed long after exposure, whereas collodion plates had to be developed immediately. These advantages allowed for the industrial manufacture and distribution of gelatin plates to a wider public, causing the photographic manufacturing industry to emerge and flourish beginning in the 1880s.[1] This image has been scanned, it exists as a negative in the museum's collection. The scanning means that it no longer appears in a negative form, and it reads instead as a photograph.

Photographic technology in the 19th century is about the search for reproduction and stability, cursed by the realisation that the light that was needed to create an image was the same light that eventually destroyed it. Materials that were used in early photography included a variety of metals, proteins and fibres. Experiments first captured images individually and uniquely, but the images would only exist for a limited period of time before they succumbed to fading from light exposure. It was the reproducibility of images that changed the way they were consumed. Now there were negatives, and images could be reproduced multiple times. Gelatin silver became popular specifically because it was cheap and stable. Platinum prints were more stable but platinum was more expensive than silver. When this image is examined, the black areas are different from digital images,; they are deeper and more saturated. Digital imagining neutralises what we see, whereas in the 19th-century contrast was the aesthetic and that was as much a function of the medium as the desire of the viewer.

Digital photography and subsequently digital *motion pictures* (which is the term still used by the US Library of Congress (LC), which is reminiscent of the term *movable type* for printmaking[2]) are still in the process of developing an aesthetic. Similarly to early photography, what is most important is not precision or accuracy (daguerreotypes were considerably more accurate than subsequent photography techniques) but reproducibility and some sort of stability. Portability is also a factor. It is somewhat ironic that in the development of capturing images, the consumption of the media has changed. Now images are rendered less permanent through social media sharing platforms adopting a temporary method of display so that viewers of images feel pressure to view them immediately. Image sharing websites rely on the near constant consumption of digital images to maintain these platforms; a rapidity that means where once you took time to notice and absorb an image, today you must consume it quickly.

This photograph was taken by James McDonald (1865–1935). McDonald photographed for New Zealand's Dominion Museum (formerly the Colonial

Museum, currently Museum of New Zealand Te Papa Tongarewa) from 1905 to 1926 along with anthropologist Elsdon Best (1856–1931); they travelled up the Whanganui River and to the North Island's East Coast and Rotorua. James McDonald has 1,220 objects listed online in the collection at the museum[3]. Elsdon Best had a series of failed business ventures and eventually ran a shop in proximity to a large Māori population. Best wrote and studied Māori navigation, architecture, fishing methods, games and lore.[4] These two people were not trained as professionals in an academic way that we would recognize today, but if they were publishing their research today, we may call them anthropologists or ethnographers.

Indigenous identities

The striking thing about this photograph is that the Māori women are dressed as late Victorians or early Edwardians, with long voluminous skirts ending in tiers of lace and ruffles that correspond to the decorations at the sleeves, and high collars. Collars remained high until the first World War, with stiff upturned collars for formal attire, and turned down collars were more informal.[5] The yoke of the dress also identifies it as Edwardian, with a ribbon to hold the collar upright on the neck, and transitioning to a sleeve that drops away from the yoke, not leg of mutton sleeves that were so popular in Victorian clothing. The seated women have hidden their feet and hands. This is most likely before the first World War because the silhouette is a voluminous one. The women wear jewellery, with the older women wearing earrings, and the girl standing at the centre of the image has a ring on her right middle finger. The hairstyles are varied, with some of the women having their hair pulled back in a style that references evening hairstyles, one has her hair completely down. On the right the figure has brought her long plait around in front of her left shoulder, which feels very contemporary to how women wear their hair today. On the smallest (possibly the youngest) figure, it is not possible to see how her hair is at the back of her head; it is only possible to see that it is pulled back away from her face. All of the women have flowers in their hair, some of which appear to be orchids and some chrysanthemums.

Many museum institutions and professionals struggle to understand indigenous identity. In post-modern conservation, conservators are very concerned with how they are perceived or what they are perceived to be doing or how they are doing it. This has led to extensive discussions about what to call conservators who are affiliated with collections that include indigenous art, artefacts or documentation.[6] The choice that conservation professionals have made is to distance themselves from ethnographic studies like those from which this image was produced, and instead to focus on indigenous and World Cultures as contemporary, living peoples. This solves one problem with collections and culture and creates another. It creates a system whereby the information that was collected and published by ethnographers does not have to be considered in the interpretation of the stuff they collected. This policy

removes people like James McDonald and Elsdon Best, as well as the Māori subjects of their studies, from the narrative, and replaces them with contemporary Māori communities and culture.

When we look at the eyes of these women and girls, we see eyes that saw Queen Victoria as sovereign. These are the eyes that first saw rugby introduced in New Zealand. We wonder what they thought of it all. The issue that museums have is that they still approach these stories as if they need to have a conclusion to them, they need Māori to inhabit a space that is pre-contact and then create a system of continuity from those people to the Māori today. Whereas it is equally conceivable that Victorian or Edwardian Māori would have as much, if not more, in common with Victorians or Edwardians throughout the Empire than with any group of contemporary people. We often want clear answers and there aren't any. This becomes jarring in teaching students about cultural identity and museum collections. Students confidently tell us that they have read one case study that included input from a person of colour and that case study came to a particular conclusion, so therefore all collections of all materials should be treated in the same way. This desire for a simple universal understanding bypasses the complexity of intersecting values, cultures and histories. Cultural sensitivity necessitates getting comfortable with answers being complex and often contradictory. A reliance on case studies to develop standard practises is problematic, and likely doomed to failure. An approach of processes is more appropriate. "If we accept the scientific and science fictional premise that change is a constant condition of the universe, then it becomes important that we learn to be in right relationship with change."[7]

We've been in the room when consultations regarding indigenous artefacts happen. We've watched people who do not speak English struggle to be the voice of their culture throughout a conversation that they are occasionally included in. It is a huge burden to put upon someone, and we think if we did it to white people more often, we could see how ridiculous it becomes. The answers that can be given in such an environment are limited already by linguistic barriers, technical language and institutional power. Other experiences have included working with a white male professor who was a gatekeeper for a collection of indigenous artefacts. A power relationship that was beyond problematic. Moreover, the monumental architecture of museums and the choices of how to display history in them will have already influenced any visitor who enters the space. The use of architecture as propaganda originated at the beginning of civilizations and continues today, indeed the monumental facades of buildings demonstrate the power of empires in comparison to each other.[8]

Around 15 years ago, conservators employed or specialised in artefacts collected by ethnographers or in ethnographic museums were called conservators of ethnographic collections. The identifier was based upon the idea that an ethnographer could or would be interested in studying the artefacts in these collections, or that these collections were curated or acquired by an

ethnographer. This was to identify the difference between collections that are chosen for cultural significance instead of artistic significance (specifically regarding the Western Canon as the source of all artistic significance). The decision was made to instead refer to these conservators as the conservators of Objects from Indigenous and World Cultures. In this case World Cultures can mean non-white and non-indigenous communities such as the Māori. It was impossible to tell from the discussions around the name change whether conservators were trying to assuage their white guilt by distancing themselves from the white people who originally studied ethnography, or collated the collections on which they work. Racism takes from all of us through limiting the narrative. Anti-racism must include the opening of that narrative to include other voices and vistas,[9] including histories that may conflict with the previously assumed anti-racism narratives.

Why does this issue come up here in Take Notice? Because a part of taking notice of thoughts and experiences is taking notice of the things that we thought were alright at the time, then upon closer examination we realised were not. There is this idea around mindfulness and meditation that we only need to unlock our minds with a blank slate whilst listening to our breath and this will be healing. Sitting with painful memories and emotions is self-care, feeling pain and fear are part of it as well. The point of taking notice is not burying everything except the happy rainbow emotions but sitting with the stuff that is difficult and taking time to feel it and eventually find a way of healing. When one guides people through meditation, one pushes when one needs to, and takes the class back when one needs to, just like in yoga, just because you can stretch to your limit doesn't mean that you should.

Noting

The vast majority of writing about art is concerned with paintings, and the majority of that writing is a study of taking notice. Occasionally an art historian takes time to look at an artwork repeatedly, and sometimes even has the chance to review these thoughts after a significant time has passed. The art historian T.J. Clark returned to the Getty museum a decade on from writing about the painting *Landscape with a calm* (1650–1651) by Poussin.[10] The elapsed time had given him the time to reflect upon that experience of in-depth noticing of the artwork.[11] Clark lamented that art historians cannot do this type of repeated viewing of works of art more often, his process of looking at the painting included a warm-up exercise of looking overall, then focusing in incrementally. In this process it is clear there is no one view of a painting, and how a painting catches your attention will be unique to you.

This is similar to what Roland Barthes called punctum: "that accident which pricks me (but also bruises me, is poignant to me)."[12] The artist will attract the viewer or invite the viewer into the painting with a device, sometimes this is unconsciously done by the artist or unconsciously felt by the viewer. At this intersection where the viewer feels they have entered into the

painting, the viewer can feel grounded and the painting will guide them to further questions about themselves and the artwork. Questions about the ambiguity of the painting, is this day or night? What time of year is it? Is the painting the beginning, middle or ending of a story? These questions and many more can be explored and the painting can even be further explored with music, and Clark suggests a Bach counterpoint for the painting by Poussin. Painting and photography allow for captured moments of time which then bring the viewer to think about change and temporality. All photography and painting are images of a past, a *natura morte* or still life and bring up questions of how humans measure time compared to how nature measures time. Our sense of a life is constrained by the amount of time we have to experience that life and the amount of time those around us have to be with us, our connection to this world and to another world.

Art historians may lament they lack the time to spend with paintings, but others in the museum world have the time. Room guides, front of house, and security guards are often the people who have spent more time than anyone else really studying a work of art. I had a position as a security guard in a museum and I spent hours in a gallery of paintings. Most of my time was spent standing and walking around the tiny gallery, and staring at the paintings or speaking to the gallery visitors, of which there were few. This was when I learned to look at paintings, to understand how they were different on different days depending on the weather or the light or how they seemed to change when a person was particularly interested in them. I also learnt to examine paintings at the same time as examining myself, which meant I began to understand how my view of the paintings changed because I was changing every day. I learned more about the artists and their manifestos, what they believed and how they were expressing those beliefs through painting. This led to a different experience when I noticed the paintings. On my final day of work I noticed a red brushstroke in one painting, and it changed the entire painting for me, it was totally different. What I learnt was that in taking notice every day, at first I was noticing what was in front of me, then I was noticing what was going on inside of me, and finally I began to notice the wonder I could bring into an experience by focusing in and then out again.

Visual art can be further noticed through technique and materials. Examining the way the paint appears depending on the type of paint used, the colours chosen, the types of brushstrokes and their subsequent effect. This is enhanced by our understanding of materials, once we know that lapis lazuli pigment is very expensive, we understand the choice an artist makes when they use it. For most of the history of art, materials are expensive and labour is cheap. This is why books were bound using small amounts of materials, but the printing and binding process were very labour-intensive. Images can be as complicated as any text and they can be more so, because the use of language constrains text to a particular range of meanings, but an image can be interpreted and re-interpreted in more ways than language.

Internal landscapes

A museum offers a landscape where collections appear, and journeys take place through physical space and through time and place by journeying with the artefacts on display. This is why having a daily walk through a space is one of the most important tasks for many museum conservators, to have that time to observe the collection and in that way take notice of ways in which it is the same or different. It is surprisingly difficult to walk through a space daily and stay in the present. It is tempting for the mind to take us to the future especially, to begin making lists of tasks or mentally preparing for conversations or meetings. This is fine, the mind will amuse us when it has time to do so, it is bringing us back to the moment and the task that we begin to train the mind and open up possibilities for the here and now. These adjustments are tiny, incremental shifts, like in turning a ship around, it is done degree by degree and there will invariably be setbacks from the waves and the wind.

In crossing a museum landscape, it is also the repetition of thoughts that can be noted. Every day will not bring a transformative moment, but noticing what thoughts come up at what point in the journey can be equally enlightening. Art is good accompaniment for thinking, art expresses thoughts and influences thinking both consciously and unconsciously. Art connects us to a past that is not so different from our present, with conflicting ideas and holds us there, while we interpret those ideas over our own experiences in that moment.

Change is noticed through repeated experiences. Collections are impermanent things, they exist in a state of change, and we project our ideas on this change. Deterioration and dissociation occur in all collections, and these are considered negative to the understanding and interpretation of the collection as a whole. However, deterioration of an individual artefact in a particular way can give that artefact more value historically and intangibly.

This is the idea of wabi-sabi, a traditional Japanese aesthetics that revolves around an acceptance of transience and imperfection. The "beauty of things imperfect, impermanent, and incomplete.[13]" Like walking along a winding river, the experience benefits from the twists and bends in the river. A perfectly straight river would have an entirely different experience. It would not be as enjoyable because there is enjoyment to be found in the acceptance of the river as it is. This challenges us to accept ourselves as we find ourselves right now, to accept the bends and twists as opportunities for exploration and enjoyment. To be in the moment.

Mindfulness

Mindfulness is a phenomenon. This growth in popularity is difficult to explain, but it is undoubtedly the biggest element of the modern wellness and well-being movement. Mindfulness is a simple practice, we are both authorised to teach it,

but it's also a deeply profound practice. One definition would be: "Mindfulness means paying attention in a particular way: on purpose, in the present moment, and nonjudgmentally."[14] There are many forms and types of mindfulness, it is around as broad a term as sport is for physical activity. It also has various synonyms: awareness, meditation, concentration or paying attention. Traditionally there are many mindfulness practises, or what are known as objects of meditation, utilising our various senses. Meditation can be sedentary or mobile, and a longer session may include both types of meditation to allow participants a chance to relax their mind and stretch their body as well. Probably the most widely known and practised is mindfulness of the breath. Paying attention to each breath in and out. Breathing is something our bodies have to do, which grounds us in the present and focuses our mind into our body. Breathing can be a point of gratitude meditation, or a point from which a body scan meditation can focus. Mindfulness is being active for the mind, training the mind to focus in whilst editing other inputs. It can be difficult for the mind to do this without bringing judgement upon yourself or your process. One cannot expect to frequently accomplish a life-altering-take-notice moment. However, it is possible to make a museum visit into an opportunity for mindfulness.[15]

Just as in the wider society, interest in mindfulness has exploded within museums, which in many ways are ideal locations for meditation sessions offering a rich and diverse source of *objects* of meditation; in both uses of the term. The Manchester Art Gallery in the UK is one of the museums developing a very robust mindfulness program, they call *the mindful museum*, it is a partnership program with the Greater Manchester Mental Health Trust. They importantly see the program extending beyond their walls "the process begins in the gallery but it does not end there; the practice of letting thoughts come and go while looking at a painting, without getting caught up or carried away by them, can be transferred to real life situations."[16] In addition to working on regular programming, they developed the temporary exhibit *And Breath…* This exhibition has been co-curated with mental health organisations Start in Manchester and Manchester Mind as well as children aged 9 and 10 years old from Charlestown Community Primary School. The guidebook and audio guide included guided meditations of less than 10 minutes, alongside the more typical art historical information about the work of art. Few museums have developed exhibits such as this, but many are offering occasional forays into mindfulness of individual works of art, such as the monthly offering from Phoenix Museum of Art, in which you will "connect with the present moment as you reflect deeply on a select artwork from our collection or a current exhibition"[17] in a programme they call *slow art*.

Slow art

It was in a report about a visit to the Louvre, that referenced the work of T.J. Clark, the term slow art was coined, named after other slow trends such as slow cooking. At the Louvre it seems very few people spent much time

looking at artworks. No longer did people sit and sketch, but instead they take images on their phone cameras and move on, with an urgent quest to complete the museum. However, one group was intriguing acting differently "they looked ... and they seemed to have a very good time."[18]

Taking notice of this difference birthed the idea of slow art; and from its birth it was connected to the idea that Taking Notice of art had a well-being component. The work by T.J. Clark that inspired this name involved him spending six months staring at two works of art by Poussin hanging in a single room at the Getty Museum *Landscape with a man killed by a snake* (1648) on loan from the National Gallery in London and the Getty's own *Landscape with a calm* (1650–1651) and writing down his thoughts. On the first day he notes that "nothing special was on my mind, I was just looking."[19] Yet he found himself returning to the gallery to look at these paintings morning after morning, and almost involuntarily he began to record his shifting responses in a notebook, which later became the basis for a book, in which the process of looking again, and again, as the conditions in the gallery and the world around changed.

Later the idea of slow art was given greater context, as it has been argued that for contemporary viewers, the contemplation of slow art is akin to religious practises during the ages of faith. "Slow art came to supplement older sacred practises by creating social spaces for getting off the train. In sum, as culture sped up and sacred aesthetic practises waned, slow art came to satisfy our need for downtime."[20] The development of the slow art within museums being an example of how audiences might Take Notice of different elements of the image, colour, texture, light, shadow, action, stillness and in taking a long time to look at an individual work of art allows for a flow state to develop, and for a different way of seeing themselves and the world than before they sat down to Take Notice.

It wasn't long before the idea of slow art was to become a movement *for* slow art.[21] It is believed that the average museum visitor spends between 6 and 10 seconds in front of any one work of art. In June 2008 Phil Terry wanted to know what would happen if visitors changed the way they looked at art, he wondered what would happen if instead of spending an hour or two whizzing through the whole museum, they instead looked just at a few works. To test this out he visited The Jewish Museum's 2008 Action/Abstraction exhibition, and looked only at Hans Hoffman's *Fantasia*, Jackson Pollock's *Convergence*, and a few other pieces. He was hooked enough to propose trying this again a year later with a group of four people at the Museum of Modern Art in New York City and looked at another small set of works, slowly. That second experiment was a success, the participants reported feeling invigorated. So, a few months later, in October 2009, Phil organised a third test, this time featuring 16 museums and galleries in the US, Canada and Europe. The concept was an instant hit; it expanded to 55 sites across the world in April 2010 and to 101 in 2012, and has been growing ever since. Slow Art Day is now an annual global event with hundreds of museums and

galleries around the world participating. The key to its success being that "there's in fact no single, correct way to look at any work of art, save for with an open mind and patience."[22] Or more enthusiastically, "It will blow your mind!"[23] Slow art activities peaked in 2019,[24] but there are already plans to start up yearly celebrations of slow art once it is safe to do so after the pandemic. This is a rare chance in a society which de-values idleness, amongst all but the wealthy, and extols the virtues of work, to sit and look at an artwork, to see the artwork and see the change over time, note the imperfections and how those accentuate the experience of seeing. In a society fixated upon speed there is a pull towards slowing down, an interest in slow thinking, to allow yourself to watch clouds, breathe slowly, and be present. Museums are already well-suited to an environment where it is possible to Take Notice, they are designed to have focus directed and then moved through their space, slowly.

Re-creating observed reality

As we have seen, the idea of sketching in a gallery, is an activity that now seems bizarrely out of place. However, drawing or sketching is an activity that embodies Take Notice. There is not an objective way to sketch, because a sketch is about what one person is seeing at that moment. Sketching was once the accepted way to document an item in a museum, and it can still be a more effective way of communicating the condition of a museum artefact than a photograph or text. Sketching is so effective because it takes time, and it takes really examining an artefact, looking at it from different angles and in different types of light, and seeing the relationships and the contradictions in it, which cannot be captured in any other way.

Photography is a useful documentation tool in other ways. It is interesting that some of the earliest photographers like Eugene Atget were embraced by surrealists such as Man Ray. Whilst Atget sought to objectively document the lives of Parisian streets, what Man Ray saw in his photos was the surreal.[25] The photograph was believed to be more mechanical, and objective, less involved with technique, than non-mechanical means of reproduction like drawing or painting, but as it became more necessary to emphasise a world which did not exist, photography began to lie to us. Now photography and video are sometimes viewed as entirely unreliable and perhaps this brings us back to sketches, or painting and poetry and other means of expression where the viewer is in conversation or participation with the creator and may have more opportunity to re-interpret or (dis)engage with the information presented.

Take Notice vs. the supremacy of sight

A major element of museology has always been concerned with Taking Notice, it is after all a central purpose of collecting: to exhibit and explore collections. Allowing access for contemplation about the museum's collection

or spaces is the mission or vision of many museums. This premise then in turn leads many departments within the museum, as well as the ways in which museum programming is approached. A museum will take notice of their audience, and build a relationship by connecting to this audience, then take feedback and acquire more information and skills they can centre programming around their audience. For example: There will be audience members with heightened sensitivities and a programme that is about taking notice will need to offer this audience an experience which will Take Notice of their sensitivities.

When we talk about Take Notice we are usually referring to the sense of sight. But as we know scholars are questioning the supremacy of sight over touch as greater understanding of ways of learning have been understood.[26] When we consider the Ways to Well-Being in relation to Take Notice, it is important that we too recognise that although much of the discussion is framed in terms of sight, this is unnecessarily self-limiting and a form of spatial exclusion. There has been much interesting work undertaken on Taking Notice using senses other than sight, such as that by the Concordia Sensoria Research Team (CONSERT)[27] who have been carrying out research on the cultural life of the senses since 1988. However, it remains true that modern museums are "empires of sight"[28] in which "objects are colonised by the gaze."[29] Touch is often an add on, and not intrinsic to the interpretation, yet it might in any other situation be strange to claim you knew anything about something without a clue as to "whether it was warm to the touch, how much it weighed, its texture, how you held it, how it articulated with the user's body or what noise it made."[30]

But artworks and museum collections can and do offer a wider opportunity for sensorial exploration. Importantly not limited to those who may be blind or partially sighted. The South Korean photographer and contemporary artist Atta Kim provides an example of a work of art that expressly offers a wide scope of sensorial opportunities for Taking Notice, including sight, sound and touch. During the Rubin Museum's exhibit *Grain of emptiness: Buddhism-inspired contemporary art*, Atta Kim's dramatic 5½ feet tall, 1,300-pound ice sculpture of a seated Buddha was exhibited[31]. Visitors were encouraged to experience this piece and to touch the cold surface of the sculpture, as well as to collect the melting water as it dripped into the pool of water at the bottom of the sculpture.

Amongst the most famous auditory works of art was produced by the artist and composer John Cage, with his work 4'33", sometimes referred to as Sonic Zazen.[32] This piece is explicitly about Taking Notice, but does not require the use of sight. In 1952 the pianist David Tudor performed this piece at the Maverick Concert Hall, taking the stage and making no sound other than the movements of the piano lid. There is a general misunderstanding about the work 4'33", it is often erroneously referred to as a silent piece, but it was in fact the impossibility of silence that led to its composition. After John Cage spent time in Harvard University's anechoic chamber, a room designed to absorb all sound, he had expected to hear nothing, but instead he heard sounds: his nervous system and blood

flowing. "Until I die there will be sounds. And they will continue following my death. One need not fear about the future of music."[33] In the Maverick Hall, and elsewhere where the piece was performed, there were sounds too. Cage describes hearing the wind outside, the rain on the roof, people chattering, confused and increasingly annoyed, even walking out.[34] The world is full of sounds. In mindfulness practice we often begin with a mindfulness of sound, especially if participants have anxiety, as it gets one to be mindful of things outside the body, before we move to the body and breath. Being involved in a performance of this piece on the centenary of John Cage's birth, we can attest that audiences' responses haven't changed dramatically. Amusingly in 2011 an online campaign sought to vote on the UK's Christmas Number One song and keep the X Factor winner from the top spot. The piece has been the recipient of "all kinds of official foolishness: one recording on YouTube has had its audio disabled for copyright infringement."[35]

In thinking about Take Notice, museums are moving beyond tokenistic approaches to access,[36] and reconsidering all elements of museology; museum collections offer almost unending opportunities for wider exploration and increasingly multisensory experiences are the norm.[37]

Notes

1 *Preservation Self-Assessment Program (PSAP) | Negatives.* (n.d.). https://psap.library.illinois.edu/collection-id-guide/negative
2 Library of Congress. (25 August 2017). *Motion Pictures in the Library of Congress* [Webpage]. https://www.loc.gov/rr/mopic/mpcoll.html
3 *Collections Online - Museum of New Zealand Te Papa Tongarewa.* (n.d.). https://collections.tepapa.govt.nz/agent/1514
4 *The Published Works of Elsdon Best | NZETC.* (2016). http://www.nzetc.org/tm/scholarly/tei-corpus-ElsdonBest.html
5 Yarwood, D. (1961). *English Costume: From the Second Century, B.C. to the Present Day.* Revised Ed. 1961. Reprinted 1975. B.T. Batsford Ltd. p. 250–270.
6 UCL Institute of Archaeology. (2015, March 14). *Conversations on Conservation of Cultural Heritage: ICOM-CC Working Group on Ethnographic Collections' Name Change.* http://uclconversationsonconservation.blogspot.com/2015/03/icom-cc-working-group-on-ethnographic.html
7 Brown, A. M.. 2017. *Emergent Strategy: Shaping Change, Changing Worlds.* AK Press. Chico, CA and Edinburgh, Scotland. p. 37.
8 Portuese, L. (2019). The Throne Room of Assurnasirpal II: a Multisensory Experience. In Hawthorn, A., & Rendu Loisel, A.-C. (Eds.), *Distant Impressions: The Senses in the Ancient Near East*, p. 63–92.
9 This realisation came about after reading numerous books, but the moment crystallised into words whilst I was reading. Gilroy, B., & Evaristo, B. (2021). *Black Teacher.* Faber & Faber. United Kingdom.
10 Clark, T. J. 2006. *The Sight of Death: An Experiment in Art Writing.* Yale University Press. New Haven and London.
11 *T. J. Clark on Poussin.* (n.d.). https://soundcloud.com/the-getty/tj-clark-on-poussin-and-the-sight-of-death
12 Barthes, R. 1981. *Camera Lucida: Reflections on Photography.* Vintage Classics. London. p. 33.
13 Koren, L. (1994). *Wabi-Sabi for Artists, Designers, Poets and Philosophers.* Stone Bridge Press. Berkeley, California. p. 7.

14 Kabat-Zinn, J. 1994. *Wherever You Go, There You Are: Mindfulness Meditation in Everyday Life*. Hachette Books.
15 Stephens, S. (2017, May 3). 12 Steps to Turn an Art Museum Visit Into Mindfulness Meditation. *Yoga Journal*. https://www.yogajournal.com/meditation/12-steps-to-turn-an-art-museum-visit-into-mindfulness-meditation/
16 The Mindful Museum. (n.d.). *Manchester Art Gallery*. https://manchesterartgallery.org/learn/mindful-museum/
17 Slow Art. (2019, May 22). *Phoenix Art Museum*. https://phxart.org/adult-program/slow-art-mindfulness/
18 Kimmelman, M. 2009. At Louvre, Many Stop to Snap but Few Stay to Focus. *New York Times,* 2 August 2009. https://www.nytimes.com/2009/08/03/arts/design/03abroad.html#:~:text=PARIS%20%E2%80%94%20Spending%20an%20idle%20morning,roam%20as%20tourists%20around%20museums%3F
19 Clark, T. J. 2006. *The Sight of Death: An Experiment in Art Writing*. Yale University Press. New Haven and London. p. 1.
20 Reed, A. 2017. *Slow Art: The Experience of Looking, Sacred Images to James Turrell*. University of California Press, Oakland, CA. p. 11.
21 *Slow Art Day History – Getting Started | Slow Art Day*. https://www.slowartday.com/about/history/
22 Kimmelman, M.. 2009. At Louvre, Many Stop to Snap but Few Stay to Focus. *New York Times,* 2 August 2009. https://www.nytimes.com/2009/08/03/arts/design/03abroad.html#:~:text=PARIS%20%E2%80%94%20Spending%20an%20idle%20morning,roam%20as%20tourists%20around%20museums%3F
23 Bailey, A. (2019, April 5). Slow art? It Will "Blow Your Mind." *BBC News*. https://www.bbc.co.uk/news/entertainment-arts-47699001
24 McGivern, H. (2019, March 27). Relax and Immerse Yourself… The Art of Experiencing Museums Slowly. *The Art Newspaper* - International Art News and Events. https://www.theartnewspaper.com/2019/03/27/relax-and-immerse-yourself-the-art-of-experiencing-museums-slowly
25 Fuller, J. (1976). Atget and Man Ray in the Context of Surrealism. *Art Journal, 36*(2), 130–138. https://doi.org/10.2307/776161
26 Candlin, F. (2006). The Dubious Inheritance of Touch: Art History and Museum Access, *Journal of Visual Culture* 5: 137–54.
27 *Senses - Home page of the Concordia Sensoria Research Team (CONSERT)*. https://www.david-howes.com/senses/
28 Stewart, S. (1999). Prologue: From the Museum of Touch. In Kwint, M., Breward, C. & Aynsley, J. (eds.) *Material Memories: Design and Evocation*, 17–36. Oxford: Berg. p. 28.
29 Classen, C., & Howes, D. (2006) The Museum as Sensescape: Western Sensibilities and Indigenous Artefacts. In Edwards, E., Gosden, C., & Phillips, R. (eds.), *Sensible Objects: Colonialism, Museums and Material Culture*, Oxford: Berg, pp. 192–220.
30 Candlin, F. (2003), Blindness, Art and Exclusion in Museums and Galleries, *Journal of Art and Design Education*, 22: 100–110. London: Birkbeck ePrints. http://eprints.bbk.ac.uk/745
31 Tricycle. (2011). Visit a Melting Ice Buddha at the Rubin Museum of Art. Tricycle, March 25, 2011. https://tricycle.org/trikedaily/visit-melting-ice-buddha-rubin-museum-art/
32 Zazen means seated meditation, and is the form of meditation undertaken in Zen Buddhism.
33 Cage, J. (1961). *Silence: Lectures and Writings*. Wesleyan University Press. Middletown, Connecticut. p. 8.
34 Kostelanetz, R. (200)3. *Conversing with Cage*. (2nd ed.) Routledge. London and New York.

35 Ewing, T. (September 30, 2010). John Cage's 4'33": The Festive Sound of a Defeated Simon Cowell. *The Guardian.* London. https://www.theguardian.com/media/2010/sep/30/christmas-no1-facebook-campaign
36 Candlin, F. (2003), Blindness, Art and Exclusion in Museums and Galleries, *Journal of Art and Design Education*, 22: 100–110. London: Birkbeck ePrints. http://eprints.bbk.ac.uk/745
37 Classen, C., & Howes, D. (2006) The Museum as Sensescape: Western Sensibilities and Indigenous Artefacts. In Edwards, E., Gosden, C., & Phillips, R. (eds.), *Sensible Objects: Colonialism, Museums and Material Culture*, Oxford: Berg, pp. 192–220.

11 Conclusion
So where to start?

In drawing this book to a close, we felt it was important to return to some of the key themes that occur throughout, as well as briefly discussing the practicalities of training, and ways of measuring success and failures. We hope this work helps us all to "experiment with the ways that we care."[1] This spirit of experimentation is essential. Freeing well-being from the austerity gospel and happiness economics will, we hope, help it to find new and interesting ways to improve individual and collective well-being, to partake in the joyous exercise of questioning and collision that the museum offers.

As we consider the future we find ourselves in a strange place. It seems clear that, should we get to a post-pandemic world, well-being practices will come to have a greater recognition and place within many parts of society, museums included. It also seems fairly likely that some of the practises that have taken place previously may be limited in their practical application whilst restrictions or uncertainty prevail. This is more so if we are willing to accept that COVID-19 is likely a preview of what is to come in terms of future viral outbreaks. The question many are asking is how do we plan for a world in which viral outbreaks and restrictions are the norm.

Many acts of care and communities of well-being find a home in the margins; whether it is necessary, desirable or possible to bring these into the centre is an open question.[2] Perhaps museums can work as a bridge between differences, a safe space to explore what might be possible. It is hoped that the reader of this book will find space, if not in the centre then in the margins, to explore and play around with giving well-being a go in their own lives and museology, whilst remaining critically engaged with the process and context of the work.

Training

Let's start with you.

It feels like there is an almost inevitability that museum well-being will become increasingly professionalised, and formal courses, or modules within courses will develop. Over time there may even be specific professional qualifications and certifications. That being said this might not happen too quickly,

DOI: 10.4324/9781003163480-11

as it has been found that even medical schools aren't training doctors in issues around health and lifestyle, particularly issues such as nutrition.[3] One of the issues being that specialist advice is typically only available to those in crisis, thus removing the huge opportunity preventive medicine offers both in patient outcomes and cost savings. The reality is that museums offering well-being programming are not attempting to supplant medical or mental health specialists, but instead can offer complementary lifestyle support utilising the Five Ways to Well-being. In essence it is our contention that although there are differences between well-being programming and other museum programming, those differences are slim enough that specialist training is not a necessary prerequisite to working on well-being in the museum. Moreover, we would suggest that increasing professionalisation may potentially actually discourage participation. Our worry is that increasing standardisation and top-down formalism may stifle a more liberatory approach based on increasing experimentation and play within an ethical framework. What is good news is that this means that there are currently no barriers to starting, and why not start with you. We admit it, this book is a self-help book after all.

Certifiable training and more

Now although there might not yet be a certificate programme in museum well-being, there are plenty of certified courses in related areas that would be worth considering. It is often the case that well-being programming is focused around, and offers support to, vulnerable individuals, and the need to take a supportive role in this process. It would be beneficial for practitioners to seek knowledge of safeguarding, frontline staff training, where and how to direct people to specialist services available, and most importantly transparency. Training will differ depending on the country and or locality so the examples given are simply illustrative and not exhaustive. It is also worth remembering that when we are talking about the wider collective well-being, we need to be aware of socio-cultural-religious aspects of our communities as well as keeping a decolonial lens to consider issues of co-option, appropriation and the Western gaze. Although there are plenty of certifiable courses and anti-racism training, really getting out and talking to people will probably bring bigger gains.

Safeguarding is an area that we would recommend. In the USA the National Adult Protective Services Association (NAPSA) offers a certification programme[4] concerned with promoting the safety, independence and quality-of-life for the most vulnerable adults in our society: the frail, the elderly, and persons with physical and/or intellectual disabilities who are at risk of abuse, neglect and exploitation. They also have published guidelines for minimum standards.[5] In the UK the rules and regulations for safeguarding are outlined in the 2014 Care Act,[6] which sets out six principles that underpin the safeguarding of adults: empowerment, prevention, proportionality, protection, partnership and accountability. The Ann Craft Trust offers training in the UK on these principles, as well as similar training for safeguarding children.[7]

The next key element we would suggest considering would be a Mental Health First Aid certification course, run by MHFA England.[8] Mental Health First Aid England is a social enterprise that offers expert guidance and training to support mental health in the workplace and beyond. Their mission is "to train one in ten people in mental health awareness and skills."[9] Another really worthwhile course has been developed by the Alzheimer's Society, known as Dementia Friends. Once you have completed the course, you can register as a Dementia Friend. "A Dementia Friend is somebody that learns about dementia so they can help their community."[10] This kind of learning is so important to make museums more welcoming. The list of possible training opportunities could go on and on, however, we would highlight that you might not need to take the training yourself. If there is an area of well-being you'd be interested in programming, and if it's not something you are personally familiar with, you might want to consider partnerships. The wonders of partnership working mean that you don't need to be a master of any topic to programme it. The University College London also offers a short course with a general introduction to culture, health and well-being.[11] A discussion of partnership working, particularly making reference to Health Partnerships is considered, along with ways of measuring impact and advocating for well-being provision in the culture sector.

Whilst building up these skills to help others, remember that you might also want to consider what skills you need to build emotional resilience, patience and boundary setting. Of course, further training could be pursued by courses in social work, including studies in relationships and service provisions. This type of training is not currently considered necessary for core museum work, but perhaps going forward one day it will be. Before you start, there is one thing that you will want to do—ensure that your own well-being is being addressed. You will want to consider how you will approach your own self-care.

Self-care as collective care

Self-care is usually considered purely an individual activity, but we wanted to share an approach beyond the more familiar for your consideration, as it centres collective care as essential to self-care. This model is called the Hologram[12] and it has been developed by Cassie Thornton, a feminist economist and artist, who on her online bio describes herself as an "artist and activist who creates a 'safe space' for the unknown." A related earlier art programme by Thornton was called the Feminist Economics Department,[13] that provides experimental economic services such as debt visualisations, alternative credit reports and feminist economics yoga. The idea was to use these varied practises to move "beyond the limits of mere survivalism and narcissistic self-care, into the generative unknown of solidarity and interdependence."[14] The key was the development of collectivity and putting aside the idea of individualism. The new Hologram model built upon this earlier work and was also inspired by the free, nonhierarchical Group

for a Different Medicine at the Social Solidarity Clinic in Thessaloniki, Greece, during the financial and refugee crises.[15] These social solidarity clinics were an essential community response to the crisis.[16] As we have seen previously, mutual aid is a vastly underappreciated part of survival in the contemporary world, and a fertile training ground for well-being and self-care.

The Hologram is a system for non-expert healthcare, with the idea that it can be practised in any setting, although it would be more at home around the kitchen table than in a clinical setting. The Hologram describes itself as a feminist peer-to-peer health care system; that is to say, it is feminist in its approach and roles are fulfilled by the four participants; there are no professional or leadership roles. It is built from a very simple premise: three people, known as the triangle, meet on a regular basis, in person or online, to focus on three elements of the well-being of a fourth person, known as the hologram. These three elements are the physical, mental and social health of the hologram (the subject). In turn the hologram teaches the triangle how to give and also receive care. Over time, each triangle reflects a multifaceted image of the person, hence the term hologram. The viral nature of this system comes from the method of expansion, in which each member of the triangle seeks to become the hologram for a different triangle of people, and from there the same pattern repeats creating an ever expanding network.[17] This work of art demonstrates that you don't need professional expertise to create networks of care. You can gather a group of friends and care for one another.

How to review the impact of well-being programming at a museum

Let's assume you've started doing well-being programming, sooner or later you'll be asked whether it's working, or for an impact assessment or even a consideration of return on investment. All these questions send shivers down our spines as we witness the world of data reshaping value in our society. It's perhaps timely to remind ourselves of the CDC definition that well-being is a measure of "what people think and feel about their lives" and the "overall satisfaction with life."[18] There is an inherently ungraspable spectral nature to the idea of well-being.

> Happiness, in short, is an elusive concept, and it is difficult to pronounce on its quality or the extent to which it (and its associated states of pleasure, well-being or satisfaction), has been achieved. What should count in the estimation of the "good life"?[19]

Some have developed frameworks for accounting for social value or social impact based on "calculating the increase in income that would be necessary for an equivalent increase in wellbeing."[20] It is clear to us another approach is needed.

The difficulties with measurability are also compounded by the conflict of timelines. Typically those asking about impact are concerned with a very short

timeline, usually less than a single financial year, in order to make future funding decisions: was this or that activity worth the money spent on it? However, the real impact of such programming is likely to be realised on a much longer timeline. For example, in meditation practice it's often advised to check in on your progress once a decade. How would a museum design an assessment system to take that into account? We continue to view the process as being more important than the end result, that the act of bringing well-being into a space in which it was not previously is inherently a good thing. It begins a dialogue and a reconceptualisation of what the space means, and that most importantly this dialogue is an on-going place of contestation, immeasurable on spreadsheet and pie charts. We wonder if we might be measuring the wrong things, and perhaps should really be looking at the extent to which the institution has changed or been impacted.

However it's also more than this. There's also the subtle intangible differences: "that tiny, glowing world of metrics cannot compare to this one, which speaks to me instead in breezes, light and shadow, and the unruly, indescribable detail of the real."[21] It is this real difference in conception, well-being is about people, and all the mess and wonder that we are. It is difficult to quantify our real world because just like ourselves it is both real and imagined. The sorts of impact we might be interested in measuring are more likely drawing from that intangible unknowable imagined world, the many weird and wonderful ways ideas once shared are absorbed and developed in terms of making a constructive difference in community. Such measurables may be problematic for questions of funding approvals, but ultimately we believe it's important to keep these ideas in mind, even if also seeking to measure data required by management and funders. We would also add that there is however, a crucial element of assessment that is essential, that of debrief with the delivery team and a re-assessment of the process. This should be built into any programme from the start to ensure it happens. This is the opportunity to get a feel for how it went and for ideas that came up about how to make improvements for the future. This process reminds us that the end goal is not delivery of this programme, but an improved programme for next time—a constant feedback loop of improved future deliverability.

So although it is our contention that it is process, rather than end result, that is the key to a successful well-being programme, attempts have been made to develop evaluation models and data analysis. It is worth pointing out that all forms of measurement are by necessity not measuring well-being, but instead measuring something measurable and attempting to apply that as an indicator in this field of subjectivity. It is useful to contemplate this difference, as one of the key problems with data. There will in other words always be an element of interpretation. There is a whole body of literature and research surrounding evaluations in both clinical and museum settings. However, for simplicity's sake, we would group evaluations into three types: Observation, Participatory, and Hybrid. These all offer different approaches, the suitability of any type will be dictated by the questions you ask and therefore what it is you wish to find out.

Observation Evaluation

Observation Evaluation[22] involves researchers observing participants in projects. This is a common assessment method used within both museums and clinical settings. This analysis typically involves looking for indicators of pre-defined outcomes, and so there is the potential risk that by directing focus, the unexpected may be missed. One of the great advantages is that this approach often uses conversations, and although there is a risk of being led, they do offer more scope than simply box ticking. The Happy Museum Project, that offers a variety of toolkits and advice regarding impact assessments and reviews, includes the following three types of observational evaluation, drawn from psychology: interval observation, frequency observation and blow-by-blow account. With interval observation the goal is to observe repeatedly after a given time, and to log the behaviours you've planned to look for using a coded system. For frequency observation, the goal is to observe a limited number of participants for a set period of time, and count the number of times they exhibit the selected behaviours. Finally the blow-by-blow aims to record everything that happens and observe behaviours that both support and refute the expectations that have been set. This is the most complex and is likely unsuitable for most museum wellbeing scenarios. In all these methods it is necessary to have a clear set of defined outcomes and related observable behaviours, as well as a coding system that allows for recording frequency and intensity.

Participatory Evaluation

The next common assessment tool used within museums is Participatory Evaluations, which seek to measure the experience from the participant's point of view, typically this would include questions pertaining to whether the participant felt their well-being was improved. It is worth considering whether feedback needs to be gathered immediately at, or after an event, or sometime later.

Researchers at University College London published a freely available toolkit[23] that includes downloads to allow you to utilise the system in your own museum setting. This toolkit was born from experience in running the Heritage in Hospitals (HinH) project (2008–2011). Based on this experience, they've kept it simple.[24] The toolkit was developed after a series of Arts and Humanities Research Council-funded workshops in London, Newcastle and Manchester. During these workshops a desire for a generic museum-focused measure of well-being outcomes was expressed. In essence the authors of this toolkit brought their experience from a more clinical setting, hospitals and care homes, and proposed a simplified approach for the museum sector. The chosen methods were selected after a review of the health, well-being and quality of life scales commonly used in clinical settings.[25] However, in practice the project team found them to be time-consuming when used outside the healthcare environments, as well as containing superfluous words and overlapping content. The chosen scales included the Positive Affect Negative Affect Schedule (PANAS) for psychological well-being,[26]

and two Visual Analogue Scales (VAS) for subjective wellness and happiness.[27] These scales ask participants to rate negative and positive words for the emotions, and rating their wellness or happiness on a vertical scale.

Other examples of participatory evaluations have been developed by the Happy Museum Project, including their amusingly titled *Happy Tracker*,[28] which was developed by the Story Museum in partnership with the New Economics Foundation. The system is designed to take a feel of participants' sense of their own well-being at any one time using their bodies as a visual indicator; although if data is needed, responses could be recorded verbally or via forms. The process is remarkably simple: participants are asked to indicate their well-being on a 0–10 scale by putting their hands above their head for ten, and down by the ankles for zero. The aim is then to discuss their score and what effect it might have. The Story museum utilised this system in regular team meetings and found some refused to take part, high and low scores were muted, but actually over time the process helped shape an understanding of what matters for each team member. This sort of thing might be useful for getting a straw poll or sense of the room at any given time.

Another option for participatory evaluation is known as Embedded Evaluation.[29] In this system the aim is to embed the evaluation into the project itself. This technique draws upon ideas of visitor participation in museums.[30] The Happy Museum offers several examples of Embedded Evaluation. At the Story Museum visitors were given labels, colour coded or otherwise, to record their comments on, and either tie to artefacts, architecture or especially constructed "mood trees." Another iteration uses red and green mood post-it notes to be placed wherever the mood felt appropriate (an unfortunate colour choice, given the frequency of red-green colour blindness).

In our own research we've seen this approach taken a step further when used at St Fagans National Museum of History, where visitors are encouraged to comment not only on the exhibits but on other visitors' feedback, creating dialogues distributed by time; in this respect it becomes even more participatory. Another interesting example is given by the Happy Museum from the Beaney House of Art and Knowledge, in which the community project Paper Apothecary wove feedback directly into the activity. The project asked community groups to devise wellbeing "prescriptions" using the museum displays, then dispensed these to the public from a pop-up paper apothecary. The paper prescriptions asked visitors to record any side-effects, or comments and reactions to their cultural treatments via a tear off slip to post into the feedback box. This may seem a more elaborate way of asking questions, than getting direct feedback, however, they're clearly more fun than forms.

Hybrid Evaluation

Our final category of Hybrid Evaluation are those that use a bit of both the other methods. Probably the most widely utilised is known as Narrative Evaluation,[31] which seeks to collate and evaluate a variety of written feedback, whether forms,

interviews, visitor comments or material produced from participatory or observation evaluations. Typically such analysis would seek to identify the main themes and then to select specific quotes which are good illustrations of those themes, and to create from this a narrative for a report. An alternative approach to identifying themes in a narrative is through a word search; which will tell you the number of occurrences. For example you might pick keywords and find out how often they appeared. If relative numbers of occurrences aren't needed, the commonly used method to illustrate word frequency would be using a word cloud software. This approach decontextualizes the language utilised by the participants and then allows the frequency of particular vocabulary to be made visual.

Another example of a Happy Museum Project Hybrid evaluation is Valuation DIY.[32] The process is designed to be undertaken in a workshop, and most interestingly aims to empower participants to move beyond assessing the extent of outcomes but also the value of the experience. This automatically necessitates a longer term consideration and an investment in the personal and collective meaning of the programming. The workshop starts with a discussion of the concept of value. What does it mean to the individual, it might be financial, it might not be quantifiable, it might be being appreciated, it might be short or long term. Then the facilitator would show the participants the outcomes that the organisers had agreed the project would generate. The group would need to agree that on some level they were all achieved. Then the group must rank the outcomes in importance; ideally a consensus would be achieved in order to make the evaluation manageable. You could finish here. However, and this is the interesting bit, the Happy Museum suggests you can dig further into values. Asking participants to consider things they value in their own lives, you can then ask them to slow these values in between the outcome values, providing a meaningful proxy value for the outcomes which come from the participants themselves. What's so interesting is that by offering participants the chance to define the things they value, you can get away from the assumptions made by happiness economists, and incidentally the Happy Museum Project, that value can or should equates to financial value.

Final review

In considering your options for assessment, we would offer these final considerations, drawing upon our experience with mindfulness. It has been said that "mindfulness is participatory observation. The meditator is both participant and observer at one and the same time."[33] In our observation as mindfulness practitioners, we are taught that all activities are imbued with three possible feeling tones: positive, negative and neutral. These are known as vedanā in the Pali canon, and as valence of hedonic tone in psychology. They form one of the four foundations of mindfulness alongside, namely mindfulness of the body, feelings, mind and phenomena. Throughout the Sutta Pitaka, the Buddha teaches that there are these three modes: *sukhā* (pleasant), *dukkhā* (unpleasant) and *adukkham-asukhā* (neither pleasant nor

unpleasant).[34] We wonder therefore whether attempting to delineate greater clarity than that is really fruitful.

Furthermore, we would remind you that if the Five Ways to Well-being are correct, as we believe them to be, then Connection itself will increase well-being. Another example of this could be seen where the Heritage Lottery Fund published an interesting study into the well-being impacts of volunteering with their projects "exploring if and how engaging with HLF funded projects has a measurable effect on the well-being and health of volunteers."[35] The report usefully compares the results with HLF volunteers and Oxfam volunteers. Unsurprisingly in both instances well-being improved, slightly more with the Oxfam volunteers. However, conclusions appear to be made on the assumption that it is the volunteering that increases well-being, and it's more a question of which type, or the specifics of the individuals involved, whereas a more intriguing comparison may have been with a non-volunteering activity that involved a similar group dynamic. We can't help wondering whether the specific nature of a well-being practice, whether it be object handling or art appreciation, or volunteering, is the source of increased well-being or whether the fact that a neglected elder in a care home, or a bored patient in a hospital ward or a neurodivergent museumgoer was given the care of connection. This doesn't detract from the viability of the programme you may wish to offer, far from it, instead it opens up the possibility that most, if not all, museum practises could, and probably do, contain a well-being potential.

We hope this is just a beginning

We believe in a museology of collective well-being.

We hope you find your own personal approach to well-being in the museum, and we support and wish you well on your journey.

We encourage you now to…

Connect. Be Active. Keep Learning. Give. Take Notice.

Notes

1 Chatzidakis, A., Hakim, J., Littler, J., Rottenberg, C., & Segal, L. (2020). The Care Collective, *The Care Manifesto: The Politics of Interdependence.* Verso. London and New York. p. 33.
2 Hadi, S. A. (2020). *Take Care of Your Self: The Art and Cultures of Care and Liberation.* Common Notions. Brooklyn, NY. p. 132.
3 Womersley, K. & Ripullone, K. (2017). Medical Schools Should Be Prioritising Nutrition and Lifestyle Education. *British Medical Journal, 359*;j4861 doi: 10.1136/bmj.j4861 (Published 2017 October 26) http://culinarymedicineuk.org/wp-content/uploads/2018/12/Medical-schools-should-be-prioritising-nutrition-and-lifestyle-education.pdf
4 National Adult Protective Services Association. NAPSA Certification. https://www.napsa-now.org/the-napsa-certificate-program/
5 National Adult Protective Services Association. (2013). *Adult Protective Services Recommended Minimum Program Standards.* http://www.napsa-now.org/wp-content/uploads/2014/04/Recommended-Program-Standards.pdf

6 UK Parliament. (2014). Care Act 2014. https://www.legislation.gov.uk/ukpga/2014/23/part/1/crossheading/safeguarding-adults-at-risk-of-abuse-or-neglect/enacted?view=plain
7 Anna Craft Trust. https://www.anncrafttrust.org/safeguarding-adults-training/
8 MHFA England. https://mhfaengland.org/
9 Ibid. (2019). *Impact Report*. Retrieved from: https://mhfaengland.org/mhfa-centre/impact-report-2019.pdf
10 Dementia Friends. https://www.dementiafriends.org.uk/
11 Chatterjee, H. (2018). Course: Culture, Health and Wellbeing: An Online Training Course from the Culture, Health and Wellbeing Alliance. University College London. https://www.ucl.ac.uk/short-courses/search-courses/culture-health-and-wellbeing-introduction
12 Thornton, C. (2020). *The Hologram: Feminist, Peer-to-Peer Health for a Post-Pandemic Future*. Pluto Press. London.
13 Feminist Economics Department. http://feministeconomicsdepartment.com/
14 Ibid. http://feministeconomicsdepartment.com/secret-chakra-feminist-economics-yoga/
15 Care Notes Collective (ed). (2020). *For Health Autonomy: Horizons of Care Beyond Austerity—Reflections from Greece*. Common Notions. Brooklyn, NY. p. 12.
16 Evlampidou, I. & Kogevinas, M. (2019). Solidarity Outpatient Clinics in Greece: A Survey of a Massive Social Movement. *Gaceta Sanitaria, 33*(3): 263–267. https://doi.org/10.1016/j.gaceta.2017.12.001 p.266.
17 Thornton, C. (2020). The Hologram: Feminist, Peer-to-Peer Health for a Post-Pandemic Future. https://thehologram.xyz/#what-is-it
18 Centers for Disease Control and Prevention.(n.d.) Well-Being Concepts. https://www.cdc.gov/hrqol/wellbeing.htm
19 Soper, K. (2013). The Dialectics of Progress: Irish "Belatedness" and the Politics of Prosperity, *Ephemera, 13*, pp: 249–267.
20 Social Value International and UK Cabinet Office. (2012). Standard on Applying Principle 3: Value the Things That Matter. *The Guide to SROI*. p. 14. https://socialvalueuk.org/wp-content/uploads/2021/04/Standard-for-applying-Principle-3.pdf
21 Odell, J. (2019). *How to Do Nothing: Resisting the Attention Economy*. Melville House. London. p. 29.
22 The Happy Museum. (2016). Observational Evaluation. https://happymuseum.gn.apc.org/wp-content/uploads/2016/03/HM_11_Observational_evaluation_Feb2016.pdf
23 Thomson, L. J. & Chatterjee, H. J. (2013) UCL Museum Wellbeing Measures Toolkit. University College London. https://www.ucl.ac.uk/culture/sites/culture/files/ucl_museum_wellbeing_measures_toolkit_sept2013.pdf
24 Thomson, L. J. & Chatterjee, H. J. (2015). Measuring the Impact of Museum Activities on Well-Being: Developing the Museum Well-being Measures Toolkit, *Museum Management and Curatorship, 30*(1): 44–62, DOI: 10.1080/09647775.2015.1008390
25 Thomson, L.J., Ander, E.E., Menon, U., Lanceley, A. & Chatterjee, H.J. (2011). Evaluating the Therapeutic Effects of Museum Object Handling with Hospital Patients: A Review and Initial Trial of Wellbeing Measures. *Journal of Applied Arts and Health, 2*(1), 37–56.
26 Watson, D., Clark, L.A., & Tellegen, A. (1988). Development and Validation of Brief Measure of Positive and Negative Affect: The PANAS Scales. *Journal of Personality and Social Psychology, 54*, 1063–1070.
27 EuroQol Group. (1990). EuroQol: A New Facility for the Measurement of Health-Related Quality of Life. *Health Policy, 16*, 199–208.
28 The Happy Museum. (2016). The Happy Tracker. https://happymuseum.gn.apc.org/wp-content/uploads/2016/03/HM_7_Happy_Tracker_Feb2016.pdf
29 The Happy Museum. (2016). Embedded Evaluation. https://happymuseum.gn.apc.org/wp-content/uploads/2016/03/HM_9_Embedded_evaluation_Feb2016.pdf

30 Simon, N. (2010). *The Participatory Museum*. Museum 2.0. Santa Cruz.
31 The Happy Museum. (2016). Narrative Evaluation. https://happymuseum.gn.apc.org/wp-content/uploads/2016/03/HM_10_Narrative_evaluation_Feb2016.pdf
32 The Happy Museum. (2016). Valuation DIY. https://happymuseum.gn.apc.org/wp-content/uploads/2016/03/HM_12_ValuationDIY_Feb2016.pdf
33 Venerable Henepola Gunaratana Mahathera. (1991). *Mindfulness in Plain English*. The Corporate Body of the Buddha Educational Foundation, Taiwan. p.147
34 Nyanaponika, T. (2010). "Datthabba Sutta: To Be Known" (SN 36.5), translated from the Pali. *Access to Insight (BCBS Edition)*, 30 June 2010. http://www.accesstoinsight.org/tipitaka/sn/sn36/sn36.005.nypo.html
35 Rosemberg, C., Naylor, R., Chouguley, U., Mantella, L., & Oakley, K. (2011). *Assessment of the Social Impact of Volunteering in HLF funded projects: Yr 3*. BOP Consulting. London. p. 8. https://www.heritagefund.org.uk/sites/default/files/media/research/social_impact_volunteering_2011.pdf

Index

10,000 steps 66
13th Amendment 62
2004 tsunami in Sri Lanka 53
2014 Care Act 109
ableism 21, 37
abolition 15, 27, 37, 62, 79
academic 1, 4, 70, 96
acceptance 42, 55, 84, 100
access: digital 16; disabled 23, 51; diversity 5; education 2, 74; mental health care 36, 45, 75; partially-sighted 10; physical 20, 58, 68; and preservation 70; and take notice 103, 105
accountability 63
actions 15, 42, 45, 56, 61, 85–87
active citizen 43, 90
active minutes 66
active viewing 5, 64–65
activism 30
addiction 55–56 *see also recovery*
advertising 57
African 21, 63
African-American 23, 63
Against Health 37
Age Friendly Museums Network 12
Age of Creativity 12
age of irresponsibility 8
ageism 37
air circulation 19
alienating 33
alienation 15
Alison Lapper Pregnant 51
All-Party Parliamentary Group of Arts, Health and Wellbeing 12
altruism 2, 5, 44, 85–89, 91
Alzheimers Society 110
American 49, 51, 53, 73, 79
American Disabilities Act 20

American Museum of Natural History 10
andesite 73
Anglo Spanish War 84
Ann Craft Trust 109
Anthropocene 16
anti: -art 65; -Blackness 37; -psychiatry 77; -racism 98, 109; *see also racism*; -suffrage 52
anxiety 42, 54, 69, 105
Arab 21, 49
Aramean 49
architecture: 19, 21, 114; Māori 96; monumental/propaganda 97; municipality 24; museum 26, 63; racism 23
archival 49
Art Fund 12
art history 57
art therapy *see also therapy*
artist: 65, 77, 98, 99; project 53; studio 24; community of 76; contemporary 44, 57, 67, 104; neurodiverse 75; proletarian 37; under-represented 55; working 23
arts and crafts 11
Arts and Humanities Research Council 113
Arts Council England 11
Asian 49
assessment 5, 64, 70, 87, 111–113; 115
assessment sheet 36
assimilationist 22
asymptomatic 6
Atget, E. 103
audience segmentation 5, 55
austerity: 8–9, age of 2, 8, 11; gospel 12–13, 32, 108; nostalgia 8; spectre of 5
authentic: 43, 44, 58, 70, 79
autism awareness 20

Index

autonomy 42, 51
Avon and Wiltshire Mental Health Partnership NHS Trust 11

back to work 36
banjo 61–62
Bare Minimum Collective 27
barriers: 109 to connection 4, 53; to learning 80; to participation 30, 55, 86 linguistic 97
Barthes, Roland 65, 98
Bartolozzi, Francesco 83
Be Active: 3, 5, 62–71, 116
Beaney house of art and knowledge 114
Beckford, P. 78
Beckford, W. 78
Beckford's Tower 78
behaviour 15, 51, 56, 80, 85, 113
belly-dancing 33
belonging 19, 52, 56, 58, 92
beloved community 38, 53
benefits: government assistance 36, positive 12
benign neglect 70
Bentham, J. 32
Best, E. 96, 97
better is the enemy of good 46
Bhaba, H. 24
bicycle desk 34
Big Lebowski 33
Big Society 9–10, 12, 15
binary 2, 37, 69, 86
Biography of the Artefact 91, 54
biomorality 4, 13, 14, 33–35, 37, 86
biophilia 21, 48
Blank slate sites 25
blind 10, 104, 114
Bloom's Taxonomy 5, 74, 81
blow-by-blow account 113
blues, the 57
Bob and Roberta Smith 53
bodhisattva 72, 73
body: count 9; difference 5; dysmorphia 54; mass index (BMI) 34; parts 32; positivity 37; everybody 21, 38; idealised 68–69; illness and 35, 37; in the museum 64–65, 68–69; mind/body 35, 101, 105, 115; social 37; of text/literature 3, 112;
bored 34, 81, 116,
boundary setting 110
Bournemouth University 11
box ticking 36, 113
brain chemistry 54

bravery 55
breakthrough 54
Bregman, R. 85
Brill, P. 53
Bristol Pound 90
British Museum 11
brushstrokes 64, 99
Buddha 10, 72, 73, 74, 104, 115
Buddhism 73, 78, 104,
budget 5, 91
built environment 24
burnout 36
business: 6, 13, 32, 36, 96; business model 66
busyness 52

Cage, J.104–105
Cairo 21
calm 8, 12, 57, 98, 102
Cameron, D. 13
Cantle Report 22
capitalist realism 13
care: home 88, 113, 116; carelessness 14; carers 15; for others 53; self-care 5, 13, 14, 35, 44, 53, 77–79, 98; self-care as collective care 110–111
Casimir, Prince J. 84
Catholic workers movement 15
celebration 57, 103
Centers for Disease Control and Prevention (CDC) 2
certification 109, 110
Champernowne, I. 76
chanting 55, 63
charitable causes 31
charities 8, 9, 87
Charlestown Community Primary School 101
childhood 19, 21
chivalry 90
chosen families 55
Christian 12, 21, 89
Christian-anarchism 89
Christmas 63, 105
church 13, 24, 52
city: 49, 56, 76; feminist 22; financialised 25; life 22; street 21
civic life 24
Clark, T.J. 64–65, 98–99, 101–102
class (group) 70, 98; class (socio-economic): 20, 79; class prejudice 13; classism 21; managerial 35, 37; middle 42, 80; politics 38; working 33
cleaning routines 19

Clegg, N. 13
Cleveland 10
climate crisis 16
clinical 12, 25, 26, 111–113
clock tower 66
club: 52; book 54; sports 31; football 31; activity 31
coalition government 8
coded system 113
coerced happiness 20
coercive power 37
Cognitive Behavioural Therapy (CBT) *see also IAPT/CBT*
cognitive dissonance 30
collection record 49
collective: joy 57; liberation 5, 53, 63; note-taking 15; property 90; self 87
collision 3, 20, 22, 23, 108
Colonial Countryside 78
colonialism 68, 78,
comfort zone 26
common ground 21–22
common land 90
communication 12, 33, 52, 88
communities of colour 23
community: care 77, 79; organisations 43, 52, 90; programming 90; wealth 91; well-being 24, 48
commute 34
commuting 24
competitive wellness 54
complementary lifestyle support 109
Concordia Sensoria Research Team (CONSERT) 104
conscious 75, 76, 100
conservation 14, 46, 96
conservators 5, 57, 64, 70, 96–97, 100
contemplate 12, 112
contested space 19, 26
Convergence 102
conversations 1, 53, 100, 113
corporate 8
corporate world 33
corporation 33, 38
cost of living crisis 14
cost savings 109
costume 57
counter-extremism 22
countercultural 10, 14, 25, 26, 33, 76
COVID-19: 1, 4, 5, 66, 68, 87–88, 90, 92, 108; pandemic 1, 4, 5, 42, 66, 90; restrictions 51, 54, 58
creation of Adam, the 90
creativity 2, 22, 25, 33, 37, 53

criminology 54
Cuban 31
cultural: appropriation 68; assumptions 5; ideal 33; sensitivity 97
Cultural Commissioning Project 12
culturally: biased 78; inappropriate 68; influenced 4
culture sector 110
Culture, Health and Wellbeing Alliance 12
Curator of Discomfort 26
customer satisfaction 5
cuts 14
cynicism 85

Dadaists 65
daguerreotypes 95
daily walk 20, 100
dance 57, 63
Dancing in the Street: A History of Collective Joy 57
Dancing Lesson, The 5, 61, 62, 64
Dass, R. 10
Data: 10, 50, 54, 77, 111, 114; analysis 112; collection 32; limitations 87; measurement 112; sets 5
Deas, J.A.C. 10
death 5, 9, 89,
Death of Sir Philip Sidney at the battle of Zutphen: He passes a water-flask to a fellow soldier, the 5, 83, 89
decluttering 12
deep: history 21, 32; noticing 5
delusion 55
dementia 110
Department for Culture Media and Sport (DCMS) 10
Department of Public Health 10
depressed 36, 57
Depression 54, 57, 69
Derry 58
detox 43
Detroit 58
Deuchar, S. 12
diorite 73
disability: 11, 20, 36, 109; access 23; advocacy 38, Disability Discrimination Act 20; rights movement 20; representation 51; sanctions 36; veterans 11
Discomfort 26,
disengagement 44, 80
Disneyfication 2
diverse programming 42

diversifying 55
diversity 5, 63, 75
divine disorder 69
doctor: 13, 35, 62, 77, 109; under doctors' orders 16
documentation 3, 4, 50, 80, 81, 96, 103
Doing good better: Effective Altruism and a radical new way to make a difference 87
doing nothing 37, 67
domestic tasks 12
Dominion Museum 95
drawing, *see also sketching*
duality 5, 53
Duchamp, M. 44
Dutch Republic 84
dystopian 19

Eakins, T. 61, 62, 64
East, the 33
economic downturn 30
economists 69, 115
Education/Learning Departments 74
Edwardian 96, 97
Effective Altruism 5, 87, 91
ego-centric 53
Egyptian 21
Ehrenreich, B. 57
Eighty Years' War 84
Eisenstein, C. 91
Éist, the 58,
Elizabethan 83, 84, 89, 90
Emancipation: 62, 63; Proclamation 62
Embedded Evaluation 114
embodiment 31, 73, 89
emergence 3, 91
emotion/al: 2, 10, 57, 65, 85, 98, 114; growth 26; needs 44; resilience 110; states 75; support 89
empowerment 109
engaged life 42
English Heritage 11
enjoyment 12, 100
entrepreneurial 13, 34
Equality Act 20
Ergotamine 25
ethnography: 98; ethnographer 96–98; ethnographic 97
eudaimonic happiness 42
eugenicist 37
Europe: 9, 10, 30, 57, 102 european identity 90
evaluation models 112
event programming 55

exchange 88, 91
exercise 66–67, 98
Exeter 76
exhibit 2, 101, 103, 104, 113
expectation 5, 69, 113
exploitation 33, 78, 85, 109
external actions 56
extra-parliamentary 15
extrovert supremacy 20
eyes on the street 56
factory floor 30
failure 15, 22, 31, 35, 68, 97, 108
Fair Museum Jobs 30
faith 13, 102
fame 50
Fantasia 102
farming 11
fat 37–38
fatigue 5, 68
fear 22, 30, 35, 53, 80, 98, 105
feedback 104, 112–114
feel better 8, 43
feeling tone 115
female 23, 68
feminism 51, 52
feminist: 51, 52, 111; city 22; Economics Department 110; Economics Yoga 110; museum 23
festival 25, 63
fifth column 35
financial crisis 44
First World War 10, 96
fit-note 35–38
fit-to-work 35, 38
Fitbit 66
fitter 13
Five Girls 95
flow 42, 102
folk art 55
food: 5, 51, 86; bank 9, 24
forgiving 86
Fountain (1917) 44
four foundations of mindfulness 115
fragment 4, 49–51, 65
freedom 20, 52, 63, 87
French 21, 84
frequency observation 113
Freud, S. 76
Freudian 25
friendship 2, 86, 91
front of house 99
Front of House in Museums 30
frontline staff 109
furloughed 30

gallery 19, 43, 44, 67, 68, 99, 101, 103
gamifying 32
gatekeeping 30, 97
gaze 65, 104, 109
gelatin glass negative 95
gelatine silver developed-out-print 95
gender: 20, 22, 79; cis- 68, 80; individual 38
genetics 42
Getty Museum 98, 102
ghosts 25
Gi-hun 89, 90
Gift economy 88, 90, 91
gift exchange 87, 90
giving person 86
global commons 5
God 13, 73, 90
Goldman, E. 63
good for you 31, 54
Google 31
Gospel of Mark 86
Gradual Abolition Act 62
Grain of emptiness: Buddhism-inspired contemporary art 104
grassroots organisation 30
gratitude 42, 44, 101
Greater London Council (GLC) 25
Greater Manchester Health Trust 101
Greece 111
Greville, F. 85
Grof, S. 25
Gross Clinic, the 62
Group for a Different Medicine 110
Group for Education in Museums 12
Gurian, E.H. 23
guru 32–37
gyms 2, 35

habits 43, 45, 63, 66, 78
habitual 13
Haig, M. 44
Haleem, A. el- 21
handling sessions 10
Happiness Economics 32, 34, 108
happiness index 9
Happy Museum Project 12, 43, 113–115
Happy Tracker 114
hauntological 21, 25
healing: 2, 21, 22, 58, 98; community 5
health: 9; partnerships 110
healthcare 111, 113
healthier 13, 66
healthy 2, 13, 33, 34, 37
hedonic happiness 41

hedonic tone 115
Heidelberg Psychiatric Clinic 76
Heritage in Hospitals (HinH) Project 113
Heritage Lottery Fund 3, 11, 116
heterotopia 19, 21, 26,
hierarchies 44
hobbies 52, 86
Hoffman, H. 102
Hofmann, A. 25
holding space 3, 26
Holloway Women's Prison 15
Hologram 110–111
home life 32
hooks, b. 24
horizontal organisational structures 52
hospital 10, 11, 21, 88, 113, 116
housing 24, 25, 86
Hsieh, T. 32
human: aesthetics 21; connection 51; -centred design 19
Human Henge 11
Hunterian, Glasgow 26
Hurst, A. 11
Hybrid Evaluation 112, 114
hyperobject 16

IAPT/CBT 36
Icarus Project 53
identity politics 51
idleness 103
illness: 5, 35, 38, 43–45, 53–54, 102; and the body 35, 37; chronic illness 5, 36
impact assessment 111
inauthenticity 44
incarceration system 87
inclusivity 25, 26, 34
Increasing Access to Psychological Therapies (IAPT) see also IAPT/CBT
indigenous 96, 98: art 96, 97; identity 5, 96; land back 23,
individualism 90, 110
inequality 69, 84
influencers 12, 42
intangible culture 25, 61
intercultural: 4, 22; dialogue 79
internal landscapes 100
internal lives 56
interpersonal narrative 53
intersectional 22, 24, 68
intersectionality of oppression 77, 85
intrapersonal narrative 53
intrinsic value 10
Islam: 73; Islamophobia 22, 38

Jacobs, J. 3, 56,
Jamaica 78
Jefferson, T. 79
Jewish Museum 102
Johns Hopkins University Advanced Academic Programs 1
jolly nice fellow 31
journaling 38, 43, 75
joyous 5, 108
juggling 5
Jung, C. 76
justice 58

Keep calm and carry on 8
Kim, A. 104,
kindness 85
Kings Servicemen 11
kitchen table 11

Landscape with a calm 98, 102
Landscape with a man killed by a snake 102
Lapper, A. 51
Latinx 49
Lavendaire 42, 43
law of attraction 69
laziness 52, 85
learn for resilience 43
leisure 51, 52, 81
lexicon 4, 6, 19
LGBTQ+ 9
liberated communities 22
liberation 5, 33, 53, 63
life satisfaction 41
lifelong education/learning 45, 79
lifestyle 12, 42, 66, 109
Limehouse Aid 24
Lincoln, A. 61–63
Lincoln, T. 61–63
local: 45, 76, 88, 90; purchasing 15; spending 91
lockdown 5, 19, 56, 66, 67, 80
locking down 15
Lombroso, C. 77
loneliness 9, 56
long COVID 5, 36, 56
Long Live Southbank 25
Long, R. 67
Lorde, A. 77
Los Angeles 49
Louvre Museum 101
love: 13, 15, 21, 30, 38, 42, 86; letter 21
low impact 64
LSD 25, 26, 76

MacAskill, William 87
magical thinking 69
male 23, 61, 68, 72, 97
Man of Genius, the 77
Man Ray 103
Manchester 101, 113
Manchester Art Gallery, the 101
Manchester Mind 101
Manchester Museums & Galleries Partnership 11
Manhattan 23
manifestation 6, 73
manifesto 27, 99
Mañjus´rı 5, 72–74
Māori 5, 94, 96–98
margin, the 24, 108
marginalised communities 2, 9
market: 8, 12; economy 91
marketing 12, 57, 78
Markle, M. 42
material: conditions 30; well-being 41
Maverick Hall 105
McDonald, J. 95–97
McDonalds 9
McMindfulness 35
meaningful life 42
measurability 111
measuring: activity 65; success 108
medical establishment 21
Mediterranean 21
memories 15, 21, 25, 98
memory 3, 50, 54
mental disorder 69, 75, 77 *see also: anxiety, depression, neurodiversity*
mental illness 45, 53, 54
mentally ill 45, 76
Merchant, N. 34
metrics 34, 86, 112
Mezzaterra 21, 22, 24, 26
mezzotint 5, 83, 84
MHFA England 110,
Michelangelo 90
microbial 10
migrants 79
military 11
mindful museum, the 101
Minecraft 73
misogyny 21 *see also sexism*
mission 2, 32, 41, 58, 70, 74, 104, 110
mixed primary uses 56
modification 20, 64
Monticello 79
Monty Python 11
moral failure 35

motion pictures 95
Mount Vernon 79
Mrs. Dalloway 56
Mrs. Delgado 56
municipalism 24–26
Museum as Muck 30
museum of care 23
Museum of Modern Art (MoMA) 102
Museum of Natural History 10
Museum of New Zealand Te Papa Tongarewa 96
museum of well-being 19
museum well-being toolkit, 43
Museum Wellness Network 30
Museums Association 11
Museums on Prescription 43, 55
music 57, 61–63, 75–76, 99, 105
mutual: aid 14–16, 24, 27; trust 56

narcissism 54, 110
National Adult Protective Services Association (NAPSA) 109
National Alliance for Arts, Health and Wellbeing 12
National Alliance for Museums, Health and Wellbeing 11
National Gallery, London 102
National Museums Liverpool 11
National Trust 11, 46
natura morte 99
nature 21, 58, 85, 99
negative affect 41
Nelson-Atkins Museum of Art 23
neurodiverse 45, 75, 87, 116
New Economics Foundation (NEF) 45
New Zealand 95–97
Newcastle 113
Newsnight 8
NHS 11, 36
No Body is Disposable Coalition 37
nondirective 41
noticing 5, 65, 98–100
noting 9, 14, 98

Objects from Indigenous and World Cultures 98
observation evaluation 113, 115
Odell, J. 52
Office of National Statistics (ONS), UK 42
Ohio 10
Oldenburg, R. 23
Oldham 22
openings 55, 80

Operation Nightingale 11
opioid crisis 14
oppression 20, 63, 77, 85, 87 *see also intersectionality of oppression*
Order of the Garter 84
othering 77
outsider art 55
overstimulation 64
Oxfam 116

Palmyra 49
Paper Apothecary 114
PAR-Q 70
Parallel Lives 22
partially sighted 10, 104
participatory evaluation 113, 114
patience 103, 110
patriarchy 22, 51, 85
Pennsylvania general assembly 62
Pennsylvania hospital 21
performance art 5, 65
person-centred approach 41
personal narrative 53, 64
personal protective equipment (PPE) 88
Personal well-being score (PWS) 42
Phoenix Museum of Art 101
photography: 5, 50, 65, 95, 99, 103; digital 95
physical activity/ies 31, 63, 65, 69, 101 *see also exercise*
police state 37
policing 22, 23
political correctness 69
political party 38, 52
Pollock, J. 102
popular culture 12
population-wide approach 45 *see also public health*
portal 3, 4, 15, 16
Portrait of a Londoner 56
positive: affect 41, 113; spiral 58
Positive Affect Negative Affect Schedule (PANAS) 113
Positive Psychology 4, 8–9, 13, 32–33, 42, 45
post-conflict transformative justice 58
post-modern conservation 96
postcolonial 24, 69
Poussin, N. 98–99, 102
preservation 62, 70
Preston model 5, 91
preventive: health measures 44; medicine 109
Prinzhorn, H. 75–76

prison 10, 15, 37
productivity 31, 33–34, 37–38, 44, 80, 86
Proletkul 37
prosperity gospel 12
Protestant 12
protests 22
proxy value 115
psychoanalyst 26
psychological 32–33, 36, 41, 45, 76–77, 86
psychotherapy 41, 75–76
PTSD 11
public domain 70
public health 10, 12, 45
Public Health England 12
punctum 65, 66, 98

Quality Adjusted Life Year (QALY) 87, 88
Queen Victoria 97
quiet 20, 26
Quinn, M. 51

R number 6
racial: identity 49; justice work 58
Racism: 21, 98, 30; history of 23, 79; institutional 86; *see also anti-racism*
ramps 20
real, the 19, 24, 112
recovery 11, 16, 55
recreational 25
refuge 36, 38
refugee crisis 14, 111
relationships 2, 42, 44, 48, 56, 58, 86, 103, 110
religion 63
relocalisation of resources 90
reparations 79
reproducibility 95
Research Centre for Museums & Galleries 11
resilience 2, 43, 56, 75, 110
resistance 24, 33, 35, 52
restoration 46, 50, 57
Restoration Trust 11
Richmond Fellowship 11
Rievaulx Abbey 11
right to be sick 37
riots 22
risk assessment 64, 69, 70
Rolling Stones, the 21
Roman Empire 84
Rorschach Test 77
routine 19, 63

Roy, A. 4, 6, 15
Royal Festival Hall 25
Royal Ontario Museum (ROM) 43
Rubin Museum 104
rupture 6
Russian revolution 37
Russian society 88
Ryff, C. 41, 42

Sae-byeok 89
safety 8, 22, 23, 109
Sang-woo 90
SARS-CoV-2 *see also COVID-19*
sceptics 6, 43
school: 5, 45, 52, 74, 80; of the blind 10; medical 109; of thought 73;
scotch egg 6
sculpture fragment *see also fragment*
Seale Hayne Hospital 11
Second World War 8
secret to a good life, The 53
secularisation 2, 63
self-acceptance 42
self-actualisation 33, 34
self-care: 5, 13, 14, 35, 44, 53, 98; as collective care 110, 111; as community care 77–79
self-help: 2, 13, 14, 109
Self-Help, book 13, 14, 32
selfish 14, 52, 85, 86
Seligman, M. 8, 13, 42,
sensory backpack 20
sensory map 20
set and setting 26
sexism 21
sexuality 20
shell shock 11
shelter 51
Shiva 73
sick: 11, 38; sickie 35; sickness 5, 33, 35, 37; pay 33; the right to be 37;
sick note *see also fit note*
sick woman theory 38
Sidney, P. 5, 83–85, 89, 90
singing 63 *see also chanting*
Sisters Uncut 15, 22
Six Happy Museum principles 43
six-factor model of psychological well-being 41, 42
skateboarder 25
sketch/ing 5, 11, 102, 103
slaves 33, 62, 79
sleep 44, 51
Slow Art 5, 101–103

Smiles, S. 13, 14, 32
smoking 34
social: capital 5, 56, 91; change 15; housing *see also municipalism;* prescribing 43; value 111
Social Solidarity Clinic 111
social-distancing 6, 19
socialising 52, 90
solidarity 8, 14, 15, 79, 90, 110
Solnit, R. 67
Somerset Public Health 45
Soueif, A. 21
sound walk 67
Southbank Centre 25
Spain 57
spatial: 19, 25–27; spatial exclusion 20, 104; spatial imaginaries 24
Specialist Educational Needs (SEN) 20
spectrum 2, 9, 10, 45
spiritual violence 34, 35
Sport in Museums Network 12
sports club *see also club*
sprung 46
Squid Game 5, 89, 90
St Fagans National Museum of History 114
St Katharine's Precinct Project 24
Stanley, J. 68
Start in Manchester 101
statue 10, 51
Stonehenge 11
Story Museum 114
stress 5, 11, 34–36, 44, 48
striving 88
studium 65
subconscious 50
subjective well-being (SWB) 41
substantial meal *see also scotch egg*
suffering 13, 36, 78, 86
suicide 5, 87
Sunday drive 23
Sunderland Council Blind School 10
Sunderland Museum 10
supremacy of sight 10, 103–104
Sutta Pitaka 115
sympathetic design 64
symptom pools 53

Tahrir Square 21
tai chi 63
teaching 52, 86, 97
Terry, P. 101
Thackray Medical Museum 11

therapeutic: 26; community 76; landscapes 11; learning 75
therapists 76, 87
Therapy: 36, 41; art therapy 5, 53, 55, 75, 76; talk therapy 53; *see also IAPT/CBT*
Thessaloniki 111
Third place 23, 24
third space 23, 24
Thirdspace 24
Thornton, C. 110
Three Questions, the 88
tidying 12
Tig, the 42
time bank 90
Tolstoy, L. 54, 88, 89
Tonglen 78
Touch: 10, 87, 88, 92, 104; in museums 10; touch points 19
tourism 44
Toyoda, S. 13
Toyota 13
trade union 30, 31, 33
tradition: 12, 23, 26, 31, 38, 57; Haitian Dance 63; Hindu 73
traffic 15, 34
training: 5, 41, 108, 111; anti-racism 109; doctors 109; conservation 46; high-intensity 68; the mind 72–75, 100, 101; psychological 45, 110
trans-action 5, 88, 90
transmission 6
transnational anglophone yoga 68
transparency 68, 109
trauma: collective 6, 58; cultural differences 53; event 4, 30; healing from 2; PTSD 11
treadmill desk 34
Tressel, R. 13
triage 37, 87
tripartite model of subjective well-being 41
Trivedi, H. 68
Tudor, D. 104
Tyne & Wear Archives and Museums 11

UCL Museums on Prescription project 55
UCL Public and Cultural Engagement 11
UK Medical Collections Group 11
unaccountable wealth *See also wealth*
unconscious 75, 76, 98, 100
undercroft 25
unemployment 32
UNESCO 79

union 30, 31, 33, 35, 52
University College London (UCL) 43, 110, 113
University of Leicester's School of Museum Studies 11
unlearn 5, 68
unproductive 23
upward-spiralling 90
user experience 56
utopia 19

vaccine 6
Venus de Milo 50
veteran 11, 21
vibration 64, 68
Victorian 5, 13, 96, 97
viral 108, 111
visitor: 4, 23, 36, 43, 54, 55, 58, 67, 74, 91, 97, 99; centre 15; comfort 79; experience 66, 104; feedback 114, 115; journey 20; circulation 19, 64, 102; participation 113; survey 78; virtual 70
Visual Analogue Scales (VAS) 114
volunteering 14, 31, 90, 92, 116
vulnerable individuals 109

Wabi-sabi 100
walking: 5, 58, 66, 67, 68, 99, 100, 105; meeting 34; tour 45
Wanderlust 67
War on Terror 11
Washington, G. 79
Waves, the 100
wealth: 86, 88; acquisition of 78; community 90–91; power and 10; redistribution 87; unaccountable 20, 37, 79

wearable smart tech 32
welfare state 9, 14
well-being: inequalities 45; outcomes 75
well-doing 14
Wellbeing Economy Alliance 14
Wellcome Collection 46
Wellcome trust 12
wellmania 43
wellness industry 12, 13
western canon 98
wet collodion process 95
Wheel of Well-being 41
wheelchair 21
whisper 22, 1
white paper 9
white rats 32
Whyte, W.H. 23
Withymead therapeutic community 76
Woolf, V. 54, 56
word search 115
workers inquiry 4, 38
working conditions 35, 52
working from home 23, 33
works of mercy 15
world cultures 96, 98
writing 81
written feedback 114

yoga 5, 38, 46, 63, 68–69, 98, 110
Yorkshire Sculpture Park 58
You are an artist 53
YouTube 42, 105

Zappos 32
zoom bombing 6
Zutphen 83, 84, 89